PAINTING
MURALS

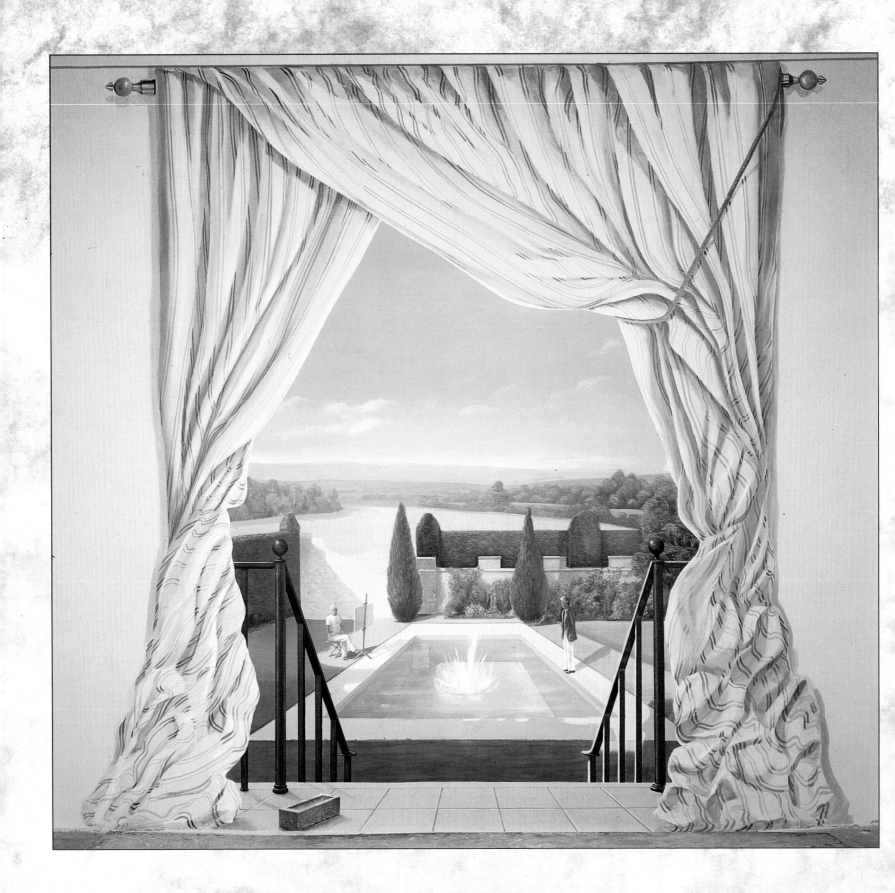

PAINTING MURALS

IMAGES, IDEAS AND TECHNIQUES

PATRICIA SELIGMAN

LITTLE, BROWN AND COMPANY
Boston · Toronto · London

For Alexa and Henry, without whom . . .

The murals specially commissioned for this book were painted by
Lincoln Seligman (pages 80–7, 94–101, 110–17, 124–33, 142–9),
Roberta Gordon Smith (pages 68–75) and Gary Cook (pages 52–9)

A LITTLE, BROWN BOOK

First published in 1987 by Macdonald and Company (Publishers) Ltd
Reprinted in 1991
This Little, Brown edition first published in 1993

ISBN 0-316-90954-8
A CIP catalogue record for this book is available from the British Library

Filmset by Bookworm Typesetting
Printed and bound in Spain

Editor: Jennifer Jones
Designer: Bob Burroughs
Photographer: Andrew Putler
Illustrator: Coral Mula
Art Director: Roberta Colgate-Stone

Little Brown and Company (UK)
Brettenham House
Lancaster Place
London WC2E 7EN

CONTENTS

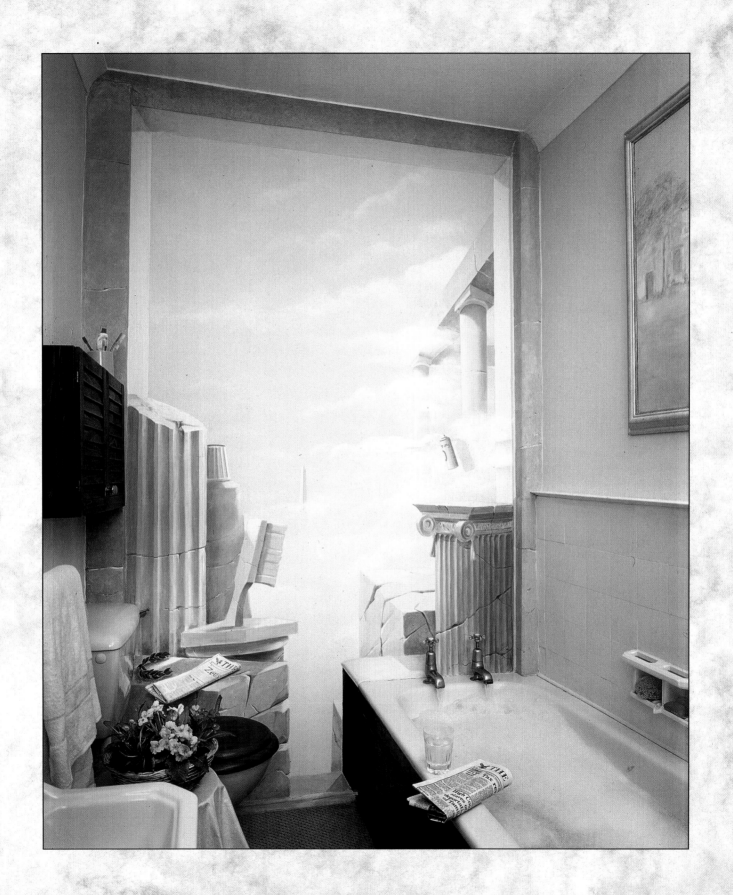

INTRODUCTION

No one needs to be told that murals are popular; they are everywhere, embellishing the interiors and exteriors of houses, buildings and offices. The recent revival in mural painting is not, perhaps, surprising, since we live in times where the decoration of our homes and work place has become one of the most accessible ways of expressing our individuality as well as offering an escape from an increasingly uniform environment.

In a crowded city where living space is at a premium, it is difficult to find a place that is not only spacious, but also one that contains some kind of architectural character. More often than not, we are faced with a series of small, sometimes awkwardly-shaped and featureless rooms. Murals are one answer; they cannot change our homes physically, but they can be used to create the illusion of space, bringing light to a dark basement, for example, or reinvesting a room that has been stripped of character with architectural details. Because of its scale, a mural transforms a room into the painting itself, and the occupants thereby become part of the scheme, reacting to it, talking about it. A mural can promote a chosen mood, inducing relaxation or, through a surrealistic scheme or distorted perspective, creating an electric atmosphere. Murals can inform, or create an illusion, transporting the spirit wherever it cares to travel – from a tropical island to a Roman spa – giving expression to our dreams and fantasies.

An external mural, transforming a wall into a piece of painted scenery, can also provide relief amongst noisy traffic, cheap concrete and narrow, grey streets. More and more adventurous murals are appearing in our modern cities. Turn a corner and you are often surprised by a large-scale and colourful extension of the architecture where you had expected a slab of bland masonry.

Whilst our private lives are lived out in increasingly small spaces, our public ones are acted out in ever more spacious, impersonal areas – lobbies, open plan offices, and community centres. Here, murals provide a focal point, and sometimes even imparting information too.

But what exactly is meant by a mural, you might ask? And what makes it different from an easel painting? Can, in fact, an easel painting also be a mural? Most art commentators agree that a mural – whether it is a painting, mosaic, collage, relief or even photograph – is a work of art that is created for a particular site so that it is incorporated into the architecture; in other words, its composition is influenced by the forces of its surroundings. An easel painting, on the other hand, can be hung anywhere and is appreciated in isolation from its surroundings even though it might enhance them.

In this book, examples of all kinds of painted murals, large and small, simple and sophisticated, are shown, providing both the amateur and the professional artist with a rich source of inspiration as well as a handy catalogue of ideas for those in interior decoration.

All the practical aspects of the preparation for a mural painting are covered in the first part of the book. This is followed by eight practical demonstrations – special projects that illustrate in detail the painting of murals. Some of these are suitable for the keen amateur artist with little or no technical skill; others will only be within the reach of the more experienced painter. Bear in mind, however, that all these murals are painted by professional artists, and that the aim of showing them at work is not only to instruct but also to inspire. All the murals shown in this book can and should be adapted to your talents.

To give a better idea of the breadth and variety of mural painting today, the pages following each practical demonstration will show you some exciting examples – both monumental and diminutive – from all over the world. Some of these are technically unexacting but impart a sense of wit and fun. Others are sensational in their ambitious scale or in their mastery of the art.

Whatever your capabilities are, there are common problems for all mural artists, so tips and shortcuts are demonstrated to make your painting life easier and more fun and to ensure that your work of art – if you so wish it – can be witnessed in the years to come.

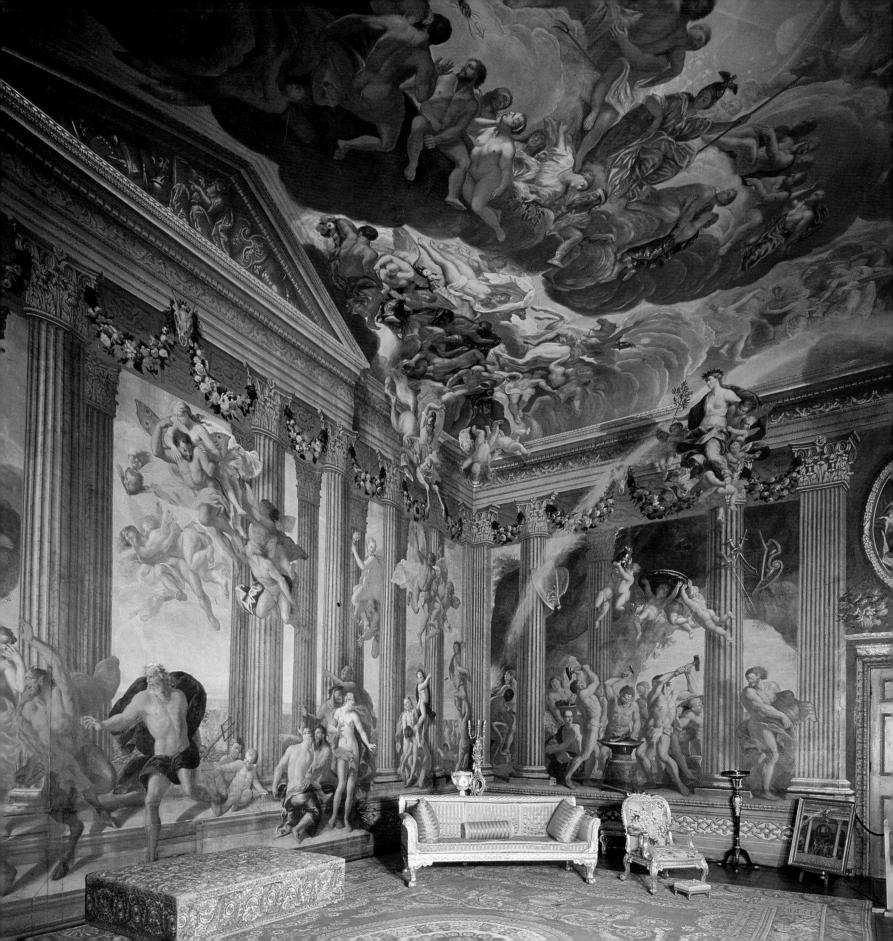

LOOKING AT HISTORY

Left The Heaven Room at Burghley House, painted 1695–6, displays the art of Antonio Verrio, a master conjurer of painted illusion. The baroque grandeur of this classical temple, not to mention the turbulent crowd which populate it, would have more than adequately set the scene for the rich pageant that took place before it.

Below Painted in the third century BC, this line of geese used to parade round an Egyptian tomb chapel. The evident charm of these fowl is captivated with a stylized simplicity and executed with a lightness of touch, which together could be said to represent a formula for successful mural painting.

For centuries, wall decorations such as frescoes, mosaics and panels have been a popular form of art, and, fortunately, many of these have survived to this day for us to admire and study. For the historian, these heirs of successive battles, of iconoclasm, volcanic eruptions and other such diverse accidents of fate reveal a great deal about their owners and their environment. For the modern mural painter, they offer a ready-made library packed with ideas and inspiration. Indeed, problems faced by mural artists have not changed much over the centuries; as we shall see, they are basically the same today as they were for the Egyptian tomb painter, the Roman villa decorator and the Renaissance fresco artist. A saunter through the history of art, therefore, will provide the muralist with a catalogue of ideas and a well-stocked fund of solutions to shared problems.

With history in all its forms, it is nice to be able to begin at the beginning. The question always is when exactly that was. An early survivor is the fragment of a frieze depicting the geese of Maidum (shown below),

which was, incredibly, executed in 2700 BC. This is all the more surprising since it was painted using powdered pigment dispersed in gum on a coat of stucco decorating a tomb chapel. The next section on paints and wall surfaces will make this seem hard to believe.

The frieze also obeys a basic principle of mural painting, equally relevant today. The geese are beautifully observed, and each is slightly different. Yet the style used is simple, stylized, painted in flat colours, and with no attempt at modelling to create a three-dimensional effect. Although intrinsic to this particular design, simplification is fundamental to all mural painting: murals that are overcrowded, overworked and over considered are rarely successful.

The Egyptians did not choose, however, to paint this way simply for aesthetic reasons. Above all, their art served a sacred purpose; at all times they strove to represent the ideal, perfect form, and the clarity and simplicity of their design was a direct result of this. The Egyptians had no word for 'artist'; painters were

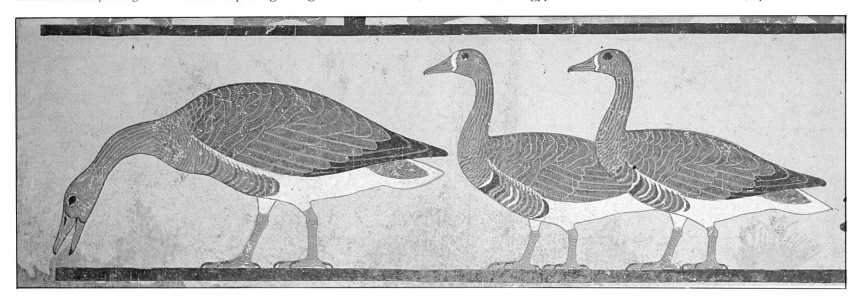

referred to as 'scribes of outline' and were regarded as part of the workforce necessary for a rich patron to guarantee a comfortable eternity. The scribes, by reproducing graphically their patron's life on earth, ensured its continuation after death, and Egyptian tombs were constructed with flat walls specifically for such paintings.

The Egyptians made no attempt at perspective as we know it today. Designs were laid out according to accepted canons prescribed by the priests. The wall area was divided into registers, the lower ones representing the foreground, those above, the backgroud. Important figures were simply made larger than the less important. No attempt was made to break into the picture space to create a stage on which the figures could be placed. Landscape was represented schematically by a sprig of vegetation or similar symbol, as seen between the geese.

Because of its graphic quality, the Egyptian style is simple to imitate; however, it is the concept of simplicity and purity of line behind the images that should be considered and included in the mural artist's battery of talents.

Greek and Roman mural painters used their talents for something other than an inventory of life. Their decorative schemes were intended as a backdrop to everyday life; they were employed to stimulate and amuse, and to provide an illusion of light in otherwise windowless rooms (windows were not used in Rome until the middle of the first century AD). Consequently technical aspects of art ignored by the Egyptians were explored systematically by the Greek and Roman painters. In a remarkably short time they reached a standard of sophistication unrivalled until the Renaissance, fourteen centuries later.

Only a tiny proportion of these wall paintings have survived for us to see today, and much of this was preserved for posterity by the eruption of Vesuvius in AD 78. The Romans at this time employed Greek painters to decorate their houses.

Like today, however, mural fashions in Roman Italy were apt to change. Vitruvius, a writer on architecture in the first century BC, was clear about what he liked: 'We now have fresco paintings of monstrosities rather than truthful representation of definite things.' He was mourning the passing of a fashion for naturalism found in such murals as that in the Garden Room of the House of Livia, wife of the Emperor Augustus (see above).

This country villa is no more, but the painting

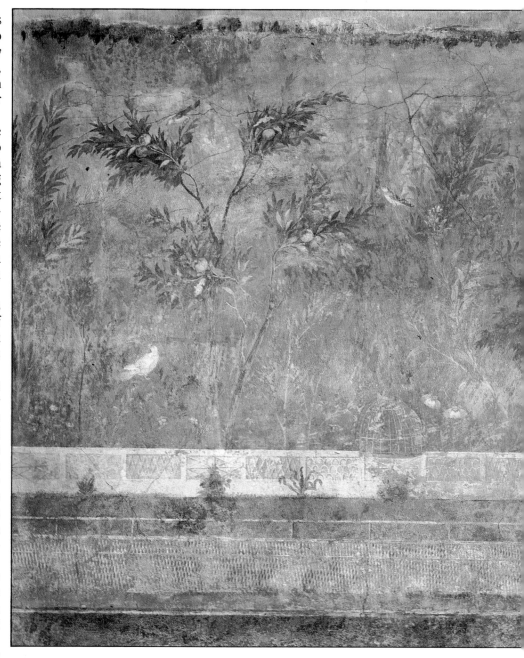

survives in a museum. Although it may be difficult to assess its true glory in such surroundings, none of its ethereal charm has been lost. The painter here has created an illusion of depth, out into the countryside, through the device of aerial perspective where the effects of the atmosphere on colour and tone cause them to appear faded when viewed in the distance. There is no jarring challenge to reality: the eye is invited to float out over this gentle scene. The design is

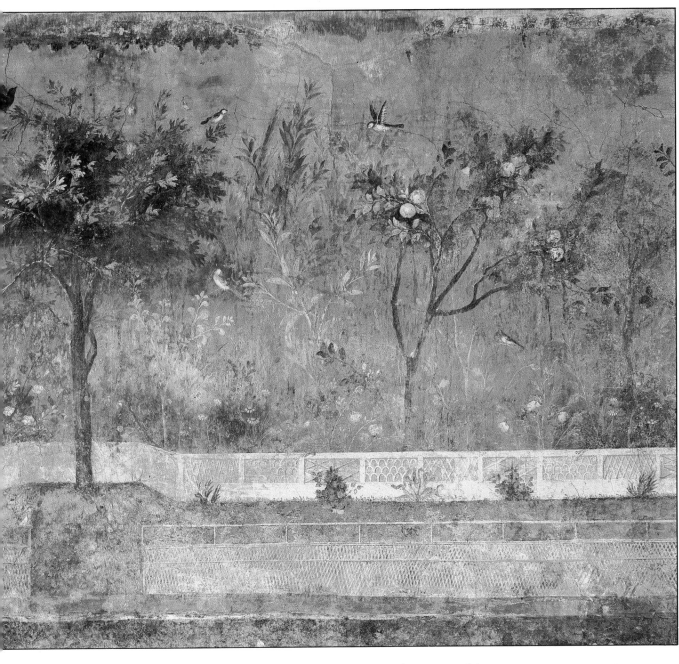

This vision of a wild garden was painted for Livia, wife of the Emperor Augustus, in her garden room in the first century BC and is now in the Terme Museum in Rome. The artist intended his work to extend the real space and to bring the garden inside the room. The pattern formed by the trees, fruit and birds is very much on the surface, creating a pretty decorative freize. Yet a feeling of depth is introduced through aerial perspective and also through the inclusion of the low fence. This makes use of the space, giving it credible depth and symmetry without interfering with the poetic beauty of the natural forms.

simple: over a background of two shades of grey-blue, stylized – yet recognizeable – flora have been painted. To emphasize the feeling of recession, the detail has been increased in the foreground. This illusion of depth is further strengthened by the inclusion of a simple device. A low fence is added – merely a decorative frieze – which isolates the pine tree in the foreground and encloses the rest of the garden. Finally, carefully observed birds and fruit are added, leading the eye across the compostition.

The success of this painting can to some extent be attributed, yet again, to its simplicity and lightness of touch. It is not a painting that is meant to stimulate the mind or elicit humour; it has no message. Here is a mural that was entirely suitable for the room it decorated – a room in which Livia could relax. The mural artist needs to adapt reality for his own needs, seeking a lightness of touch.

For direct contrast with the informal structure of Livia's garden scene, let us turn to Leonardo da Vinci's *Last Super*, painted in the late 1490s. Little of the original exists – even sixty years after its completion the diarist Giorgio Vasari describes it as a muddle of blots. But the design, as we know from the few drawings that have survived and from copies, is largely original (see page 47).

Leonardo painted his masterpiece in a dining-hall – the refectory of the Convent of Dominican friars at Santa Maria delle Grazie in Milan, Italy. His chosen subject, following tradition, was suggested by the use of the room. It is painting with a message for the contemplative friars. Here, taking place in the room beside them, was the reenactment of one of the most dramatic moments of Christian teaching.

The success of Leonardo's *Last Supper* was due to a great deal of planning before he began painting. This development of the composition, as will be seen later (see pages 41-50), often constitutes the most creative aspect of the mural painter's work. We know of Leonardo's methods from other compositions; how he made use of a structure of perspectival lines and strong compositional elements – gesticulating arms, for example – to hold his design together. The vanishing point in this composition coincides with Christ's head and the eye is directed there by the receding lines of the background architecture. The design is uncluttered and strong, entirely fitting the bare room in which it was painted.

Not all mural painters in the past followed Leonardo's example in the precision of the planning stage. Indeed, it has recently been confirmed by the restoration of the Sistine Chapel ceiling that Michelangelo drew many of the figures freehand, guided by the forces of the architecture. Certainly, there are many mural painters today who support Michelangelo's approach. But what is important is that both these great artists, with their different methods, were at one with the site they were painting, and their work, in its integration with its surroundings, bears witness to this fact.

About thirty years after *The Last Supper*, Jacopo da Pontormo produced what seems like a very different type of painting in the Medici villa just outside Florence at Poggio a Caiano. Here, in the blissful Tuscan countryside, the ruling Florentine family spent their summer days. Pontormo's designated lunette captures the bucolic humour of the setting, depicting Vertumnus and Pomona, the Roman god of harvest and goddess of fruit trees. The life-like figures look down on the vast hall, with a coffered, vaulted ceiling overhead and the side walls painted, as was intended, with classical subjects.

Pontormo had to deal with some specific problems. The first, which is more common these days with large external murals, is that the lunette is viewed at a distance from below. A complicated composition containing small details would not have been appreciated. Consequently, the figures have been scaled up and presented isolated in their own space. Other elements have been pared down to a minimum.

Another problem was posed by the circular oculus opening, dominating the space. Pontormo chose to integrate this architectural feature into his composition, making it an important part of the structure. He does this in part with the tree, which appears to spring from the oculus. This anchors the oculus in the composition and also helps to unite the figures, some of whom, on their perilous parapet, appear to cling to it for safety. To incorporate the oculus further, its curves and those of the lunette are reflected in the outlines of the individual figures and the folds of their drapery as well as the tree branches. These curving lines hold the composition together. Lastly, Pontormo has used the oculus as a source of light and, perhaps, also a centre of light, as it seems to hang in the picture plane, suspended, like the sun.

Walls are often seemingly marred by the inconvenient evidence of everyday life. Today, rather than an oculus, we are more likely to have to deal with light switches or radiators. If possible, these should not be lamely ignored or hidden – like the oculus window in Pontormo's mural, they should be seen as a challenge to invention, and integrated into the composition.

Light switches and radiators – if they had existed – would have gone unnoticed among the extremes of the Baroque decorators. Their artistic contortions have to be experienced rather than merely viewed in reproduction to reap full benefit. The results, as can be seen opposite, give the impression of a heavenly rush-hour, with all the bustling that this might involve.

In 1695-6 Antonio Verrio, the painter and, one could say, 'architect' of the Heaven Room at Burghley House, turned a sedate state interior in Lincolnshire into a classical temple. Not satisfied with that, he peopled it with a turbulent mass of heavenly and earthly flesh, suspended, rising and falling, between the columns of a garlanded colonnade. The lighting is dramatic, the colours deep and rich. Empty, the room seems forlorn and the energy of the painting misplaced. But it is not

A mural painter often needs to incorporate a difficult fitting or architectural fixture in a composition. For us, today, it is more likely to be a light switch or radiator, but for Jacopo da Pontormo, in 1519–20, in the Medici villa outside Florence, it was an oculus window which dominated his lunette. Nevertheless, he was able to integrate the feature in a very graceful way. Indeed, the oculus becomes the pivot of his composition, uniting the principal figures of Vertumnus, the Roman god of harvest, and Pomona, goddess of fruit trees.

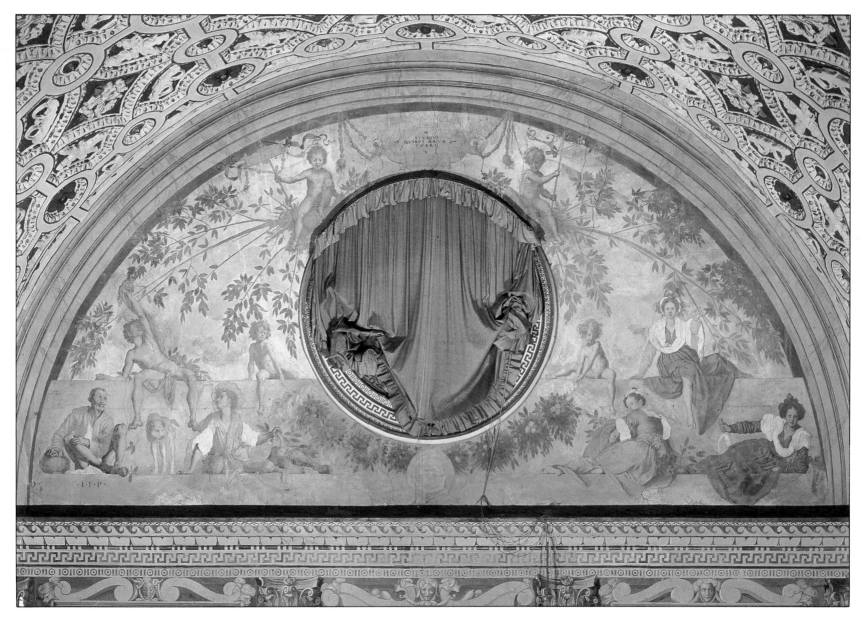

difficult to visualize it as it was meant to be – populated with a similarly energized crowd (see page 8).

Verrio, in contrast to the Renaissance artists, has chosen to override every aspect of the real architecture, creating a total illusion. The room becomes an open-roofed temple with the room's actual boundaries subverted to this cause. Figures appear to burst out from the wall's surface and, in addition, an illusion of limitless space is created beyond. To show how he can manipulate space purely with the help of a brush, Verrio creates a credible illusion of a rainbow striking down from heaven into the central space of the room.

This example shows the extremes of space manipulation possible with mural painting, but it also serves to remind us how 'rules' in art are made to suit the times. This dramatic illusion formed the backdrop for a certain lifestyle and, indeed, could be said to set the pace. Equally, the then contemporary frenzied style of life could also be said to dictate the techniques used in the painting. The heavy colours, unnatural light and stark sculptural modelling of Baroque figures produce a powerful configuration, but this was made necessary by the exaggerated, overbearing nature of reality itself.

For some, it must have been a relief when, in late

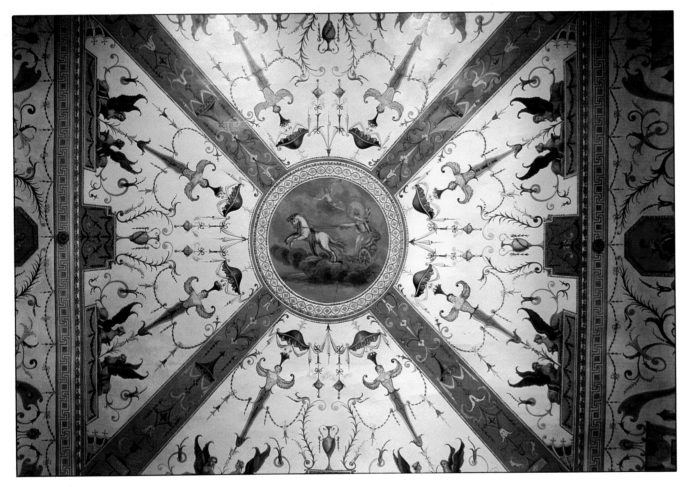

Not all architecture cries out for a trompe l'oeil extension of space. Sometimes a flat decorative scheme is more appropriate in emphasizing the natural boundaries of a room, and can also require less demanding artistic skills. The delicate ornamental decoration of this ceiling in Kensington Palace, London, was painted by William Kent in the early eighteenth century. The skills needed for such a scheme would have been learnt by Kent in his early life, in Hull, when he painted coaches.

seventeenth-century Italy, the concept of decoration began to change towards a lighter, less constrained, style. Figures were painted as if floating weightlessly and the mood of the painting became less fraught. The style changed accordingly: artists used a more golden, sunnier range of colours; the lighting became softer and the application of the paint less heavy.

The Rococo style flourished mainly at the court of Louis XV although it also found favour throughout Europe. In Italy it was promoted by one of the most popular artists of his time, Gian Battista Tiepolo, who revived the flagging Venetian School. Today, like their Baroque predecessors, Tiepolo's great decorative schemes are disarming in their magnitude. Yet, seen in detail, the marvel of this great artist's fluid style can be appreciated. Certainly, the facility with which he painted bears witness to the self-confidence and speed with which he worked. His figures are reduced to a simplified form and appear almost cartoon-like. Only necessary detail is retained, colours are simple and applied thinly with minimum modelling.

Another phase of the Rococo style can be seen in the ceiling painted by William Kent in Kensington Palace, shown above. Such decoration seems quiet and sedate after the extravagance of the previous century. The richness, torment and three-dimensional impact of the Baroque is replaced by this flat, delicate ornamentation, which looks back to an early phase of Roman art for inspiration. The walls and ceilings are patterned with symmetrical designs – arabesques and scroll-work – with the emphasis on the two-dimensionality of the architecture. No attempt is made to 'pierce' through the surface to create an illusion of space.

The choice of a flat, decorative style of mural can be dictated by the architecture of the room. Here, it is a very noncommital, yet decorative, backdrop; a style which, again, reflects the age it was painted in. Such two-dimensional decoration enforces the natural boundaries of the architecture, in direct contrast to the exuberance of the Heaven Room. It is interesting to

note that, even if we are not consciously aware of this, if such a main-supporting wall is 'pierced' illusionistically with a three-dimensional painting, it can promote a subconscious feeling of agitation and unease. Obviously, this can be used to advantage if such a mood is required, otherwise a design can be devised which emphasizes the flatness and strength of the wall, such as those of the ornamental Rococo era.

The mood of a mural can be controlled by colour too. A wonderful example of this is provided by the French painter Henri Matisse in his work *Music*. In about 1908 Matisse was commissioned by the Russian art collector Shchukin to paint a decorative canvas panel for the staircase of his Moscow house. Shchukin, ecstatic with the design for this panel, *Dance*, also ordered an accompanying work to be called *Music*.

We do not know how much Matisse knew about the precise location for his work, but in an interview in 1909 he specified his intention to use three colours for the *Dance* panel: blue for the sky, pink for the dancers and green for the hill, which were also used in *Music*. 'We are achieving serenity by the simplification of ideas and manner', he said. Indeed, the colours do convey the required feeling of serenity.

When you look at this painting, the eye and the mind juggle with the information supplied. The figures, like those of Pontormo, are isolated in their own space, but this time it is the colour that unifies them rather than just the design. The poignant colour used for the figures has the strength to bring them forward from their background, preventing the forms from appearing simply as an abstract pattern on the surface.

Can this painting be described as a mural? The fact that *Dance* was painted for a stairway, with *Music* as the companion piece, could qualify it as such. Matisse answered this question himself in the early 1930s when he returned to the dance theme in a large mural. In a letter to the Russian art expert A.G. Romm he noted: 'This panel [for the Barnes Foundation in Philadelphia] was painted especially for the place for which it was

Colour can be particularly evocative in a mural that dominates a room. It can influence the mood, the light and even, it sometimes seems, the temperature of the surrounding space. Henri Matisse painted two canvas panels in about 1908, *Dance* and this one, *Music*, for a particular site which he did not visit, although he chose colours that would convey a feeling of serenity. The combination of pinkish red, blue and green here form an abstract pattern on the surface, but, because of the strength of the pinkish red of the figures, they are also thrown forward into a different plane.

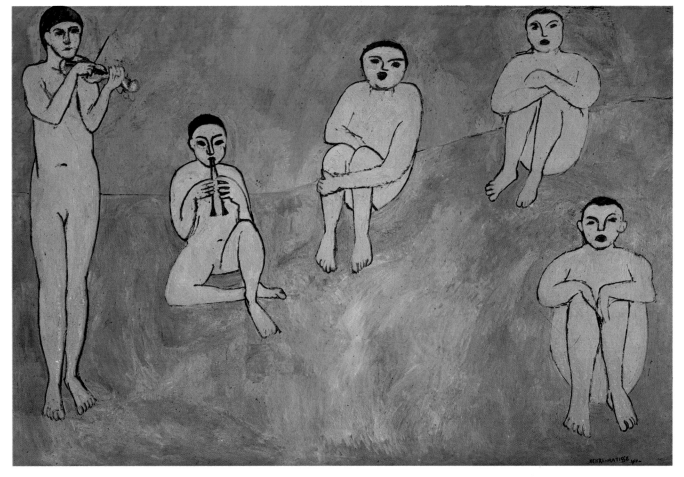

intended. I look upon it as a part of the architecture whereas the Moscow panel is still bound by the demands of the picture itself (that is, something that could be hung anywhere).'

It is perhaps in the abstract mural that the power of colour is most appreciated – not only to promote a mood, but also to demonstrate the force of one colour over another. The French artist Fernand Léger, when discussing mural techniques, noted that 'a square metre of yellow commands a surface four times its dimensions'. Indeed, the varying strengths of the colours, even contrasted with white, make the shape in Léger's designs appear to overlap and sometimes come away from the wall – if not break into it. But his mural compositions (only two are known to have had specific sites in mind) were aimed at reinforcing the flatness of the wall, even though they were intended to create energy. With such murals, the union with the architecture is almost complete, and they were particularly suitable for the purist style of building admired by Léger in the 1930s.

Abstract murals today are most commonly found decorating exterior walls where the structure needs to be emphasized rather than undermined. Even so, such murals are more often an extension of colour decoration rather than abstract designs in their own right. Whereas interior abstract murals were particularly suitable for the architecture of the 1930s, today's architecture does not invite such liberties.

But it is to Mexico that many muralists of the twentieth century turn, at some point, for inspiration. It was there, after 1910, that the politically inspired artists used the mural for revolutionary propaganda, and, in doing so, dragged out of obscurity the concept of mural painting as a serious and useful art form. The resulting impetus not only affected political beliefs and artistic development, but also forced manufacturers to develop a modern paint to cope with their demands.

In the forefront of all these changes was David Alfaro Siqueiros, who was perhaps one of the most fiery of these revolutionary artists. Like others of the same group, he considered that mural painting had a social role, not only in its information and aesthetic qualities, but also in the way a mural can be painted by a group. The detail shown here of his mural entitled *Patricios y Patricidas* was painted in the Old Customs House of Santo Domingo, Mexico City, starting in 1949. It was never finished. In the foreground, Siqueiros' wife symbolizes liberation through struggle, which is represented by the horseman in the background.

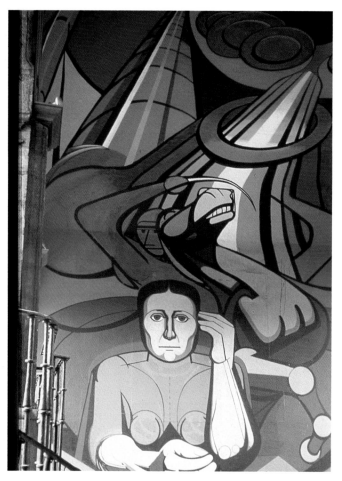

Today, murals are part of the urban scene, helping to combat the monochrome drabness of the inner city. Often these monumental murals are much more than just a way of brightening up a down-at-heel area: they also convey a particular message, taking their cue from the Mexican muralists. The mural *Patricios y Patricidas*, begun in 1949 by David Alfaro Siquieros, of which this is a detail, was painted in the Old Customs House of Santo Domingo, Mexico City. Through it, he advocated liberation through struggle, transmitting his ideology by the use of simple colourful images.

Sequeiros manages to transmit his ideology with forceful energy. His images are simplified but sculpturally solid – even where they are unfinished. But it is with the abstract shapes – cones and disks – and with colour, that he energizes the composition and unites the often disparate elements, integrating the whole into the surrounding architecture.

It is murals such as these that remind us of the diversity of ideas involved in the art of mural painting throughout history. Ideas that are conveniently waiting to be plundered by painters today. We have seen, too, how these ideas and styles were greatly influenced by the surrounding architecture, which in turn was created in answer to a social need. We have seen murals working within the bounds of the architecture; or treating it with disdain, adding a sense of anarchy. As in all branches of the arts, this brief review reminds us that there are principles and rules to guide us, but that they can also be kicked against in the time-honoured tradition of the artist.

GETTING READY TO PAINT

It helps with any project to spend some time at the outset in planning your course of action. As with all painting projects, you have first to decide upon and prepare the surface. For a mural, you may be considering a wall, wooden or canvas panel, or a surface of fabric, metal or plastic. You need to collect together the neccesary materials and equipment, and make some decisions about the type of paint you are going to use. This practical section provides ideas and advice on all these aspects of preparation, as well as plenty of useful tips and suggestions for short cuts.

Before any dreams of painting murals can be fulfilled the site must be chosen. More often in fact, it seems to choose you: a wall 'cries out' to be painted; shutters 'stare at' you blankly, inviting artistic treatment. The ideal site for a wall painting is a smooth, uninterrupted wall. But, as you will see from the examples in the following pages, successful murals are often painted on far from perfect walls. Some surfaces are peppered with light switches, radiators, and wall sockets; others are oddly shaped and interrupted by fireplaces, doors or windows. However, such obstructions can and should be positively incorporated into a mural design.

A mural will be more effective and last longer if time and care has been taken in the preliminary preparation of the paint surface. Although this sounds like a declaration of hard labour for all mural painters, it is in fact more a declaration of intent. Fortunately, all most surfaces need before you start painting is a good cleaning to wash off the dust and grime that inevitably accumulates, particularly in a city.

If your wall is in bad condition, you will have to think again. Basically the amount of time, and money, you want to spend on putting it right very much depends on whether you wish your masterpiece to be conserved for posterity or whether you are prepared to leave it to fate.

If the prospect of such preparation is too daunting you might – rather than ditching the whole idea – consider painting on a moveable support, such as a panel or canvas, which can be fixed to the offending wall either before or after painting. This has the added advantage that such a support can be removed to a new home later, if required. These various options and their preparation are also reviewed in this section.

The type of surface you choose and its size, position, and accessibility will in turn influence your choice of medium and therefore the equipment you will need. For a simple mural, you will be delighted to find that highly technical equipment is not usually necessary and that items commonly found in the home, such as decorators' brushes, rollers and possibly a pair of step ladders, are all that are needed to do the job properly. Even more unusual equipment can often be substituted with household equivalents.

Finally, the section reviews the vast array of paints available for mural painting, assessing their suitability for various surfaces and considering their merits in terms of durability and cost.

Interior Surfaces

The term 'mural' has come to have a wider meaning than the original 'wall painting'. Murals are now painted on a wide variety of surfaces; indeed, these days wall paintings are often painted on panels – wooden, canvas, metal and even plastic. This means that artists who are not prepared to get involved with problems associated with walls can easily adapt their painting methods to murals. Even painting a wall may include covering plastic light fittings and wall sockets, metal radiators and pipes, wooden skirting boards and shutters; so invariably other surfaces are involved.

For ease of painting, you need a clean, dry, smooth surface. If the surface is clean and dry, the paint will be protected; if it is smooth, it will not interfere with the overall effect of the mural. However, when preparing walls, for example, it really is not necessary to get carried away by the minutiae of filling every tiny crack and pit, only to find you have run out of energy. Most murals are meant to be seen from a distance, where slight imperfections in the wall surface will not be noticed. Otherwise, an uneven patch – for example, where you removed a picture hook – can be disguised by, say, an artfully placed cloud. A stippled background will also hide minor imperfections.

Buildings, however, vary tremendously in their method of construction, in their propensity to dampness, and so on – so if you suspect any serious problems, consult a reliable builder as to what method of preparation will be most successful.

WALLS

Most interior walls are plastered. Old plaster, previously painted, if both the plaster and paint are in good condition, forms an excellent foundation for a mural. Fortunately, this is the surface that most mural painters will be faced with.

If the wall has been newly painted, you are ready to go. Check that no dust has accumulated; if you suspect it has, dust down thoroughly with a soft cloth or use a vacuum cleaner with a soft-brush attachment.

City walls attract dirt and grime quickly, so, if the paint on the wall is fairly old, it will need cleaning to enable the new paint to adhere properly. Clear the area in front of your wall and, wearing rubber gloves, wash down the wall with plenty of water and decorators' sugar soap, which contains an abrasive element, or,

Filling small cracks
Small hairline cracks are difficult to fill successfully and may need opening up. Using a screwdriver or putty knife, carefully scrape out the loose plaster so that the filler can be more easily inserted.

Before you fill the crack, make sure it is free of dust and particles of plaster by cleaning it with a small brush dampened with water. An old paintbrush or toothbrush will do the job well.

Chemical paint stripper
Apply this with an old paint brush, leaving it to soften the paint before you attempt to scrape it off. Make sure you wear protective gloves and clothing.

alternatively, liquid detergent, which will remove dirt and grease. Then rinse the surface thoroughly with clean water and allow it to dry.

Most household paints will make a good base for your mural if they are in good condition. However, problems arise if the existing paint on the wall is oil-based and you want to use a water-thinned paint. If the oil-based paint is old, you will only need to rub it down well with sandpaper and prime with a coat of emulsion. If, however, the oil-based paint is new and you want to use a water-thinned paint such as acrylic, you will need to remove the base paint – use any of the methods detailed under *Flaking or blistering paint*. Alternatively, apply a barrier of sealer priming solution, although this will negate the benefits of the porous nature of acrylics.

Once you have cleaned the wall, check the surface

The all-purpose filler can be applied with a putty or narrow filling knife or a domestic knife, if not too precious. Press the filler along the crack, making sure it fills it properly. Scrape off any surplus, but leave it slightly proud of the surface.

Once the filler has dried out, sand it smooth with a sanding block. These can be purchased at most hardware stores or you can wrap a sheet of sandpaper round a block of wood. Sand the surface gently with a circular motion until it feels smooth with your hand.

Hot air blowers
These are effective on emulsion and oil paints. Holding the blower in one hand, tackle one small area at a time, removing paint with a scraper held in the other hand.

residue distemper (see below) with primer sealer; treat nicotine or smoke stains with alkali-resisting primer. Fill cracks in the normal way and sand level.

Problem surfaces
Flaking or blistering paint This should be removed by scraping and sanding. If it covers a large area, it is probably easiest to remove the paint by abrasion, a blow-torch or paint solvent. If you use the latter, you must wash down the wall afterwards. Any unevenness should then be levelled with filler. Allow it to dry, and rub down with fine sandpaper. Now the plaster is ready to be painted with a relevant primer (see page 40).
Distemper This is a powdery wall finish that rubs away and neither paint nor paper will adhere to it. Wash it off with water and a sponge, changing the water frequently. When the surface is dry, finish with a coat of primer sealer before painting.
Damp-associated problems Damp problems are more commonly associated with exterior walls but can also be found inside. Such problems are discussed and treatment suggested on page 22. However, if you are painting on an internal wall which is open to the elements on the other side, check that there are no drainage problems on the exterior such as leaking gutters, which can cause damp and salts to seep through to the interior.

Mould, which sometimes appears as black or brown spots on an internal wall, may well be caused by condensation, so consider more efficient ventilation. If it is caused by rising or penetrating damp, seek professional advice.
Deteriorating plaster Old plaster that is crumbling and almost falling off the wall (described in the decorating trade as 'friable' or 'chalky'), should be removed and the cause of deterioration located and dealt with. Replastering will provide a durable surface, although time is needed to allow the plaster to settle (see page 20). Alternatively, the problem site can be hidden behind a moveable support such as wooden panels or canvas (see pages 24–5).

Another option is to have the plaster removed and a waterproof fibre sheet (known as a 'lath') fitted over the wall instead, which can then be plastered (a process known in the building trade as 'furring'). The sheeting acts as a barrier between the beleaguered wall and the plaster carrying the paint and yet it allows the air to circulate and any damp to evaporate. It does not, of course, deal with the basic problem. This sheeting can be bought in rolls from building supply merchants.

carefully for cracks, holes and minor imperfections. These should be filled or evened out with a proprietary filler and, when dry, sanded smooth. An area of shallow pitting can be dealt with by using a decorators' brush to apply a mixture of filler thinned with water to paint-consistency. Sand down when dry and repeat if necessary. Then apply the relevant primer (see page 40) for the paint to be used.

If the plaster is good but slightly uneven overall, and you do not want to replaster, consider papering the wall with a lining paper or using a moveable support – canvas or wood (see pages 24–5).
Ceilings It is important to set up a stable work station (see page 29) before tackling ceilings. Like walls, wash with detergent or sugar soap, then rinse thoroughly with clean water and allow to dry. You will need to treat

If the problem area is patchy, you can bind the friable plaster with a stabilizing solution, even off the surface using a filler, then cover the plaster with scrim, a loosely woven canvas that should be professionally fixed to the wall. The wall can then be papered. Muralists who prefer to paint on paper tend to use this method so that their work can be moved if required.

New plaster Replastering a wall is a tricky business, so unless you are adept at such tasks you will need to call in a professional. There are, however, some points to watch for.

There are different types of plaster: some need to be left to dry for a number of months, whereas some are ready for paint almost immediately. In a new building you should consult the architect or builder involved.

A newly plastered wall is thought by many to be the best possible surface to paint on. New plaster, however, in a new building is not a recommended surface for a mural if you are looking for any degree of durability. The plaster often cracks due to the settling of the building, and any damp remaining in the building materials will evaporate on the surface of the plaster, bringing with it the salts present in most building materials. This is damaging to most paint films. (See page 22 for treatment.)

It is better to leave such plaster to settle for at least six months and then use porous water-thinned paints – emulsions, vinyls, acrylics – which will let the wall breathe. Oil-based paints or wallpaper should not be considered for at least twelve months. Alternatively, you can paint on a panel that can be fixed to the wall (see pages 24–5).

A newly plastered old wall should not provide so many problems. If possible, leave the plaster to settle for three months although many builders advising muralists would scoff at such precautions.

WALLPAPER

If wallpaper is smooth, well-fixed and in good condition and it accepts paint, it is perfectly suitable for a mural. Ideally, the joins will be abutted rather than overlapped. Some papers, however, are treated to withstand condensation and these are not recommended for painting on. Another potential problem is that the dyes can bleed through the paint, so test a small patch before you do anything else.

To prepare wallpaper for painting, wipe down or vacuum the wall area. Then, to prevent the paper absorbing too much paint, apply a coat of glue size before the undercoat for oil-based paints; water-thinned

Stripping wood
A blow torch with a flame-spreader attachment is most effective for removing paint from wood. Wear protective gloves and cover the floor with a non-flammable covering. Keep the flame moving and take care not to scorch the wood by holding the torch too close.

For areas covered with thick, hard paint, you will need a blow torch with a concentrated flame. Work from the bottom up and scrape off the paint with care, avoiding damaging the wood. Once clean, smooth down the surface with fine sandpaper before priming and painting.

paints can be applied direct, thinning down the first coat with 25 per cent water.

If you decide to paper the wall for the purpose of painting it, there are various options. Lining paper is suitable for most paints and is cheap, but it is not a very fine paper to paint on, it is not strong and it tends to yellow with age. For a more durable work, use pure rag wallpaper which can be purchased in wide rolls, reducing the number of joins. This is more expensive, but if fixed to a scrim it can be removed and re-fixed elsewhere if necessary.

WOODWORK

Most walls are interrupted at some point by painted woodwork – skirting boards, picture rails, window and door frames, shutters and so on. Most woodwork will have been painted with gloss paint, which is not the easiest paint to paint over. Any paint with a high shine

will not accept further layers of paint unless it is first keyed (given a rough surface) by rubbing down with sandpaper or glass paper.

There is a product on the market described as liquid sander which saves the labour and dust involved in conventional sanding. The liquid is applied with a rag, and removes grease and dust while keying the surface. It is then removed with a damp sponge and the surface left to dry before painting.

New wood needs to be sanded down until smooth. Seal any knots with wood-knotting solution otherwise they will stain the covering paintwork. Then prime with wood primer or a multipurpose universal primer.

Pits or cracks in the wood surface must be primed first before filling with a flexible multipurpose filler. Rub down when dry, then prime the filler.

METAL

Because metal is usually very smooth, you will have to coarsen the surface with sandpaper, glass paper or wire wool. Acrylic paint tends to adhere better, but for both oil-based paints and acrylic, you will need to sand and prime with a metal primer appropriate for the metal involved. Large sheets of aluminium, which are flexible and durable, are becoming more popular for mural work. Artists' acrylic paints or oil-based paints, or cellulose car paint, can be used. The latter is more durable if sprayed on in an even coat.

Radiators often have to be incorporated into a mural. When purchased, they usually have a very basic coat of primer. Remove any rust spots with sandpaper and touch up these areas with metal primer. When dry, paint with oil-based paints. The problem here with oil-based paints is that when the radiator heats up, light and pastel colours tend to yellow. For this reason, some artists use water-thinned paints instead although, as the heat causes deterioration, manufacturers do not recommend them for radiators.

PLASTIC

Your mural may be interrupted by a light switch or plug socket plate, but these can be incorporated into the design and painted. If possible, unscrew the light switch fitting from the wall and paint the plate separately. Do *not* attempt to paint the switch itself or the sockets. If the fitting cannot be removed, turn off the electricity supply at the mains before painting and take care not to interfere with the actual switch or the plug sockets. Paint is likely to chip off such fittings because they are in constant use. Alternatively, for light switches, a

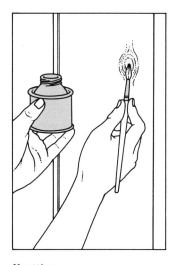

Knotting
Above top All knots in wood should be sealed to prevent resin from seeping out and staining the paint. Make sure the area is smooth and paint-free: use a sanding block or paper to sand along the grain. Clean off any dust with a rag soaked in white spirit. *Above* Next, apply a shellac-based knotting solution with a small brush. Allow to dry before applying a second coat.

transparent plate, which would not interfere with the painting, could be used.

Plastic sheeting is now often used by scenery painters for theatre work. Emulsion paint made by Rosco (see pages 34-5 and 163) has been formulated to be used in this way and bonds with the plastic to form a strong film. For a temporary mural such a surface is worth considering.

CERAMIC TILES

Glazed ceramic tiles are not easy to paint over and, in addition, they are usually found in bathrooms and kitchens, where condensation causes problems. The paint tends to peel off the shiny surface, which is difficult to scour in order to provide a key.

While acrylic paints can be used, they will peel off if knocked or scratched. Alternatively, Flo-Paque enamels, which are widely available in 'tinlets' primarily for use in model making, have proved to be suitable and relatively long-lasting (see page 38). These paints can be applied direct and, apart from cleaning the surface to remove dirt and grease, no preparation is necessary.

FABRIC

A real window in the middle of a mural, if not incorporated into the design, can emphasize the discrepancy between illusion and reality. One answer is to paint on a stretched canvas which can be inserted at night (see page 126). Otherwise, you can paint on a plain blind using acrylics or, if you find it easier, fabric paints.

If you want to use a blind instead of a canvas, it is easier to make up the blind first, checking that it is the right size and length for the window. Do not, however, apply any of the fabric stiffener spray at this stage. If you wish, you can paint the blind in position. Otherwise, unroll the blind and paint it on a protected floor. When the paint is dry, apply the fabric stiffener as directed on the aerosol can.

Temporary backcloths for party decorations or for theatre use can be painted using vinyl matt emulsion. The good quality brands are surprisingly flexible. For the 'cloth', use an old sheet or buy cheap cotton. For more durable mural backdrops, use canvas, which can be bought in many different weights, widths and prices, and treat it as you would if it were stretched.

To paint a cloth, either lay it over plastic sheeting on the floor, or hang it on the wall by nailing it to a 2-inch (5-cm) square batten of wood the same length as the width of the painting.

Exterior Surfaces

Pollution in city centres makes them unsuitable places for murals. This, however, has not prevented – and indeed should not prevent – muralists from carrying out their sometimes physically exacting task of enlivening some of the more dismal corners of our environment.

The life-span of an external mural will depend largely on the wall – its condition and location – and on the standard of preparatory work, as well as the choice of paint. A wall that is battered by the elements and pollution will retain a mural for much less time than one that is dried out internally, and protected by an eave, portico or trees.

Few external walls – unless you are basking close to the equator – are free from damp-associated problems, but external paints have been developed to survive such conditions, and many contain fungicides. In addition, there are special priming agents to combat most of the common wall ailments (see page 40).

You will obviously be restricted as to when you can work. Your wall should be thoroughly dry, so the winter months are to be avoided. Some paints cannot be applied in temparatures below 5°C/41°F and the weather needs to be dry too. High humidity, apart from increasing drying time, can be damaging to paints. If possible, choose a warm day with some sun, but organize your work so that the sun does not shine on the drying paint. If it starts to rain while you are painting, stop and resume only when the wall is dry again. An alternative to painting on exterior walls direct is to use a moveable panel (see pages 24-5).

WALLS

External murals are often large and in awkward places. The simple instruction 'clean off any loose material with a wire brush' can in fact seem like a life sentence when faced with the side of a building. The answer is to employ contractors or elicit the support of a team of workers to operate in shifts.

Any natural growths, efflorescence and other damp-associated problems should be cleaned off first as outlined below. Now, with a solid foundation to work on (see opposite), wash down using a hose, long-handled scrubbing brush and cleaning agent. Take extra care under eaves and windowledges, where soot and grime builds up. Rinse off the cleaning agent with clean water and allow the surface to dry out.

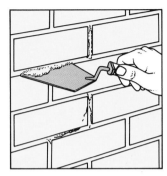

Making good brickwork
Repoint where necessary using a sand and cement mixture.

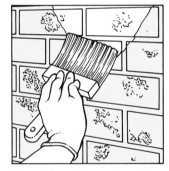

Clean off mould growths with a hard brush and bleach solution. Rinse off after 48 hours.

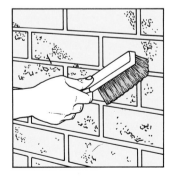

Use a stiff brush to remove dust and any residual mould. Repeat bleach solution if necessary.

If you are dealing with a large wall area that is of poor quality, or your mural is to be a bequest to future generations, sand-, shot- or water-blasting will do the job best. This will involve professionals and is pricey, but it will remove old paint, rotten plaster and clean up brickwork to give a pristine surface to work on.

Once clean, the surface then needs to be made good. Clean out defective pointing and repoint the wall and fill big cracks with a mixture of one part cement to four or five parts sharp sand. Any small cracks can be filled with an exterior flexible stopper. Repair any defective patches in rendering with mortar.

Surface problems

Damp is the arch enemy of the wall painter. It causes various problems, such as fungi and the destructive issue of salts known as efflorescence. Left unresolved, these will have a detrimental effect on bricks or wall plaster and eventually the paint surface. Sealing primers can block off the damp in the short-term, but the cause will need to be eradicated in the long-term.

Natural Growths Fungi and algae which sometimes appear on the wall as black or brown spots, or moss are well known signs of dampness.

Armed with rubber gloves, clean off such growths with a solution of one part bleach to four parts water applied liberally with a hard brush – an expendable nylon brush is best. Work into the surface well, then leave for 48 hours before rinsing off with clean water. Brush off any remaining growths with a stiff brush when dry. Repeat the process if necessary. Make sure the surface is completely dry before applying paint. At this stage, you might consider the application of a fungicidal primer or a paint containing a biocide.

Efflorescence You will have come across this as a whiteish bloom, particularly common on new brickwork. Efflorescence appears when clay bricks are exposed to damp; as they dry out, the mineral salts inside the clay crystallize, staining the surface with a powdery deposit. This is very damaging to the paint surface, and will result in paint deterioration. Efflorescence can also appear on bricks that contain no soluble salts (for example, calcium silicate bricks), but in such cases the cause is salts coming from the ground

With a bristle brush, remove the white crystals and, when the salts have ceased to appear, prime the wall with an alkili-resistant stabilizing solution.

Staining Water and iron stains should be investigated and the cause dealt with. It is usually just a case of clearing gutters. Iron stains should be sealed with an

alkali-resistant stabilizer and the iron-work causing it should be sanded and primed with metal primer to prevent further staining.

BRICK

It should be pointed out straightaway that some bricks should never be painted, so always check with a builder first if you are in any doubt. However, sand-faced or rustic clay bricks, and those made of calcium silicate or concrete are all suitable for painting as long as you use water-thinned paints.

Bricks also come in a wide range of textures. Engineered bricks, for example, are very smooth and it is sometimes a problem to get paint to adhere to them. Bricks vary, too, in their ability to absorb paint. Sometimes this porosity will vary over the surface of a wall, adding to the problem.

Undoubtedly, painting on brick is hard work because the paint has to be worked into the irregularities of the surface. Brick is often unyielding to the brush, and it is difficult therefore to achieve fine detail and to get a flowing brushstroke. This can be partly overcome by applying extra coats of undercoat, even if these are only applied locally in the places where you wish to paint in your details.

However, bear in mind that, if seen from far enough away, the uneven surface of any brickwork will disappear. You can even take advantage of the regular pattern of the brickwork and use it like graph paper to create a design. Many schools have painted murals using this method.

RENDER

External walls are rendered (which is equivalent to internal plaster) in different textures and colours of sand and cement in different ratios, thus providing a range of surfaces to work on. External renders are usually coarser than internal plaster because they contain sand. They are consequently harder work to cover and discourage detailed brushwork.

Basically, the same rules apply to render as they do to plaster, so consult page 19 if you have a problem. If the wall is damp or water is able to permeate between the render and the brick, the mural will not last long. Make sure the render is dry before starting any painting work.

METAL WORK

Guttering and drain pipes, which often need to be incorporated into a mural design, will need to be well prepared; otherwise they may eventually deface the

Towers and ladders
Platform towers, available from hire shops, are constructed from interlocking tubular sections with boards to provide a platform. Casters enable freedom of movement, but make sure they are locked before use. Never climb up the outside of a tower or it might overbalance. When using a ladder, set it 3 feet (1 metre) away from the wall for every 13 feet (4 metres) of height. On soft ground, place on a board and secure with stakes.

mural with rust stains. Remove all loose paint and rust with a wire brush. Dust off, then prime bare areas with an exterior metal primer.

PLASTIC AND WOODWORK

The same methods of preparation apply for these surfaces outside as inside (see page 20). You can paint on plastic pipes with gloss paint, but plastic window-frames should not be painted.

SCAFFOLDING

For larger murals, and particularly where a number of painters are involved, you will need to erect scaffolding. Usually, this means calling in the professionals who can advise you on safety and accessibility to the wall surface. Although it may sound extreme, sometimes it is easier to hire a suspending cradle like those commonly used by window cleaners, or a hydraulic lift.

Whatever is required, you will need to book hired equipment well in advance, particularly in the spring, which is peak decorating time. Make sure that ladders are never left up against scaffolding when it is not in use, or children might feel they are being invited to use this equipment as a climbing frame.

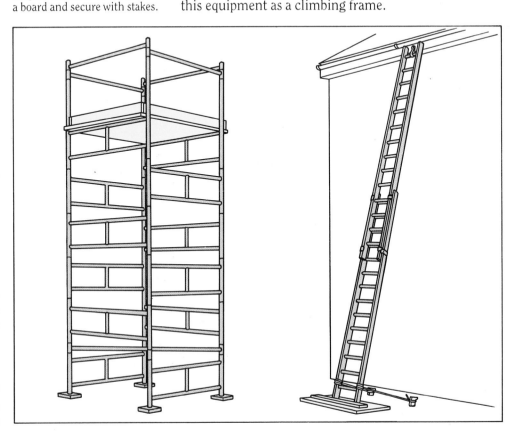

Moveable Supports

There are many good reasons for painting on a moveable support that can be fixed on a wall. One of the greatest advantages is that it gives you the option of moving your mural wherever you might be.

Sometimes, it is the poor condition of the wall that drives a painter to superimpose a support, which can cover up most wall ailments. For others, however, the choice will be made through habit, and perhaps because, by using a familiar support, it will make the task seem more approachable.

Moveable supports, however, are disapproved of by certain artists, who consider that the essence of a mural is that it should be an intrinsic part of the architecture and therefore of the wall. A compromise of sorts can be reached by sticking canvas or high quality paper to the wall. Marouflaging canvas to the wall in this way (see opposite) or sticking up pure rag paper (which does not discolour and can be obtained in wide rolls) backed with a scrim (see page 20), provides a moveable support which seems in every way part of the structure.

The advantage of moveable panels is that you can begin painting anywhere you like – for example, in a spare room or, if you have one, a studio. It is best, however to move the support to its intended position once you have finished the initial stages of painting. Even if a design has been carefully planned, you may find that when the painting is installed certain aspects, such as proportion or the level of light, require that the design be modified.

The type of support you choose will depend on the surface you require, the size of the area to be covered, and the weight that the wall can support. Rotten plaster will not be a safe foundation for heavy chipboard, particularly if it is to be attached high up on the wall. Stretched canvas is very light and is easily removed from its stretcher, rolled up and reassembled. There is a traditional respect for canvas too, so your mural is more likely to survive changes in taste even if it is rolled up and stored in the attic for a while. Canvas is also easier to alter in shape, should that be necessary (though it hardly bears thinking about). The surface of some types of canvas is quite textured, which sometimes, if viewed from close up, can destroy the illusion in a more subtle trompe l'oeil.

Measuring up Measure the space carefully. Do not assume that two apparently straight sides of a wall are

Stretching a canvas
Fold the canvas round the frame. Staple or tack in place.

Pull the canvas corner across, checking the right side before stapling in place.

Fold over the flaps of canvas tightly to form a neat corner. Staple or tack them down.

parallel or the same length. If it is a large space, divide it up into a number of manageable-sized panels. These will be dictated by the maximum size of your materials. Canvas can be supplied in a range of widths, so check with your supplier

Subtract one-half inch (1 cm) from the measurements all round to allow the support to be inserted into the space. Any discrepancy can be filled with, for example, a proprietary filler or strips of wood, or a strip of beading can be tacked round the perimeter.

Whichever support you choose, it will need priming before painting (see page 40).

CANVAS

Canvases come in a range of types, weights (thickness) and weaves. As a smooth surface is usually required, a finer weave is best. Cotton duck is now very widely used, as fine linen is very expensive and not freely available. The irregularities of cotton duck – knots and scags – can be a problem but there is a good range of weights, and both fine and coarse weaves are available. Canvas made from man-made fibres is cheap, but artists used to natural fibres find it unrelenting.

If you want to improvise cheap scenery for a play or party, old sheeting of cotton material can be used with emulsion paints.

Stretching a canvas

This can usually be done for you by your local suppliers of stretchers (the wooden frame supports) or canvas. Otherwise, it is a job which is not as difficult as it looks.

To stretch your own canvas, you will need stretchers, canvas, canvas pliers, ruler, scissors, set-square and staple gun or hammer and tacks.

The stretchers can be bought to size, ready cut, with corner wedges to regulate the tension of the canvas. Assemble the stretchers, checking the right-angles, then cut the canvas, with the weave parallel to the longest side, with about 1½ inches (4 cm) to spare all round. Put the stretcher frame on the canvas, then fold over one side and staple or tack it to the back of the stretcher, starting at the centre. Repeat for the opposite side, using the canvas pliers to stretch and hold the canvas in position. Repeat until the canvas is taut and smooth. The corners can then be folded flat and secured. If there are minor creases, adjust the corner

wedges or dampen the back of the canvas with water. If the canvas is unprimed, remember that it will shrink a little with priming, so the tension should be reduced.

Marouflage

This is the technical term for fixing canvas to a wall or, more commonly, a wooden panel. The combination of canvas and wood – even hardboard – makes for a strong support. It also has the advantage of appearing and feeling more like a wall. However, if you want to marouflage a particularly large area you may need to get professional help.

To marouflage canvas to a board, first iron out any creases in the canvas with a cool iron. Then paint adhesive on the back of your canvas and on your support. Acrylic medium or undercoating can be used for this as the acrylic resin is an effective adhesive. Make sure that the adhesive used is compatible with the paint you intend to use. Next, carefully lay the canvas over the support, smoothing out the creases and the glue with a rubber-faced roller. A culinary rolling pin, if used gently, will also do. Make sure the canvas is well fixed round the edges of the panel or board. This will protect the weakest part. Wrap the edges of the canvas over the back and glue down. Neatly fold the corners and stick.

If the canvas is very loosely woven (muslin works well when applied to hardboard), lay it smoothly on the board and then paint the binding agent (glue size for oil paints, acrylic medium for acrylics) on top.

WOODEN SUPPORTS

There are advantages to using a wooden support – natural, ply or composite. It is easily available and to many the prospect of dealing with it is less awe-inspiring than the thought of stretching or marouflaging canvas. There are many types of woods and boards, suitable for most circumstances. Sometimes it is easier to see what your local wood merchant stocks and take it from there.

Natural woods Panels made of natural wood are now seldom employed although their use over the centuries has proved that hardwoods – mahogany, walnut, oak – if well-seasoned, are certainly durable. They are expensive however, and usually very heavy. Consequently, plywoods, sometimes faced with a veneer of mahogany, are more practicable. Natural woods should be prepared as for woodwork (see page 20).

Plywood Plywood is made up of various thin sheets of wood glued together, and is sold in a number of thicknesses. The weight will be affected by the number

Marouflaging canvas
Paint the back of the canvas and the front of the panel with glue.

Gently smooth the canvas over the panel. Fold the canvas over the edge to the back.

For neat corners, paint adhesive on the underside of the flaps and between them and press down.

of plies, and so will durability – the more layers, the stronger the panel will be. Strips of wood need to be fixed to the back of plywood – a process called 'cradling' – to prevent warping. The edges, which have a tendency to split, should be painted with a sealing primer and, if possible, protected by a frame. All plywood needs to be primed on both sides to prevent bowing.

If the board is going to be exposed to uneven moisture levels, marine plywood should be used instead. Although marine ply is more expensive, it has, as its name suggests, been developed for marine use and will stand up to exterior conditions better than most wooden supports. Otherwise, water- and boil-proof ply (known in the trade as WBP) is a cheaper alternative; it will stand up to a certain amount of damp, but will not survive outside for too long.

Hardboard These sheets of composite boarding (made of compressed wood fibre) usually come in two thicknesses (⅛ inch and ¼ inch/3mm and 6mm) and are readily available at timber merchants in various sizes. Hardboard is relatively cheap and freely available, but it is not very strong and has a short life expectancy. Because it is very light, you should consider marouflaging with canvas (see above) if extra strength is needed. Hardboard is not suitable for use outside.

Hardboard has a smooth and shiny side, while the other is textured. Both sides can be painted on, but the smooth side is generally more useful for mural painting. Again, cradling is necessary. To prepare the smooth side for painting, lightly sand down and prime according to the paint to be used (see page 40).

Chipboard Chipboard is made of compressed wood chips in a resinous binder. It is relatively cheap and has the great advantage that it does not require cradling. On the negative side, it is heavy, is only moderately durable, and tends to disintegrate around the edges. The surface is very absorbent and ugly to work on even when primed. Two coats of gesso (available from art shops) will provide a smooth workable surface. Chipboard is not suitable for outside use.

Medium-density fibreboard (MDF) MDF, like chipboard, is made from compressed fibre with a binding agent and is heavy. Unlike chipboard, MDF is silky-smooth, dense and cuts leaving a clean edge. Because its smooth finish repels paint, it requires sanding lightly before applying paint.

Essex Board This laminated cardboard is cheap, very light and ideal for a temporary mural inside. It can, however, be marouflaged with muslin, which will certainly extend its life expectancy.

Brushes and Applicators

Paint can be applied with almost anything and there are well-documented cases of some of our great artists using fingers, feet, rags or anything else to hand. Of course, artists' brushes are made for the job, and the range of shapes and cuts encourage the artist to produce a host of different brushmarks.

For painting murals, however, and certainly for large-scale ones, you will probably find a selection of decorators' brushes and applicators, such as paint rollers and spray guns, useful, as well as a range of artists' brushes for painting in the details.

ARTISTS' BRUSHES

Artists' brushes come in different shapes – round, flat and filbert – and a range of sizes. They are made from different types of hair, bristle and man-made fibre. The type of bristle affects the brush mark, flexibility and paint retention. Sable is universally regarded as being the best hair for brushes, but the price of even the smallest sable brush has put them beyond the reach of many artists.

Wall surfaces, even the smoothest plasters, are cruel to brushes because of their ungiving nature. For this reason, many muralists who paint directly on walls have been converted to the much cheaper nylon brushes. These are now of a much improved standard. The softer, more expensive bristles, such as sable or squirrel, are not recommended for the tougher wall surfaces. However, many painters find that the sensitivity and natural flow of these brushes is not quite matched by their nylon equivalents, and use the superior, soft brushes for finer detailed work. If, however, you are painting on a moveable support – smooth wood panels or canvas – then the usual rules apply: buy the best you can afford and look after them well.

For mural painting, you will need a range of shapes – round, flat and filbert – and a range of sizes within these categories. This selection is largely a matter of personal taste. The medium you use will, of course, also affect your choice of brush. Acrylic paint is reckoned to be tougher on brushes than oils. The size of the project, too, will govern your choice – the larger the mural, the larger the brushes.

If you use both oil-based and water-thinned paints, then it is wise to have a separate range of brushes for each type.

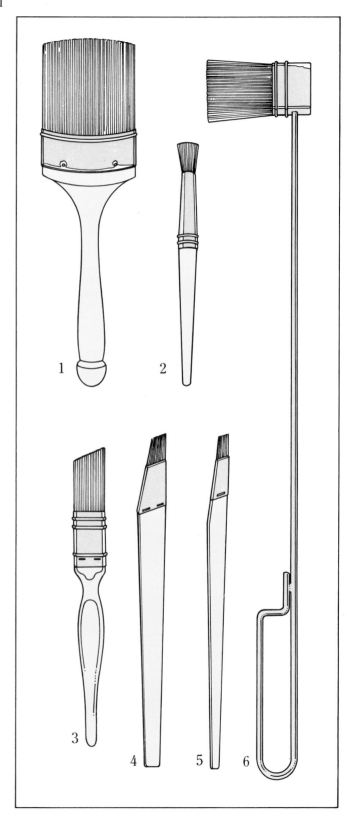

Specialist brushes
These are not always essential equipment, yet you may find that your style of mural painting or a particular site will send you in search of a helpful brush. A proper round-edged varnishing brush (1) has more bristles to help smooth out the varnish; a round fitch (2) is cheap and useful for stippling. For straight lines, it is worth trying a cutting-in brush (3) or a lining fitch (4 and 5). To reach behind pipes and radiators, use a wire-handled crevice brush (6).

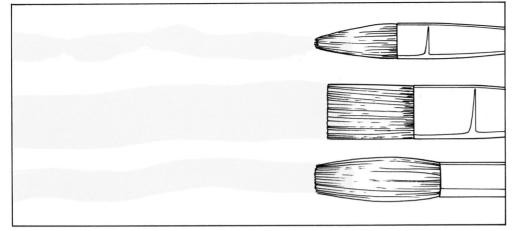

DECORATORS' BRUSHES

Again, you will need a selection of general purpose brushes for applying paint to large areas and for blocking in expanses of colour. To start with four brushes will be enough: 4-inch (10-cm), 2-inch (5-cm), 1½-inch (4-cm) and 1-inch (2.5-cm).

The cheapest decorators' brushes are a false economy because they have poor paint retention and tend to shed hairs all the time. A good bristle brush is therefore recommended. Break in a new brush at the undercoating stage so that any loose hairs will be shed then and can be picked off when the paint dries.

SPECIALIST BRUSHES

There are a number of 'specialist' brushes to choose from. Although these are not strictly necessary, they can be useful. A crevice brush, with a wire handle that can be bent to any angle, is handy for tricky corners; a cutting-in brush has its bristles cut at an angle for painting straight lines; a round fitch is cheap and useful for stippling, or for any repeated brushstrokes that are hard on the bristles and do not require the sensitivity of a more expensive brush. For spattering, an old toothbrush is ideal.

CLEANING BRUSHES

Most paints are easy to clean off when wet and almost impossible when dry. It is difficult to clean brushes as you go, particularly when you are covering large areas. Have a pot of solvent, appropriate to the medium you are using, to hand and rest the brushes in this until you have time to clean them properly. Do not leave the bristles resting on the bottom of the pot for too long or they will become distorted. Hook brushes to the side of the pot with wire, or use the hole which is bored in the

Artists' brushes
Because the mark made by a brush is affected by its shape, size and the type of hair used to make it, it is important that the right brush is chosen for a particular job. The filbert shape (*top*) makes a good leaf shape. The flat brush (*middle*) can be used end-on to add dabs of dry paint. A round brush (*bottom*) can be used for all manner of techniques.

stem of most decorators' brushes to suspend them in the solvent.

When you have time, work out as much paint as possible on newspaper or kitchen paper, then dissolve the remaining paint in solvent (white spirit for oil-based paints; water for water-thinned paints). When all the paint has come away, shake out any excess liquid or water and dry off the brush with a clean rag or kitchen paper. Brushes cleaned in white spirit should occasionally be washed carefully in warm water and soap. Nylon brushes can be set into shape with soap when not in use. Store all brushes carefully, either flat or with the bristles upwards. High quality bristles should be stored in moth-proof cannisters.

ROLLERS

Paint rollers are ideal for applying an undercoat quickly and easily, although this method is likely to use up more paint. Rollers come in various widths with a range of sleeves. The cheaper foam rollers not only tend to spray, but also invariably leave a textured surface that is more difficult to paint over, so choose a short pile lambswool, sheepskin or synthetic equivalent for a smoother finish.

Rollers are used in conjunction with a paint tray. Pour paint into the base of the tray and roll the sleeve backwards and forwards in the paint until it is coated. Remove excess paint on the ribs of the tray, then apply the paint in a criss-cross direction to cover the wall.

SPRAYING EQUIPMENT

To cover a large area with a smooth coat of paint, a paint sprayer or gun can be useful. These can be hired in various sizes but they need practice to achieve successful results.

AIRBRUSH

This instrument, which is used for producing delicate gradated tone-work or very precise hard-edge detailed work, has been used effectively by muralists. By altering the pressure or the distance between brush and support, the density and area of the spray and, therefore the tone, can be controlled.

The airbrush, however, is a precision instrument, and good quality models are expensive. Before embarking on a major project it might be worth having a trial run with a borrowed model. Otherwise, you can get the feel of the technique using car spray paint, although there is no real comparison between the finesse possible with these and that of the genuine article.

General Equipment

Little specialist equipment is needed for mural painting, and most of it can be home-made using easily available materials. Your needs will depend on the size of your mural and the medium you decide to use. The sort of equipment you might need and some useful tips on how to use it are detailed here, but do not be intimidated by the length of the list. As you will see in the step-by-step projects, only a few items were used in each case.

Before you start painting, it is worth making sure you have the equipment to hand for each stage of the mural. This will prevent unnecessary distractions. It is very annoying to have to keep interrupting your work flow to find the all important eraser, brush or whatever.

GETTING READY

First of all, you will need to get the site ready. If you are working inside, make sure that the room is clean and dust-free. Ideally, the area in front of where you want to paint should be cleared completely of furniture and carpets rolled back. Otherwise, cover the floor and any fixed furniture with dustsheets or sheets of polythene, which can be purchased in economy rolls or sheet sizes. To ensure that these do not work loose, pin them round furniture or tape along the base of the wall with masking tape, which can be easily removed later without damaging the paint surface.

If possible, lay out all your equipment on a table (a decorators' collapsible table is useful) within easy reach. Some artists use an old trolley on wheels which can be easily moved along as and when necessary. Keeping your equipment neatly in this way will ensure that trimming knives and paint pots are kept out of the way of inquisitive children or careless spectators.

As you work, try to return any paint pots and equipment to the table instead of using the floor area in front of your painting. This area needs to be free as you will need room to paint and also to stand back and assess your progress. Clutter underfoot can be dangerous as well as distracting.

Whatever your resolution before you start, do not think your clothing will escape unblemished in a pristine condition, particularly if you are painting with someone else. Wear old clothing or overalls, and make sure that they are loose so that you have enough room to bend and stretch to the outposts of your mural.

GENERAL EQUIPMENT

- dustsheets or polythene sheeting
- masking tape
- charcoal and/or chalk
- pencils
- eraser
- 1-yard (1-metre) rule
- string
- plumb line
- spirit level
- protractor
- French curves
- craft knife
- scissors
- cardboard
- re-sealable plastic paint kettles
- buckets
- plastic cling film
- ceramic palettes, bowls or foil containers
- stick or spoon for stirring paint or stirring attachment for electric drill
- all-purpose filler
- flexible filling knife
- sand paper
- wire-wool, soap-filled pads or abrasive powder
- sponges, rags and kitchen paper

Equipment for mural painting can often be substituted by household equivalents. Of course, you will not need all these utensils, but make sure you have assembled what you do need before you start work.

Unless you like premature hair streaks, it is wise to cover your head with a hat or scarf, and always remember to wear suitable shoes for ladder climbing or whatever physical assault course your mural painting involves you in.

If you do not take this advice and get paint on your clothes, try to remove it before it dries – with a solvent for oil-based paints (though test materials for fastness) and with water and soap for water-thinned paints. Dried paint is more difficult to deal with. Water-thinned paints can sometimes be removed – if the material will take it – with hot water and detergent. Otherwise, soak with alcohol and the paint should disintegrate.

The list opposite may seem daunting, but, as has already been noted, these are only suggestions of what might be necessary. Certainly, you will need dustsheets or polythene sheeting and masking tape to stick them down. And masking tape has, of course, a host of other uses; in painting, it is particularly useful for masking off straight-edged areas you wish to remain paint-free.

Other equipment you are likely to need includes a piece of charcoal or chalk or a pencil to draw in the design, plus an eraser, which, if it is good and soft, will

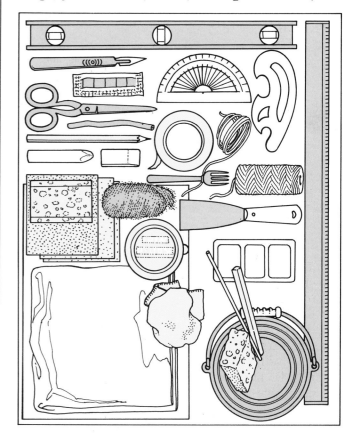

work just as well on walls as anywhere else. Here, too, a 1-yard (1-metre) or perhaps a 2-yard (2-metre) rule is a great help; you can make your own using a length of 1-inch (2.5-cm) square wood and marking it off. String, attached to a good symmetric weight (a fork, for example), will act as a plumb line to test vertical lines in the mural design. These can also be checked with a spirit level, which, in addition, can be used to make angles of 90° (otherwise, use a protractor). String is also invaluable when used in conjunction with a pencil, instead of a compass, to draw circles. If your design incorporates curves, a set of French curves (plastic stencils) are extremely useful, and a craft knife is preferable to a pair of scissors for cutting cardboard templates (see page 49).

When it comes to mixing paint, there are a number of containers to choose from, including plastic pots, jars, earthenware pots and resealable plastic kettles (sold at DIY shops), although what you choose depends to a certain extent on the medium you use as well as personal preference. If you are using water-thinned paints, a bucket to hold water is essential, and plastic cling film to seal pots that do not have lids. For mixing smaller amounts, you will need a palette. For water-thinned paints, ceramic palettes and bowls are best as they are easy to clean, or use disposable tin foil dishes. Wooden palettes are not recommended for acrylic paints, but are fine for oil paints. For mixing large quantities of paint, you will need something to stir it with, such as a spoon or a piece of wood; otherwise, a stirring attachment for an electric drill is useful.

Unfortunately, mistakes do happen. Filler, a flexible filling knife and sand paper will help you fill small holes in your mural. Wire-wool, soap-filled pads will gently rub away dry paint, or use an abrasive powder. Finally, all artists need sponges, rags and kitchen paper to wipe away stray paint, mop up, dry off and so on.

SCAFFOLDING

You need to be able to get to all parts of your wall and sometimes this is not as easy as it may sound. For most internal murals, step ladders are all that you will need. Make sure that they are level and properly locked into position before you use them. Otherwise, a pair of step ladders or trestles and a scaffold board (all of which can be hired) will give you more freedom of movement and stability. Do not overload the board: two people on it at the same time can cause problems with balance.

For the odd detail higher up the mural, a ladder can be used (some step ladders extend into ladders). The

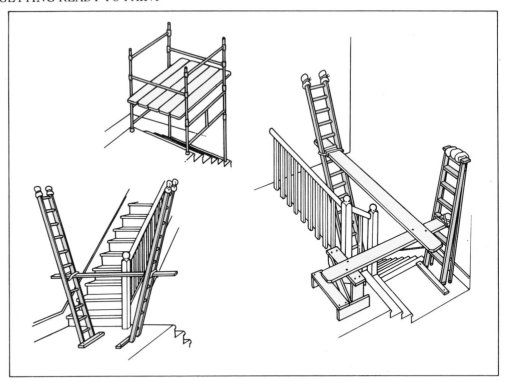

Painting stairways
This can involve you in some dangerous gymnastics unless you make sure you have a stable platform from which to work. Ladders, towers and boards can be hired and combined to make a suitable base. Tie boards to ladders and nail a batten to an uncarpeted floor to prevent ladders from slipping. A straight flight will take a wider tower with adjustable feet. Do not overload boards and obstruct stairway traffic while work is in progress.

ladder should be placed at 70° to the ground and you will need to pad the ends at the top of the ladder with soft rags so that it does not damage the paint surface. If possible, rest the bottom of the ladder on a patch of floor cleared of groundsheet. If the floor is shiny, use a rubber mat. Attach the paint pot to a rung with an S-bend hook so that you always have a hand free to hold on. Try not to get carried away so that you lean too far away from the ladder – a recipe for disaster.

For long, high murals, and especially for ceilings, you may be happier with a scaffolding tower, which can be hired in various heights and sizes. These are made up of interlocking sections that are easily assembled. Once installed, you can gain easy access to any level.

A tower is an almost essential piece of equipment for painting ceilings of any complexity. Without the right equipment, this can be a neck and back breaking experience. The tower can be adjusted to the right height so that you can work with the minimum of stretching or straining, but even so, do take frequent breaks as painting ceilings is undoubtedly one of the most tiring forms of mural painting. Towers can also be supplied with castors so that you can move along the mural as required. Make sure, however, that the castors are locked before you use the tower; it is vital to have a stable working station at all times.

Paints

For those who like painting, an art supply store is an Aladdin's cave. But paints used for mural painting are as likely to be purchased from a DIY store. Paints for a mural need to be tough and able to withstand a certain amount of wear and tear – more so than those used for easel paintings, which are usually hung out of reach. But what you choose very much depends on what you have planned for your mural and your own artistic temperament.

Painting with a medium you know and love will give you a head start in producing a successful work of art. This means that you should not be dissuaded from using soluble paints – watercolour, gouache and poster paints, for example – by what seems to be irrefutable evidence against their suitability. One only needs to be reminded of the numerous examples of eighteenth-century Chinese wallpapers which are still to be found in some English country-houses. These were mostly handpainted in gouache and yet, against all odds, they have survived over two hundred years' worth of wear and tear, coal fires and changes in fashion to give pleasure to the present generation. This example also highlights the importance of a sound structure and the quality of the substrate – the stucco, plaster or render – rather than the paint itself.

Only paints that are considered appropriate for modern mural painting are discussed here. The traditional method of fresco, using wet plaster, is excluded because of its unsuitability for exterior work in today's pollution-ridden atmosphere. As a method for both interior and exterior mural painting, the fresco effect has been largely replace by the German dry fresco method described on page 39.

WHICH PAINT?

Identifying paints, and defining their usage, can be difficult. They are sold under a variety of names and brands in different countries, so it is essential to know how they are based. In this section the two main categories of permanent paints suitable for mural painting, water-thinned and oil-based, are considered.

Paints are made up from pigments ground to a fine powder suspended in a binding agent. In oil-based paints the binder is oil – linseed, safflower, soya, and so on. Other paints use synthetic resins as a binder. Most household emulsions and artists' polymers, acrylics, for

example, use vinyl or acrylic-based resins. Cheaper paints are padded out with extenders or fillers – usually chalks or clays – and many household paints contain additives to extend shelf-life. Most paints can be thinned down to achieve various effects. Oil-based paints are thinned with oil or turpentine (or, more economically, white spirit) while the synthetic resin paints are diluted with water.

These two categories of paint – oil-based and water-thinned – can be used on a variety of surfaces. However, lack of preparation, poor adhesion and incompatible or unsuitable materials will lead to the deterioration of the paint surface in a remarkably short time. It is therefore worth taking a little time to assess the situation before choosing which paint you want to use for the job. This is usually merely a case of using common sense. In the end, the decision will be governed by a number of factors: the surface you intend to cover; the location; the cost; expectations of durability; and personal preferences and expertise.

The surface
Manufacturers recommend certain paints for certain surfaces if durability is required. Consult the chart on page 40 for suggestions and if you are in any doubt, read the literature provided with all paints, usually condensed in some form on the container or provided by the supplier on request.

The location
The location of your proposed painting will certainly influence your choice of paint. For example, your options will be greater if you are tackling an internal dry wall than an external wall that is being attacked by pollution and the elements.

The cost
Cost is important when choosing paints, because of the large areas to be covered. Paints vary tremendously in price, and if durability is not the first concern – and often it is not – then it is a good idea to seek out the cheaper varieties. Muralists working on interiors frequently use ordinary household paints. These are cheap, easily available, simple to use and sold in large quantities. Because they were not developed for artistic use, they can contain additives which increase shelf-life and make application easier – and this probably makes them less durable. But it is still advisable to consider economizing by using household paints, and, if the conditions are right, they will endure far beyond the

expectations of the manufacturers.

Cheaper versions of artists' materials such as oil and acrylic paints (often referred to as students' paints) economize in the pigments used and contain more filler. They are therefore not so lively, flexible or durable but you need to weigh up these factors against the price.

Durability

How long should a mural last? Although professionals feel the need to offer some degree of longevity, it is not necessary to ensure that every mural has to last indefinitely. Fashions and circumstances change. Unlike movable easel paintings, murals cannot be easily stored out of sight, to await a possible revival of interest. Instead, they are frequently repainted or destroyed. Many urban murals were painted in the first place in order to brighten up a run-down, shabby area, or lend some colour to a piece of derelict land – and these are just the spots which are likely eventually to be drastically redeveloped, sweeping away the drab walls on which the artist worked. Murals also usually lack the protection given to other works of art, and frequently, of course, they have to face up to the weather. Many factors, therefore, can conspire to destroy the mural – and certainly the professional artist is only held responsible for deterioration of the paint-film if it has been inexpertly applied.

The subject of durability, however, should not be entirely overlooked, even though it need not become an obsession. On the whole, a paint with a recommended lifespan of five to ten years is appropriate, and the manufacturers' estimates are frequently conservative. Where durability is a major concern, this usually means more careful preparation and more expensive paints, used with knowledge and skill.

Preferences and expertise

As artists have their own preferences where paints are concerned, this often governs the type of mural they are prepared to paint and the location. Personal preference also affects the choice of paints. Some paints are considered easier to apply. Acrylics, for instance, are uniform in character and very versatile. On the other hand, the silicate-based Keim paints for dry fresco (see page 39) will ensure longevity – but are tricky to work with and require expertise and practice.

If, after research, you realise the mural you want to paint requires paints you have not used before, do not be put off. Artists are constantly reinspired by the

discovery of new paints and the techniques made possible with them. So it is worth experimenting.

WATER-THINNED PAINTS

The advantages shared by the group of permanent water-thinned paints considered here revolve round the fact that they use synthetic resins as a binding agent and are thinned with water. But their quality – particularly concerning their durability and flexibility – does vary.

The fact that they are thinned with water means they are easier to deal with and odourless. Cleaning brushes, equipment and yourself also becomes a much less arduous task. On the whole, they dry quickly which, if you are covering a large area, is a great advantage. Drying time is the time it takes the water to evaporate, depending on temperature and conditions.

Any mistakes can be rectified before drying by wiping off with a damp cloth; yet, once dry, these paints are tough and water-resistant. The water-thinned paints covered in this section are also porous, allowing the surface underneath to breathe and any moisture present to evaporate.

The character of these paints means that, when undiluted, they have great covering power – so that lighter colours can cover darker ones. Yet when they are thinned down with water the colours can be used in transparent glazes not unlike watercolour paints.

Finally, for the muralist, it is the quality of mattness which makes these paints particularly suitable. A gloss or sheen is usually a distraction on large paintings which are viewed from many angles.

Primers and undercoats

Where you are using a brand paint, follow the manufacturers' advice on priming and undercoats. It is important to remember that water-thinned paints mentioned in this section should not be applied over oil-based primers or undercoats. Suggested primers of different surfaces for the paints covered in this section are given on page 40.

ARTISTS' ACRYLICS

In this group of water-thinned paints, artists' acrylics are highly regarded for their quality and durability. As one might expect, such quality is not cheap. These paints, which have been in use for more than three decades now, offer all the advantages of emulsion with superior colour quality, tested durability, flexibility, strength in the face of damp problems, and light

fastness. They are also recommended for external work.

Acrylic paints dry quickly and, unlike oil paints, all colours tend to dry at the same rate. The tough, flexible, water-resistant film that is formed when the paint dries is also porous. This allows any damp in the wall to escape and prevents the paint from blistering, something which oil-based, non-porous paints are likely to cause in the same circumstances. Acrylics, again unlike oils, do not yellow or harden with age and can withstand changes in temperature.

The colour range is glorious. It includes traditional pigments associated with oils or watercolours – Hooker's green, burnt umber, raw sienna – as well as some new chemically contrived pigments created to replace those colours which were incompatible with the resin binder, such as phthalocyanine green, crimson and dioxazine purple.

Acrylic colours come in tubes, jars and sometimes 2.25-litre (84-fl oz) economy containers. Stick to one brand if you can, as they all have slightly different constituents and may not be compatible. However, it is worth trying out the different makes as they vary slightly in texture and thickness. Rowney recommend their Cryla Flow formula for mural painting, which has been developed for easy application over large areas without loss of colour quality. With the mural artist in mind, popular colours in this formula can be obtained in 2.25-litre (84-fl oz) containers. Winsor & Newton recommend their Artists' Acrylic Colours which can be ordered in large amounts for special projects.

Acrylic paints and media
Acrylic paint is sold in both tubes and pots. The different makes are worth investigating as they vary slightly in consistency and in the colours available. For extensive murals, large quantities can be ordered.

Supports

One of the great advantages of acrylic paints is that they can be painted on almost anything – brick, wood, plaster, cement, ceramic, paper, metal, plastic, fabric – unless the surface is shiny or greasy.

Acrylic paint, however, has trouble adhering to oil-based paints (although oil paints can be painted over acrylics). Old walls painted with oil-based paints should not cause any problems. Rub down well with sand paper and prime with a coat of acrylic gesso primer. A coat of new oil-based paint will need to be treated with a sealer priming solution, although even then it will not provide a very durable base. It is often difficult to tell what sort of paint you are working on; if you are unsure, prime the surface with a sealer before applying an undercoat.

Scour shiny surfaces with glass paper and remove grease with glass paper and white spirit. For highly absorbent surfaces, prime with a coat or two of acrylic gesso primer first.

Techniques and Media

Acrylic paints are famed for their versatility. They can be used neat, like oils, and yet they dry quickly. They have tremendous covering power if used in this way, yet if diluted with water they lose little of their strength of hue and can be applied like watercolours, building up translucent layers of glazed washes. Yet again, acrylics can be used to produce a very flat paint film with hardly a trace of a brushstroke, which is what many muralists aim to achieve.

One of the joys of acrylic paint for the muralist is that it dries to a matt finish. Sometimes, however, a more glossy finish is required, perhaps to imitate that of oil paint. A number of additives (media) can be added to the neat acrylic. These can be either mixed with the paint during the work, or applied later to the dried surface of the finished mural.

Retarder Retarder can be used to hold up the drying rate of acrylic paint, and this is useful for beginners because it slows down the work and enables the paint to be 'moved around' on the surface as with oil paint. Normally, acrylic dries too quickly to permit this manipulation. The effect of the retarder, however, is diminished if you add water to the mixture, which is why it has become unpopular among some artists.

Flow improver This is similar to adding linseed oil to oil paints, in that it increases the flow of the paint without losing much colour strength.

Gloss, matt and gel media When added to the paint, these media, as their names suggest, slightly alter the

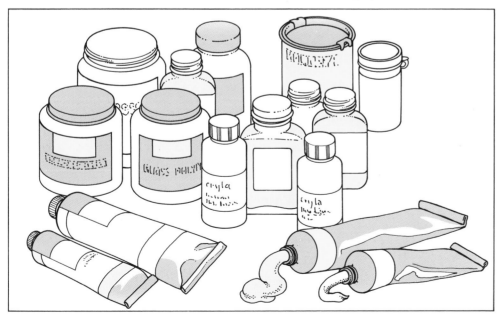

Blending
Acrylic paint dries quickly and therefore any blending must be carried out at speed. To merge two colours so that a gentle transition from dark to light is achieved lay the colours side by side but not touching.

Quickly and lightly, with a clean, wet, soft brush, merge the two colours together by running the brush along the edge where they meet.

On a larger area, spray lightly with clean water to keep the paint wet but make sure the mist is fine or it will drip down the painted surface. Otherwise, if the paint is undiluted, use a little retarder to prevent the paint drying out too quickly.

consistency and final appearance of the paint. But, although they extend the paint, some artists consider that they also reduce its vibrancy.

Correcting

If you make a mistake or change your mind while the acrylic paint is still wet, you will find that it can be wiped off with a wet cloth or sponge

If the paint has dried, you have various options. You may be able to paint over the mistake as acrylic dries opaque and therefore covers well. Otherwise, gently rub off the paint with water mixed with an abrasive cleaning powder or a soap-filled wire-wool pad. Be careful to wash off any remaining soap before you continue painting.

VINYL AND PVA PAINTS

These are cheaper versions of artists' acrylics. There is a marked drop in quality and this is reflected in the price (they are roughly one-third cheaper). Winsor & Newton recommend their Vinyl Colours for mural painting and sell them in economy plastic pots of 250 ml (18 fl oz) and 1 litre (35 fl oz). These are graded – possessing 1–5 stars – to indicate the degree of lightfastness. Rowney's PVA colours are sold in 130 ml (4.5 fl oz) tubes.

The paints behave in a similar way to acrylics (some artists find them more free-flowing) but economy is achieved by the use of inferior quality pigments, and this is reflected in the results. The resin binder seems to be less robust and cannot take too much dilution with water without curdling. Consequently, for thin washes (and for use in a spray gun or airbrush), dilute these paints with a solution of 50 per cent water to 50 per cent acrylic medium.

INDELIBLE GOUACHE

Gouache paint is prized for its soft matt finish and brilliant colours. As demonstrated by the Chinese with their hand-painted wallpapers, gouache can be used for mural painting, but it is not waterproof. It can be made indelible by combining it with acrylic medium but this will reduce the potency of the colours and affect the special finish associated with gouache.

The French firm Lefranc & Bourgeois now produce a ready-mixed permanent gouache called Flashe. This paint is similar to artists' acrylics, yet muralists find it has unique properties associated with ordinary gouache. It also dries to the same tone, unlike acrylics.

This gouache can be used on all surfaces but, like acrylic, it will not adhere well to oil-based paints yet can

be used as an underpainting for artists' oils. The manufacturers recommend priming using universal primer, with the first coat well diluted.

EMULSION

One type of paint that is extremely well-suited for murals – and ideal for beginners – is emulsion. Common household and exterior emulsions, readily available in a range of colours and varying amounts, is quick to dry and is cheap.

Because of highly competitive research and development between market leaders, emulsion has improved tremendously in recent years. The pigments are better and more finely ground, and the resin binders have also improved in quality. It is now common to find specialist painters such as sign writers using emulsion where once they would have used more expensive paints.

One word of warning: emulsion paints vary in quality between brands, so buy the best quality you can find. This will not increase your costs. Economy versions of this paint are usually padded out with extenders and fillers, reducing the potency of the colour and the percentage of resin. Consequently, cheap emulsions are weaker and will not cover as great an area as their more expensive equivalents; so there is no saving. Paints sold under the description of 'trade' emulsions, on the other hand, are usually of the same standard as the manufacturers' household quality. They are cheaper because they are sold in large quantities.

One drawback with emulsion is durability. The manufacturers are loathe to quote a greater life expectancy than 3-6 years. For many that is time enough, and these estimates are often outlived on well-prepared, problem-free walls. But emulsion is not durable in the face of damp from within the wall or condensation from without, or their associated problems. Emulsion paint, which often contains cellulose, tends to absorb humidity which finally causes the paint film to crack and deteriorate.

Emulsions are sold under a wide variety of names. The water-thinned varieties described in these pages come in two main categories – vinyl or acrylic matt emulsion, which dries matt; or the silk varieties, which are recommended for use in bathrooms and kitchens but dry to a slight sheen and are therefore not so popular with muralists.

Techniques and media

Emulsions can be diluted with water to create thin washes which dry very quickly, sometimes within

Painting a flat coat
Dip the brush into the paint until the bristles are half-covered, then dab the brush on the side of the container to remove excess paint. Begin at the top of the wall, working away from the light in horizontal bands.

To remove any brushmarks and to ensure a smooth finish, 'lay off' with light vertical strokes in a downward direction when painting the top of the wall. Always remember to hold a wide brush by the stock (the part between the bristles and the handle).

minutes. Used full strength, they have strong covering power. They can be mixed together, although it is wise to use the same brand. Emulsions are best used for flat areas of colour, but they can be employed with other paints to produce a more delicate range of colour.

Colour-range Many stores selling emulsion tend to impress you with a seemingly endless display of colour cards, encouraging buyers to think they stock every colour and shade of the rainbow. On closer analysis, these 'different' colours are often found to represent only minute changes in tone, which is fine for the home decorator but frustrating for a muralist. Fortunately, more exciting ranges of ready-mixed emulsions can be found, usually from large stores dealing with interior

Left For the lower half of the wall, brush over the brush marks in the same way, with the 'laying-off' strokes coming upwards instead. *Below, left* You may decide to use a paint-roller, which is quick and easy. This method, however, leaves a textured surface which some muralists dislike. Dip the roller in the paint in a tray and work in along the tray ridges. Apply the paint in a criss-cross direction, working across the wall. A roller will use more paint than a brush.

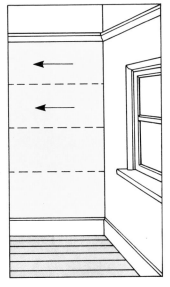

Sequence of painting
Begin by painting the highest point: the ceiling. Next, paint the walls. If possible, work these in horizontal bands starting at the top. Keep the light in front of you and work away from it so that the surface is devoid of shadows and progress can be monitored. Woodwork, including the skirting, should be painted last.

design, many of whom promote their own colour range of fashionable colours to coordinate with their fabrics. These will be a little more expensive but worthwhile, saving you from mixing your own.

Alternatively, in the ready-mixed market, again for a little more money, an excellent range of deep, rich colours have been developed by suppliers for theatre use – backdrops and scenery painting. Rosco's, with outlets in Britain and the United States, have two types of high quality emulsion in an excellent range of colours. A good 'palette' made up of smaller pots of their most popular colours can be purchased as a trial set. These would be enough for a small mural.

Mixing colours The narrow and sometimes insipid range of colours offered in the household ranges can be extended by the addition of pigments to an emulsion base – usually white. Many muralists add artists' acrylic paints or gouache to vinyl matt emulsion with no adverse results. If anything, this combination seems to strengthen the emulsion although, of course, it weakens the quality ot the artists' paints. Consequently, the manufacturers warn against non-compatibility and do not recommend such a combination. However, many paintings executed with this combination are over fifteen years old without showing signs of deterioration. It is important to use a good quality emulsion base, and to test it with your paints for compatibility, checking that it does not curdle.

When artists use acrylic or gouache plus emulsion, they tend to start with the background, blocking in colours in pure emulsion. As the work becomes more detailed the proportions change and more acrylic paint is added to the emulsion until the final details are painted in pure artists' acrylic.

Alternatively, pigments can be mixed into the emulsion base. These can come in various states: 'universal' pastes, dispersable powdered pigments or stainers. Make sure stainers do not contain oil, otherwise the paint will curdle. The pigment must be added a little at a time and stirred in well before more is added. Too much pigment can reduce the strength of the binding paint, causing the colour to separate into 'puddles'.

When producing your own colours in this way, you will need to get to know their individual properties, particularly concerning light-fastness. On the whole, the organic colours are stronger than the inorganic ones. The colours are graded for light-fastness as for artists' colours, so you can refer to these charts. Otherwise, the pigment producers will provide you with more precise information.

Water-thinned exterior emulsions and masonry paints
A wide choice of exterior emulsions can be used for murals. These paints have been formulated to cope with the weather, pollution and damp associated with exterior walls. Consequently, they are usually stronger than emulsions recommended for interior use, and they often contain fungicides to deal with natural growths caused by dampness.

Many of them, however, are not suitable for other than hard-edge painting in abstract or very simplified designs, as the paint can be difficult to work with, especially those with a rough texture. Some exterior paints are described as latex paints, which does not

necessarily mean they contain rubber – only that they dry to a flexible film.

Colour ranges are even more restricted than for interior emulsions; powdered or paste pigments, however, can be mixed as described above to extend the range. Exterior emulsions are usually sold in large quantities, which makes them uneconomical to use ready-mixed unless you are painting a large exterior mural using only the most basic colours.

OIL-BASED PAINTS

This family of paints, ranging from artists' oils to household gloss and alkyd-based emulsions, is strong and durable when used in the right conditions. Although the paints dealt with below vary greatly in their quality, they share basic characteristics as a result of their ingredients.

Oil-based paints do not dry quickly like water-thinned ones. It is usually not possible to recoat household paint such as eggshell for about sixteen hours. Gloss paints need to be left from sixteen to twenty-four hours and artists' oils from one to ten days. But this need not be a disadvantage. Artists' oils, for instance, can be reworked on the surface of a painting before they dry. For some time after their initial application, they can be changed or even wiped off.

Problems can be caused, however, by the fact that oil-based paints dry to a non-matt finish, ranging from the silk-like sheen of eggshell and the translucence of artists' oils, to the highly reflective shine of gloss paint. Household gloss has been developed by manufacturers to resist dirt, and are easier to clean than some of the matt-finish paints. But they reflect the light, and this can be very distracting for the viewer of a mural – a similar effect is caused by putting glass over a painting. A glossy finish also highlights an uneven surface, so, unless the mural is to be viewed only from a distance, matt paint would be recommended here.

Oil-based paints dry to an impermeable, waterproof film. So although they protect the surface, they prevent damp from evaporating. This can cause water-filled blisters which eventually burst, rupturing the paint film and causing considerable damage.

Finally, heat tends to speed up the yellowing process in some oils, so care should be taken when painting radiators, or on walls (even on marouflaged canvas) behind which hot-water pipes lurk. Intense spot-lights can cause staining too; these should always be placed at a suitable distance from the painting, using a diffuse lamp (see page 159).

Making a mahl stick
Cut 2 grooves 1 inch (2.5 cm) in from dowling 1 yard (1 m) long. long.

Take some cotton wool and tease it until it makes a ball. Fit this over the grooved end.

Cover the ball with a piece of cotton. Tie with string, using the grooves to stop it slipping.

Rest your brush hand on the mahl stick as shown. This helps to steady the hand and keeps it clear of newly painted areas.

ARTISTS' OIL PAINTS

Artists' oils have an excellent reputation for quality and durability, founded on centuries of use. Many artists feel that paints other than oils lack subtlety and versatility. The fine quality of these paints, and the techniques they make possible, are not easy to imitate with other media. There are many different brands of Artists' oil paints of varying quality and consistency. The cheaper oil paints (usually called Students' oils) tend to use less expensive pigments and contain more inert filler and are consequently of a lower standard.

Artists' oils, like other paints, are divided into organic earth colours (siennas, umbers and terre verte), metal salt colours (chromes, titanium, zinc and lead) and those derived from coal tar. Some colours are more lightfast than others and, to help you, most brands have a graded system to indicate the extent of this. As a rule of thumb, earth colours are more permanent than inorganic colours.

The drying time of oils varies from colour to colour, from a few hours to a number of days. The earth colours dry quickest. Drying time is also affected by humidity, and by the thickness of the paint.

The problems of oil paints which have been mentioned earlier should not deter a skilled oil painter unless he or she is considering exterior work. Luckily, not all murals need to be painted directly on to the wall, so oil paints can be chosen. For the beginner, however, other paints are more suitable for murals.

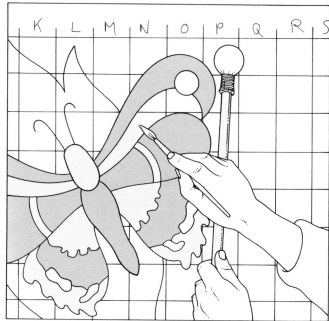

Supports

Oil paints have survived on a wide variety of surfaces. But using them on plaster or directly on brick is not recommended because the impermeable paint finish prevents any dampness from evaporating. Artists' oils are recommended for work on moveable panels such as canvas, wood and even paper and aluminium.

Canvas, wood, paper Canvas ready primed for oil paint can be supplied in various widths by art stores. Some artists prefer to do this preliminary work themselves.

All absorbent surfaces need to be sealed and protected. If not, they will absorb the oil from the paint, reducing it to useless flakes – and the oil and certain pigments will eventually rot the fibres in untreated canvas and paper.

The traditional method is to seal the surface with glue size. Canvas and wooden supports (not necessarily paper) then need a ground (undercoat). Both the size and various different grounds can be purchased ready made-up at art suppliers.

Alternatively, acrylic primer or an acrylic undercoat can be used to prime canvas or board for artists' oils. The first coat, which should be diluted, will seal the surface (sizing will cause this ground to crack). A second, full-strength coat should then be applied.

Aluminium Aluminium and aluminium alloy need no priming when used with oil paints. If the metal is polished, you will need to abrade it with wire wool to give it a tooth and then clean it with turpentine. If it has been sandblasted, you will need only to clean it.

Brick and plaster Walls will need to be primed with a sealer solution before painting, to prevent uneven porosity, so that the oil from the paint is absorbed evenly over the whole surface. Sealers themselves contain oil so it would be wise to use an oil-based undercoat for the ground. If you notice that the undercoat is drying in uneven patches, then the sealer has not been effective and you might consider using paper or canvas over the top for an interior mural.

Techniques and media

Oil paints can be used in any number of ways, but the three basic approaches are impasto, glazing and 'alla prima'. Impasto, where the paint is applied thickly, is rarely called for in mural painting, where a smooth painted surface is normally required. Glazing gives a wonderfully translucent quality to a painting. To create this effect, usually several layers of translucent paint have to be applied, either over a ground or underpainting (or impasto). Often the ground is tinted first with a

Flat grounds
Above To lay a flat ground or layer in artists' oils, mix up in an earthenware bowl enough turpentine with a little paint to cover the area. *Above right* Dip in a clean absorbent rag and rub this over the canvas in an even, circular motion until the surface is covered.

coat of thin, translucent colour either before or after the underpainting – i.e. when the main areas of the painting are blocked in using one or several colours, again applied thinly. 'Alla prima' is a technique whereby paint is applied directly and opaquely to the support, giving a fresh, spontaneous effect.

There are numerous diluents, mediums and varnishes that are used to alter the consistency and character of oils. This is a complex subject, so only the most common products are described here.

Diluents These are solvents use to dilute oils, which also speed up the drying process. Turpentine (known as mineral spirits in the U.S.A.) is the most popular, but white spirit, although of a poorer quality, is much cheaper.

Mediums Linseed oil is the most commonly used and comes in various forms. Stand linseed oil thinned with turpentine is ideal for mixing with oil paints to create glazes. Poppy oil is also useful, particularly for 'alla prima' painting, but as it dries slowly and has a tendency to crack, it should not be used where you want to build up layers of colour.

Varnishes These are particularly useful for mixing with tube colours to create glazes, and are also used as a protective coating. Varnishes can be bought ready-made, but many artists still prefer to mix their own.

OIL-BASED HOUSEHOLD PAINTS

These come under a variety of names – eggshell, alkyd-based, midsheen, silk or satin finish paints. They are intended for interior work such as walls and woodwork. Their main disadvantage is that they have a strong smell which puts some people off.

There is no reason why these paints should not be used for mural painting, but they are not commonly employed except as a ground for artists' oils.

If you require a sheen finish to make cleaning easier, a water-thinned silk or satin emulsion paint would be more practical.

GLOSS PAINTS

These strong paints dry to a flexible, dirt-resistant, waterproof film which is left unscathed by minor knocks and scratches. They can be used on most interior and exterior surfaces which are dry and have been correctly primed. Most gloss paints have recommended undercoats – but make sure that you prime plaster, or any exterior render, with alkali-resistant primer before applying the undercoat.

The majority of gloss paints are oil-based. Some, however, are thinned with water and are basically household emulsions with a higher concentration of resin. Known as vinyl enamels, they are not as glossy as their oil-based relatives.

SIGNWRITERS' PAINTS

These good-quality paints – expensive and not always easy to find – come in a wide range of colours. They adhere well to rigid, shiny surfaces and are therefore recommended for smaller projects involving glass, glazed tiles or plastic.

Contrary to expectation, signwriters' paints dry to a matt finish and the colours seem dull until varnished. In the United States, Japan colours have the same constituents, but the pigments are of a higher quality and give better results.

The paints can be used on top of an oil-based undercoat or directly on shiny surfaces which have first been cleaned with turpentine to remove grease.

MODELLING ENAMELS

Enamels for painting models – alkyd-based oil paints thinned with white spirit – are often used by signwriters nowadays as an alternative to traditional materials. They are particularly suitable for bathroom tiles.

These readily-available modelling enamels are resistant to steam, oil, fumes and dirt. They adhere well to rigid surfaces including glass, ceramics, plastic, polystyrene and wood. And they come in a wide range of colours which can be intermixed. You can choose between gloss or matt finish. The latter has a dull sheen unlike the true, light-absorbing matt finish of water-thinned paints.

Painting lines
Painting a straight line of constant width can be tricky. Charge your brush with paint then, holding a rule off the surface of the wall with the left hand, paint along the rule so that the metal ferrule of the brush presses against the side of the rule.

For a broader line, either apply more pressure to the same brush or use a larger brush depending on how thick you want the line to be. Even pressure is difficult to maintain as you draw your hand along the rule, so it may help to practise on sheets of paper taped to the wall first.

Cleaning brushes
If a brush needs soaking, drill a hole through the handle, push a nail through and suspend in a jar of suitable solvent. Rinse and hang up to dry.

The Flo-Paque range is stocked by art stores worldwide for use by model makers. Although it is common to find this paint in small 'tinlets', larger quantities 250 ml (18 fl oz) can be obtained.

Surfaces need to be dry and grease-free before painting. Clean with white spirit if necessary. Seal wood with a suitable undercoat. If you want to use modelling enamels on glazed bathroom tiles, the tiles should be allowed to dry out and then cleaned thoroughly with white spirit before painting.

OTHER PAINTS

This final section covers paints that, although perfectly suitable for mural painting, do not fall into either the water-thinned or oil-based categories. These include cellulose lacquers, tempera, and the silicate-based paints specially developed for exterior work.

CELLULOSE LACQUERS

Cars, buses and trains have been protected for many years by cellulose lacquers which are suitable for exterior surfaces, particularly aluminium. The paints produce a glossy finish and if applied correctly they can last for fifteen years.

Cellulose lacquers cover well with one coat, but some colours – such as yellow will need two. These paints have a strong, unpleasant smell and inhalation is dangerous, so a well-ventilated area is necessary. They also have a high flash point, igniting easily, so do not smoke near them.

These paints have to be applied in a smooth, even coat, otherwise they tend to crack. They are therefore unsuitable for painterly styles and are best if mechanically sprayed, along with templates or masking tape for hard-edge styles. If the area you wish to cover is not too great, aerosol cans of cellulose lacquer can be obtained from car accessory suppliers.

Some artists spray car paints on top of emulsion or acrylics to produce graded tones on a large scale. The effect is similar to airbrushing. Paint is sprayed over an area of flat colour. Use a template to mask off the area; then hold the can away from the surface – usually about 1 foot (30 cm), away, but follow the instructions on the can. Research shows that if the sprayed lacquer is too dense, it eats into the layer below, eventually destroying it. A light spray on the other hand bonds with the underlying paint to provide a hard surface. Cellulose lacquers are not compatible with oil-based paints.

TEMPERA

Pure egg tempera has a dry matt quality which is unique. It is perfectly suitable for murals, but is not a paint for the beginner because it has to be built up in carefully controlled layers, which dry very fast, requiring experience and patience.

Pure egg tempera does not stand up well to damp. It dries to a brittle finish which is not suitable for flexible supports such as canvas, unless marouflaged to the wall. The most suitable support is wood – well-seasoned, natural wood panels, hardboard or chipboard. Both canvas and wood need to be sized and primed with gesso before applying the paint.

Egg-oil emulsion tempera is made by adding oil (linseed or stand) and sometimes damar varnish instead of water to the pure egg mixture. The result is a more glossy, flexible finish. This paint takes a long time to dry out completely – sometimes even as much as a year. Once dry, however, it is hard to beat for durability.

Spattering paint
On walls, use an old toothbrush to create a fine spray.

For panels on the floor, hit the brush's ferrule against the left hand, spattering paint downwards.

SILICATE-BASED PAINTS

These are the only paints with a reputation for being as permanent as the stucco or render they cover, even in the face of strong light and adverse conditions such as pollution. The silicate-based or mineral paints, the most famous of which are produced by the West German firm Keim, work on the same basis as the traditional fresco techniques in which the paint soaks into the stucco to form an impregnable layer. The results are difficult to fault (and have survived admirably on buildings at Stein am Rhein in Switzerland since 1890), and the main drawbacks are the tricky method of application (when compared with the ease of external emulsion) and the expense.

Keim 'Artist' technique A paints arrive in kit form containing paint and a fixative. The chemical reaction caused by the combination of fixative, paint and stucco results in the formation of silicate crystals which reflect the light, making the colours vibrant. The stone-like surface formed by the paint is porous to moisture and allows the material underneath to breathe.

For this Keim system to work, the render must be at least $\frac{1}{4}$ inch (5 mm) thick; it must contain cement and slaked lime and be slightly rough. Once this layer has been made good as specified on page 23, it has to be thoroughly wetted and then covered with an $\frac{1}{8}$ inch (4 mm) layer of Keim preparation, 'Malgrund'. This layer must be kept wet with distilled water throughout the painting stage.

The paints come in a paste form and can be diluted with distilled water. Surprisingly, they are thin and transparent. The wet-on-wet technique of painting (wet paint on wet plaster) takes a little getting used to, but the paint can be easily wiped off and altered if it has not been fixed. Work can stop at any time, but the paint surface must be protected from the sun and the stucco rewetted before painting is resumed.

When the painting is finished and dry, it needs to be sprayed at least five times with the fixative solution, waiting twelve hours between applications. Finally, the surface is tested to ensure the paint is truly fixed; if it isn't, it will rub off like distemper.

This may appear to be a lengthy process, but the result is a mural which should be secure for many generations

The Keim technique B 'Decor' paints differ in that they are distributed in powder form and are then mixed with the fixative before application. They therefore dry and harden in one. They are less time-consuming than technique A, but difficult to alter once applied.

GUIDE TO PAINTS, PRIMERS AND SURFACES

	Brick	New plaster, new or old building	Old painted plaster	Canvas and textiles	Wooden panels, plywood and composite board
WATER-THINNED PAINTS Artists' Acrylics (E) and Vinyl and PVA (E)	Acrylic gesso primer.	Acrylic primer ×2. Dilute 1st coat with 25% water.	Acrylic gesso primer ×2.	Apply direct or acrylic gesso primer ×2. Dilute 1st coat with 25% water.	Acrylic primer. For composite board, use acrylic gesso primer ×2. Dilute 1st coat with 25% water.
Indelible gouache (Flashe)	NR	Universal primer, sizing (casein, ammonia and disinfectant) and vinyl matt emulsion.	Universal primer.	Apply direct or prime first with universal primer.	Universal primer.
Household emulsion (vinyl matt)	If dry: apply direct. Dilute 1st coat with 25% water.	Apply direct. Dilute 1st coat with 25% water.	Apply direct.	For temporary mural: apply direct.	Apply direct. If composite board very absorbent, use gesso primer.
External emulsions (E)	Apply direct.	Apply direct to render/concrete.	Apply direct.	NR	NR
OIL-BASED PAINTS Artists' oils	If dry: sealer primer and gesso ground.	Only after 12 months. Sealer primer and ground or oil-based household paint.	If dry wall: sealer primer, and ground or oil-based household paint.	Size and oil ground, or acrylic primer.	Size and gesso ground, or acrylic primer.
Oil-based household paint (egg-shell, silthane, silk)	Only if brick 12 months old. Alkali-resistant primer and proprietary undercoat.	Only after 12 months. Alkali-resistant primer.	If dry wall: apply direct.	NR	Universal primer and proprietary undercoat. Treat woodwork with knotting solution first.
Gloss paint (E)	Only if brick 12 months old. Alkali-resistant primer and proprietary undercoat.	Only after 12 months. Alkali-resistant primer and proprietary undercoat.	Proprietary undercoat.	NR	Universal primer and proprietary undercoat. Treat woodwork with knotting solution first.
Signwriters' paint (E)	NR	NR	NR	NR	Acrylic primer. For composite board, use acrylic gesso primer.
OTHER PAINTS Modelling enamels (E)	NR	NR	NR	NR	Acrylic primer. For composite board, use acrylic gesso primer.
Cellulose lacquer (E)	NR	NR	Acrylic primer or vinyl matt emulsion.	NR	Emulsion or acrylic priming coat.
Tempera	NR	NR	NR	NR	Size and gesso ground.
Silicate-based paints (E) (Keim paints)	NR	'Malgrund' ground.	Remove paint, then 'Malgrund' ground.	NR	NR
E – can be used externally NR – not recommended	NOTE: The building trade refers to primers (which seal or treat problems) and undercoats (which prepare the surface for further painting). Artists refer to primers (sometimes glue size) and grounds (undercoat).			For other surfaces, see Appendix on page 161	

GETTING DOWN TO IT

While the execution of the design is often the most exhilarating and creative stage of mural painting, it can also be a time of uncertainty and doubt. This section will help you with ideas for developing a design for your mural. To start with, there are some suggestions about choosing the subject. Then different aspects of composition are surveyed to help with the structure of your design. Finally, various approaches to design are outlined, including some hints on how to transfer the design to your chosen site.

Once the search for inspiration is on, the senses are sharpened: small details suddenly attract your attention, and indeed, subject matter can spring from unexpected places, at the oddest of moments.

Some artists store these ideas in their heads; others resort to sketchbooks. A sketchbook is worth keeping because, apart from giving some order to your ideas, it is a useful repository for flashes of inspiration, which often fade as fast as they appear unless recorded.

There are many ways to get your imagination flowing: for example, by browsing through books, old postcards, magazines and exhibition catalogues. Get into the habit of collecting such material – anything that catches your eye – although filing it in a useful or logical way may be more difficult. On the other hand, a sift through an 'ideas box' filled with such material can be thought-provoking when starting off cold on a project.

The muralist often gets the most inspiration from the site itself. After a few brain-storming sessions in the bath, get as close to the site as possible. Walk around, getting a feel for the space and surrounding architecture. Unlike most easel paintings, a mural is part of its surroundings, so the setting will influence it more than it would a painting on a wall. The mural can also dominate and control the space.

Choosing the Subject

While inspiration for a subject may be flashing before you, preliminary investigation will ensure that your brilliant idea really does suit the site.

First consider what you want your mural to do. Equally, a narrowing-down process – a systematic exclusion of ideas that would *not* work – is also valid and helps to highlight the possible advantages and disadvantages of the 'survivors'.

Function of the room

While murals are painted for all sorts of wild and wonderful reasons, often they are created to emphasize the function of a room or building, to affect the atmosphere, to set the scene. The prominence of a mural in the room invites the spectator to enter into the spirit of the subject matter, be this fact or fantasy. A small city dining-room, for example, with walls painted with bucolic country scenery will help those at table to relax. As well, the illusion of space will seem to 'push back' the walls of the room, making it appear larger than it is.

A mural painting can change a small, dark, windowless room into a beach house, a Pompeiian reception room, a garden folly or an abstract fantasy. Such illusionistic wizzardry can also turn a building of architectural insignificance into a focus of interest. Different types of rooms will inspire different types of murals; a company boardroom, for example, does not necessarily require a mural that transports the directors to another world, much as they might wish it. It is more likely to require a subject that activates minds and inspires ideas.

A mural might even promote a particular idea, or contain subtle propaganda. Mural art has been used in this way for many years. Mexican muralists, who re-established international esteem for their art between 1910–40, expounded their political views in huge, highly coloured murals. These days, similar messages proliferate throughout city centres. And, of course, we cannot forget the frescoes illustrating Christian doctrine that can be seen in churches throughout Europe.

Above all, however, murals are personal; they reflect the tastes of those involved in their creation. Certainly all art does this but somehow a mural is more intimate because of the spectator involvement. Many murals are portraits of their owner, not necessarily including a physical likeness, but more often a composite biographical mixture of fact and fantasy which gives an insight into the individual concerned.

Finally, we cannot overlook the important fact that murals are works of art which should be valued for these qualities alone, be they decorative or challenging. A mural in a room, like any fine work of art, gives it a unique focus and a talking point, which enriches the quality of life there.

Architecture

The architecture of a room can influence your subject, style and composition.

First, look at the wall itself. Is it one of the main supporting walls of the building or is it merely an internal wall, dividing one space with another? Purists say that if you paint an illusionistic view on a load-bearing wall, which seems to pierce it, you can subconsciously cause discomfort to the viewer. The same feeling can be experienced by creating a view of the outside world on an obviously internal wall. Such theories are there as a guide and are to a great extent ignored by mural artists – some would say to their peril.

Still, the surrounding architecture and even smaller interruptions in the wall should not be overlooked. Indeed, they can often by wittily incorporated into the mural design. Take note of any prominent architectural forms or forces which can be reflected in the design, linking it visually with reality. If executed cleverly, the incorporation of the room's structure into the painting increases the mural's power to embrace the viewer.

Fixed features and the design
Below Here, a chimney breast, complete with fireplace and two flanking recesses, is the site for a mural. The design disregards the fireplace and depicts a trompe l'oeil scene of the countryside, leaving the mantelpiece apparently suspended in space. *Opposite* The dominant ogee shape of the fireplace has been taken as the starting point of the design, thus providing a visual link between the real and painted scene. The recesses are given a plausible structure with arches of the same shape through which the scene is viewed.

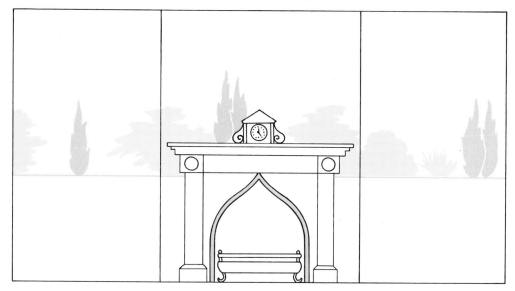

Composition

With the subject matter settled, the next stage is the composition. If you are a beginner, it is best to keep your composition simple. Even if you have done some painting, the scale of mural usually requires a reappraisal of your style. The increase in scale requires the discipline to think big and to distil and simplify every aspect of your art. If too many elements are included in the design and each is worked up to a high degree of detail, you will be in danger of setting yourself a life-long task. The essence of mural painting is in the lightness of touch. An overworked mural is often overbearing and dull.

Once you have amassed the visual information needed for the composition, you will need to arrange it to achieve the effect you desire. This can be a spontaneous display of the various elements, or a studied interlinking structure. The following explains some of the more important and detailed aspects of mural composition.

Element of Surprise

Because a mural quite often covers a large area, a strong composition can have an overpowering effect. But, if the mural is empty of ideas, it is all too obvious.

An element of surprise in your composition – something which is not immediately obvious at the first glance – adds spice to the design. As murals are often first seen at a distance and then studied more closely, it

Framing a mural
Creating a frame around a mural composition – an archway, door or window opening – will provide an acceptable link between the real and painted architecture, and also reduce the area that needs to be painted. Here, a simple window mural is designed for a blank wall, bringing light and a feeling of space to the room.

is possible to do this with smaller details. Visual jokes performed in this way can provide an amusing or dramatic focus, but beware – jokes pall easily. Nevertheless, individuality is an integral part of painting in any form, so do not worry unduly.

A feeling of movement in a composition – or the inference that it just has or will take place – adds a further dimension. This need not involve action in the most basic sense – running or leaping figures. An impression of movement can be given with evidence of the wind blowing, such as bending trees, or billowing curtains; or the stillness of a scene can be broken by strong compositional lines leading the eye across the surface of the mural.

Creating a frame

Sometimes you will not want to paint the whole wall area – except maybe in the most cursory manner. The best way to cope with this is to make a frame for your composition – a window or archway, for example. This need not be complicated, indeed it need not even appear to be three dimensional, but it will act as a link between the real architecture and the illusion of reality you are creating. It will also restrict the amount of detailed painting you will need to do. The scene viewed through the frame can be painted in a certain amount of detail, while the surrounding area, perhaps representing brickwork, will need less time and attention. For a first-time mural, a window opening about 5 feet × 4 feet (150 cm × 120 cm) is a good, manageable size.

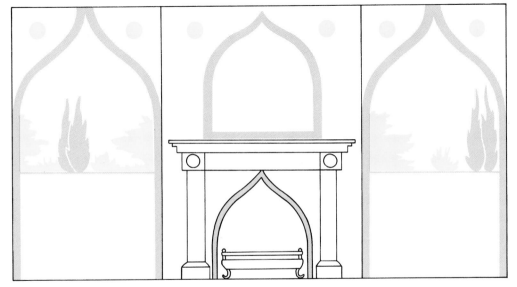

SCALE

Scale is another aspect of composition which can be manipulated to strengthen the effect of the mural on its surroundings. To gain a dominating role for your mural or to inspire a sense of tension or even fear, you can increase the scale, populating your picture with giants. You will have to exaggerate the scale, too, if your mural is to be seen from a distance. On the other hand, reducing the scale has the useful effect of appearing to increase the size of the wall.

Scale is important when figures are introduced into a composition. If you are trying to paint an illusion of reality in a normal-sized room, then a figure in the foreground should be normal human height, about 5 foot 6 inches (165 cm), with the eye level on the horizon line. Now imagine other figures, of the same height, in the background. Their eyes, too, should be level with the horizon. Even though you will obviously make adjustments in order to depict smaller or taller figures, this basic guideline will give the viewers the illusion that they are 'in' the picture, sharing the same horizon as the figures. If a mural is to be seen from a distance, figures will have to be greatly exaggerated in order to be clear.

To achieve variety, figures need to be shown from different angles and in varying positions – sitting, lying, standing. Use photographs from magazines for models if you cannot persuade a friend to pose. A polaroid camera can be useful, reducing a real-life pose to two dimensions and making it easier to capture, especially if the pose cannot be held for long.

HIGHLIGHTS AND SHADOW

In trompe l'oeil painting, highlights and shadows are very important in order to produce a convincing three-dimensional illusion; yet the trick is to keep them simple. Shadows can also be used in the composition to link various elements.

Take a tip from the Renaissance fresco artist and choose a source of light which actually exists. For example, if you are painting on a wall and the adjoining wall has a large window, use this as the direction from which your light appears to come. Sometimes you can combine it with an imaginery lightsource, usually the sun in the scene you are painting.

Remember that shadows cast by sunlight change according to the hour of the day. At midday the sun is overhead so there are few shadows and the light is bright and has a bleaching effect on colour. Any shadows cast are dark and strongly defined. Shadows in

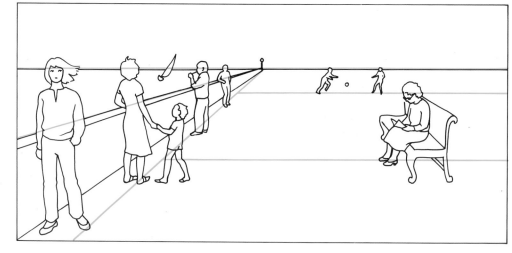

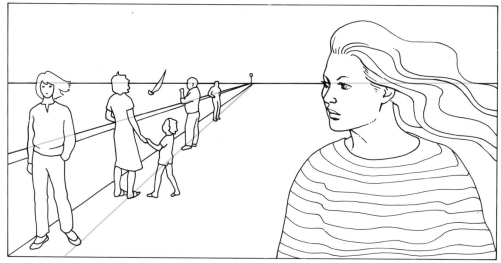

Figures and scale
Top When a mural is at floor level and forms an illusory extension of a room, figures in the foreground of the composition should be normal human height (about 5 feet 6 inches/165 cm) and their eyes level with the horizon. As a rough guide, figures in the background will also have their heads on the horizon line and will decrease in size the further away they are. *Above* An increase in scale can make a dramatic composition.

the early morning or late evening are long, and weaker in tone and definition, and the light is often golden in colour. Light from an artificial source is harsh and the shadows deep. The further the object is from the light, the weaker the contrast.

Many trompe l'oeil artists bathe their paintings in bright light which gives the finished picture a clean crisp appearance and in turn fills the room with light. The tonal contrast is exaggerated and simplified so that shadows are darker and highlights lighter. You will find, however, that if you use pure black in your painting this will appear to hover, standing out from the wall surface. You can of course take advantage of this if you want an object to come forwards.

Painting shadows Shadows and highlights are best added in the last stages of a painting. Shadows are most effective if they are applied as a glaze of diluted pigment

GETTING DOWN TO IT

Light sources
Using the available light source in the room to 'light' the mural can be effective and help form a link with reality. Here, the light appears to come from a real window in an adjoining wall, casting light from the left, across and into the mural so that a shadow from the plant appears to fall across the terrace.

Here, the light source is taken to be the sun in the mural, which is out of sight and to the top right of the mural. The shadows of the balustrade form a pattern on the terrace. Note how these two different light sources alter the composition and how shadows can be used creatively in the design. Often a muralist will use both these light sources – as would be the case in reality – to light the

over the painted surface that they cover. This allows the colour of that surface to qualify the shadow, as it does in reality. Shadows are not all grey; they are sometimes pink, purpleish or yellow. They are, however, never black. Shadows are affected by the light and by the colour of the object which casts them.

Just as shadows are never pure black, highlights are seldom pure white – the only exception, possibly, is highlights on highly reflective metal.

Tone This is a difficult concept to grasp. We talk about murky tones or bright tones and what we are referring to is in fact the different grades of a single colour affected by the strength of the light. A bright light will throw an area into high tonal contrast – for instance a blue ball would have areas of deepest blue, and palest blue, verging on white; a weak light would make it range from a mid-light blue to a mid-dark blue.

Because of the often-substantial area that needs to be covered when painting a mural, maintaining an even tone throughout can sometimes be a problem. If possible, mix up enough paint to use throughout the project as matching colours is sometimes difficult, particularly with acrylics which dry darker.

In murals containing architectural features or large areas of the same colour, particularly those seen from a distance which need to be simplified, you can reduce your areas of light and shade down to three tones of the same colour – a base colour in a medium tone, a highlighter and a shadow tone. In Project 3 this system has been used.

COLOUR AND COMPOSITION

Colours are an important part of any design, but in a mural composition their effect is exaggerated because of the area covered.

Colour can be used in a composition to link the various elements of the design. The eye naturally follows from one dash of, say, red to another and can be thus inadvertently coaxed across the picture space. The same method can help link a mural painting to the room, through its decoration or an architectural feature. For instance, many Victorian houses have sections of stained glass in their windows, and these colours and shapes could be picked out for special treatment in a mural design. Equally, colours and patterns in fabrics or, say, a Persian rug in the room, can be echoed or even reproduced as part of the mural design.

It is well-known, too, that colours have an effect on the mood of a room. Certainly, this can be exploited in a mural. A mural painted with warm yellows and pinks will seem to flood the room with sun. Blues, greys and greens will keep a room cool.

Some colours are stronger than others. They seem to come forward out of the picture plane if used in any great amount. A figure wearing a red coat will automatically stand out and come forward in the picture plane. Likewise, some colours dominate their neighbours. For example, a small amount of pure yellow goes a long way.

Finally, colours can be exploited for the effects they produce against each other. Complementary colours – those which are opposite in the colour circle: red and green, blue and orange, and purple and yellow – seem to shimmer when they meet. Areas painted with small dabs in these pure colours fuse together when viewed from a distance to produce a luminous effect.

Perspective

Creating an illusion of three-dimensional space on any two-dimensional surface is a problem faced by all artists. This is particularly true of murals because they are rarely viewed from a single point and are likely to be looked at from many angles. Consequently, a scene that is realistic from one angle will look distorted when viewed from another.

But an illusion of reality is not always the aim of the muralist. Throughout the history of art, various systems of representing space have been devised and these can be used to great effect in the structuring of a mural composition. The Ancient Egyptians, for example, arranged their compositions so that those elements that were meant to be furthest away were positioned highest up. Size denoted importance rather than proximity. Such a perspective system can be used effectively if a decorative, flat mural is desired with no illusion of three-dimensional space.

ARTIFICIAL PERSPECTIVE

The system of linear perspective most commonly used today was evolved in Florence in the early fifteenth century. It is based on the fact that receding parallel lines appear to converge on the horizon. The point of convergence is called the vanishing point. This artificial perspective can be manipulated to produce excellent visual tricks, but it cannot always provide a simple solution to the problem of space. Consequently, for the beginner at least, dramatic or complicated perspectives should be avoided. However, an artist's role is to interpret his or her vision of reality; the rules of perspective are there to help structure the compostion and must not be allowed to dominate it. Perspective scenes in mural painting require a certain amount of pragmatism and compromise. Painting what you see, and then experimenting with various positions until it 'looks right', is quite possible if the perspective plan for the mural is simple.

Viewpoint

The first step in devising a perspective scheme for a mural is to establish the point from which the mural will be viewed. Because in mural painting there is rarely a single viewpoint, you first need to establish the principal viewpoint. Often this will be the point of entry into the room, but it will also depend on the site. The

GETTING DOWN TO IT

The horizon line
In a mural, the placing of the horizon line is often controlled by the eye-level at the principal viewpoint. *Top* If the observer is standing, the horizon is set at head height. *Centre* Where the mural will be viewed from lower down, the horizon should be lower. *Above* A high horizon belittles the viewer.

eye is often happier, however, to continue believing what is presented to it first. This fact tends to militate in favour of this viewpoint. Other viewpoints may be close to the mural or far away, which will in turn affect the scale of the composition.

Sometimes the function of the room suggests a viewpoint: in a dining room the principal viewpoint will be at the dining room table; in a bathroom, from the bath, and so on. Once you have decided where the main viewpoint should be, your design can be drawn with this in mind.

In a large mural with a number of objects drawn in perspective, distortion caused by choosing one particular viewpoint can be avoided if three viewpoints, each with their own vanishing point, are devised.

Eye-level

Now the eye-level needs to be established. To create an illusion of real space, place the horizon line in the mural at the level of the eye of the viewer at the principal viewpoint. Thus if the viewer is standing, the eye level will be higher than if the mural is viewed from low down, from a swimming-pool, for example.

But the horizon in a picture is also fixed, and does not change with your eye-level. Try painting a line across a wall to represent the horizon, placing this about 5 feet (150 cm) off the ground. Because this is about eye-level, you will find it comfortable to look at. Now, wipe away the line, and repaint it, this time 3 feet (90 cm) or so above the floor. View this while standing up, then from a sitting position on the floor. You will see what a difference the change of viewpoint makes. The lower line is very uncomfortable when viewed from above. As no one eye-level is suitable for both sitting and standing positions, a compromise is often the only answer.

Finally, try painting a horizon line as high up on the wall as you can reach, and see how small this high line makes you feel. This, and other built-in reactions can be used by the mural artist in manipulating the viewer's emotion. Note, too, how such a simple line can set the scene for your mural. It is always a good way to start – and it can always be changed at a later stage if necessary.

Perspective systems

The simplest system is one-point perspective where there is one vanishing point in the composition. This is where you, the spectator, are looking through a window (the picture plane) at, say, a box, of which you can see

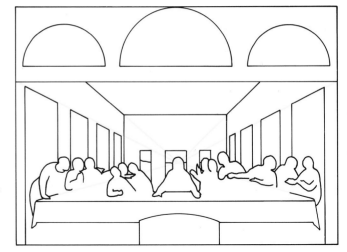

two sides, the front which is facing you, and the top. If the parallel sides of the top plane were extended, they would meet at a point on the horizon called the vanishing point. The true illusion of recession is only achieved, however, if you stand stock still, facing the view, with a hand over one eye. Conjuring up such a ludicrous image does not instil confidence in one's artistic potential, yet it is just this system that Leonardo da Vinci used to great effect in his *Last Supper*. Here it works because the perspective is not allowed to dominate the composition. When we look at this painting, our attention goes to the drama; we do not marvel at, or indeed even notice, the perspective, and this is how it should be.

More complicated systems of perspective can be used,

Leonardo's *Last Supper*
Based on one-point perspective with the vanishing point on Christ's head, the receding lines are enforced by elements in Leonardo's composition – arms and even folds in the drapery – which direct the eye towards the centre. If viewed from the side, the table top might appear distorted, so it is artfully draped with the figures.

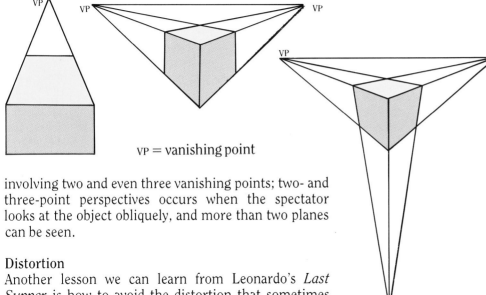

VP = vanishing point

involving two and even three vanishing points; two- and three-point perspectives occurs when the spectator looks at the object obliquely, and more than two planes can be seen.

Distortion

Another lesson we can learn from Leonardo's *Last Supper* is how to avoid the distortion that sometimes occurs. He has used the one-point system of perspective to convey a feeling of depth in the picture, and the problem areas – principally the table top, which would appear distorted if not viewed centrally – he drapes with the personae of the drama. Similar problems can be overcome, or at least camouflaged, with a convenient piece of foliage, a figure, or any other element.

Another way of avoiding extreme distortion is to use round or 'soft' forms in your composition, and to distract attention from problem areas by keeping tones and colour contrasts low-key. For example, if you want to create a frame for your mural – an opening through which the scene is viewed – classical architecture with round columns are easier to deal with as they can be seen from any viewpoint without distortion.

Systems of perspective
Above, far left In one-point perspective, two faces of a cube are visible and the parallel sides of the receding plane, if extended, would meet at the vanishing point. *Above, centre* In two-point perspective, three planes are visible and there are two vanishing points. *Above* In three-point perspective, when the three planes are viewed from high up or from low down below, three vanishing points are created.

Finally, let us not get too involved with the precision of illusion. The distortion that perspective can introduce can be blatantly exploited and enjoyed. It can electrify an otherwise idyllic landscape, introducing movement, and subtly suggest that all is not quite as it should be.

Aerial perspective

When using aerial or atmospheric perspective, objects close to us can be seen more clearly and in greater detail than those far away, which the atmosphere drains of colour, tone and detail. Consequently, distant hills often have a blueish tinge. The early sixteenth-century formula for landscape was to paint the foreground using browns, the middle-ground with greens and the background with blues – a crude but useful guide.

Aerial perspective is not restricted to mural landscapes. It also applies to urban scenes and other subjects. If you paint a clock tower in the background with every detail of the clock painstakingly revealed, you will find that your eye will refuse to let the tower remain in the background, and that it will appear to jump forward to take its place in the foreground. It is very easy to get carried away with a certain area and overpaint the details. With quick-drying paints, the tonal value can be 'knocked back' by painting over a glaze of white paint tinted with blue.

It is necessary to stand back constantly and appraise your work, checking that each part of it is tonally correct. Familiarity breeds blindness in the artist and sometimes it is difficult to remain objective. On such occasions, it is best to look at the reflection of your mural in a hand mirror. This enables you to see the work afresh.

The Design

Making the first mark on a sheet of white paper can be daunting enough – but when your are faced with a large expanse of wall it can be even more frightening. This is just one reason why you should consider making a detailed and precise design for your mural before putting the brush to the wall. Some painters like to establish every aspect of the work, including colour, on a plan on paper – the equivalent of what the Masters of the past called their 'cartoon'. This finished design is carefully 'squared up' and then transferred to the wall.

Other painters prefer to draw a rough sketch of the main elements of the composition, and then move to the mural. They boldly rough out their design straight on the wall. For them, precise design is too restricting.

For the beginner, it is advisable to take the first approach, and make a careful design on paper. The predictability of the process helps bypass the anxieties of making the first mark on the wall.

Sometimes the choice of approach is made for you by the position of the site. A very complicated, detailed view which incorporates difficult perspective needs to be worked out on paper first. A mural of any major size, or one in an inaccessible position, also needs thorough preparation. It is not easy to create the design directly on the wall if it involves climbing down a scaffolding tower every time you want to view your progress.

THE PRELIMINARY SKETCH

This can be executed in any medium, but charcoal and pencil are most commonly used. If possible, make some sketches while sitting in the room or near the site of the mural. Otherwise – if, for instance, you have only one chance to visit the site – take some photographs from various angles, particularly at the place (or places) from where the mural is most likely to be first viewed.

If you want to help yourself, or someone else, envisage how the mural will look, you can photograph or sketch the proposed mural site and then colour in the design on a piece of transparent acetate which can be fitted over the site area.

Some finished designs, or cartoons, are works of art in themselves. Indeed, because so many mural sites are temporary, a cartoon is often the only remaining record of the existence of a mural. Consequently, museums and galleries are becoming more interested in them.

It is worth taking time, therefore, with your design,

Squaring up
Once you have decided on the design for your mural, draw a squared grid over it in pencil. Start with the vertical lines and place them about 1 inch (2.5 cm) apart, then draw in the horizontal lines. The size of the squares may have to be smaller if your design is very complicated.

Now repeat the grid on the wall. If your design has a 1–inch (2.5-cm) grid, to double its size, draw a 2-inch (5-cm) squared grid; three times as large, a 3-inch (7.5-cm) squared grid, and so on. Use a soft pencil, charcoal or chalk to draw in the lines, or use masking tape, which can be removed once the design has been transferred. Use a plumb line and spirit level to check that your lines are truely horizontal and vertical.

using good quality paper and materials. If possible, a highly finished design should be executed in the same medium as that intended for the mural itself – as a record of the medium used and also because it is easier to be more accurate with colours when transferring the design to the wall.

TRANSFERRING THE DESIGN

There are various ways of transferring your design to the wall or other chosen site. Some will use the design as a general guide and transfer it freehand. This undoubtedly produces a more spontaneous line, but it is not always possible for the less experienced.

Squaring up For others, the system of squaring up a design to enable it to be transferred to the wall is appropriate. This is a traditional technique, taught in

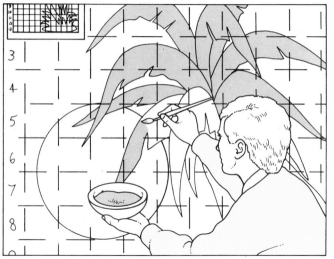

With the design close at hand, carefully copy the outline of your plan square by square using a soft pencil or charcoal. If you want to reintroduce a more spontaneous line at this stage, paint along the outline in a freer manner using thinned paint in a neutral colour such as yellow ochre or brown.

The design is now ready for painting. If you have drawn in charcoal, be sure to flick off any excess dust with a soft cloth before you start to paint.

Templates
Right A template is useful to produce a clear-edged area of flat colour using sprayed paint or to repeat complicated outlines. Cut the shape from card using a craftknife or scalpel. *Below* Fix the template in place, then trace the outline or stand about 1 foot (30 cm) away and spray the paint on evenly.

the string between two points and pluck it like a guitar string, flicking the powder onto the wall. This should leave the required line across the mural surface. Another option is to use masking tape to mark out the lines of your grid. This is perhaps the easiest method, but care must be taken when removing the tape or you may pull away some of the paint surface as well.

With the design close at hand, carefully copy the outlines of your plan square by square. Some painters do this with pencil or charcoal, and then paint along the outline with diluted paint, in a freer manner, to reintroduce a more spontaneous line.

Rather than inventing a design, you may want to copy a picture or photograph. You can do this, too, by tracing the outline and then squaring it up as shown. Otherwise, a number of different elements can be traced

from a number of sources to make up a design. In the first step-by-step project (see page 52) a design inspired by Egyptian tomb reliefs is traced and squared up as described above.

Templates If there are some complicated outlines, which are repeated, you might consider cutting out a template. The individual balusters of a balustrade can be tedious to calculate each time. A template is best cut from card, but paper will do if necessary. Draw up the required outline on the card and cut round as cleanly as possible with scissors or, better still, a craft knife. This template can then be held in position using tape for tracing around the edges.

Large-scale cartoons Some artists like to produce large-scale cartoons, the actual size of the wall, so that they can see the effect of their design and check for

art schools. It requires you to think out the design in detail before putting brush to wall. But it is methodical and therefore helps you to get going without being overpowered by the expanse of blank wall. The first step is to draw with a pencil vertical lines, about 1 inch (2.5 cm) apart, over your design. Then repeat, drawing horizontal lines. This grid will help you to transfer the design square by square. The size of the squares will depend on the size of the design sketch and also on the amount of detail; a more complicated design will obviously need smaller squares.

Next, repeat the grid on the wall two, three, four or five times larger or whatever the size requires. These lines can be drawn using pencil, charcoal or chalk and a 1-yard (1-metre) rule or piece of wood. Alternatively, rub chalk or charcoal along a piece of string. Then stretch

scale. Tape large sheets of cheap paper together until the area required is covered. The design is then sketched in charcoal or paint. Painters in the past preferred to use this method, as the cartoon could then be divided up and given to various assistants.

Once the design has been finalized, it can be transferred to the wall using the traditional method. First, prick round the outline with a sharp instrument or pin (a wheel of pins has been devised for this job). Then attach the cartoon to the wall with masking tape. Either mark through the holes with a pencil, or dust the holes with cotton wool dipped in charcoal powder which will show up on the wall. These dots can then be joined together to form the outline.

If you wish only to transfer some simple geometrical shapes, you can cut along the outlines of the cartoon and use it as a template instead.

Projector One modern method of enlarging a design on a wall is to use a projector. If you employ an overhead projector, you can make a design, complete with grid, on paper and focus it straight on the wall. The extent to

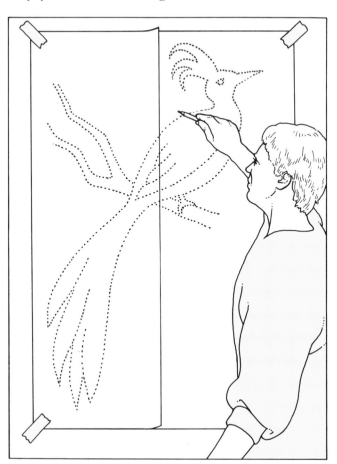

Transferring large-scale cartoons
With a large-scale cartoon the actual size you want your mural to be, the simplest way of transferring it to the wall is using the traditional method. First, prick round the outline with a sharp instrument or pin or even a wheel of pins. Then, tape the cartoon in position on the wall and mark through the perforations with either a pencil or cotton wool dipped in charcoal dust. Carefully remove the cartoon from the wall and use the dots to draw in the outline. The mural is now ready for painting.

which it is enlarged depends on how far away you place the projector. At about 7 or 8 feet (210 cm/240 cm), the image will appear enlarged approximately sixfold. You can reproduce and enlarge any photograph or illustration this way. If you are working out of doors, you will have to do this at night.

If you use a slide projector, you can simply project a transparency of a scene on the wall, and trace around the main elements.

You can also ink in the outline of your design on clear acetate set into a transparency frame and then enlarge it on the wall with your projector. This is particularly helpful with architectural perspectives.

UNDERDRAWING OR PAINTING

The underdrawing can be executed with a soft pencil. If you intend to use thin washes of paint, however, you may find that the pencil shows through. Many mural painters apply thin washes of paint without worrying about the underdrawing showing through. But sometimes a soft pencil catches the light, even with a few washes of paint over it. This can be distracting to the viewer, so it helps partially to erase the pencil with a soft eraser once the effect of the design has been assessed. Otherwise, charcoal or chalk can be used and dusted off before painting proceeds. If charcoal is not dusted off, it can dirty the first layers of lighter paints.

With looser styles it may be easier to lay down your underpainting with a brush and a thin mixture of paint. The type of paint will vary according to the medium used, but diluted acrylic paint is compatible with most paints. It dries quickly and can be easily removed if required. A good procedure is to work with the brush in one hand, and to hold a damp sponge in the other, ready to wipe off anything that is not right. If the paint dries too quickly (and such a thin wash will dry quickly), simply paint over it with the base colour and start again. Alternatively, you can correct the line a little, as you would in a sketch. To remove the paint, rub very gently with a soap-filled wire-wool pad and a little water. If you rub too hard, you will break through to the undercoat which will then need building up again.

Whatever method you use, once you have roughed out your design, check that the scale and proportions are correct for the room. Do not be afraid of reorganizing the configuration a little. It is a good idea to take a break from the painting before appraising your progress – absence from the workplace can do wonders for your self-critical powers!

THE PROJECTS

There is something heady about the scale of mural painting that releases an often repressed artistic energy. This expansive approach to painting often needs to be coaxed out of the closet. For some, it has languished there since childhood when painting walls persistently failed to elicit the joy and praise intended. But now that mural painting is enjoying a restored popularity, the brush can be taken up once again.

Even so, the sight of a blank, staring wall can be a daunting prospect for the uninitiated. In the following pages, therefore, some of the basic painting skills useful in mural painting are demonstrated and explained. The first project is designed for those who are keen but lack confidence. By working through the steps you will be painting a mural almost before you know it – not without effort, but by following simple instructions. All you need are some fundamental skills more associated with manual dexterity than artistic talent. If you can follow a recipe, you can paint such a mural.

After this simple start, the projects vary in the demands that they make on your skills, but each mural introduces further ideas on technique, subject matter and style. To follow the painting of these murals precisely, step-by-step, would take up too much space; so particular techniques, tips and shortcuts are studied in detail as they emerge.

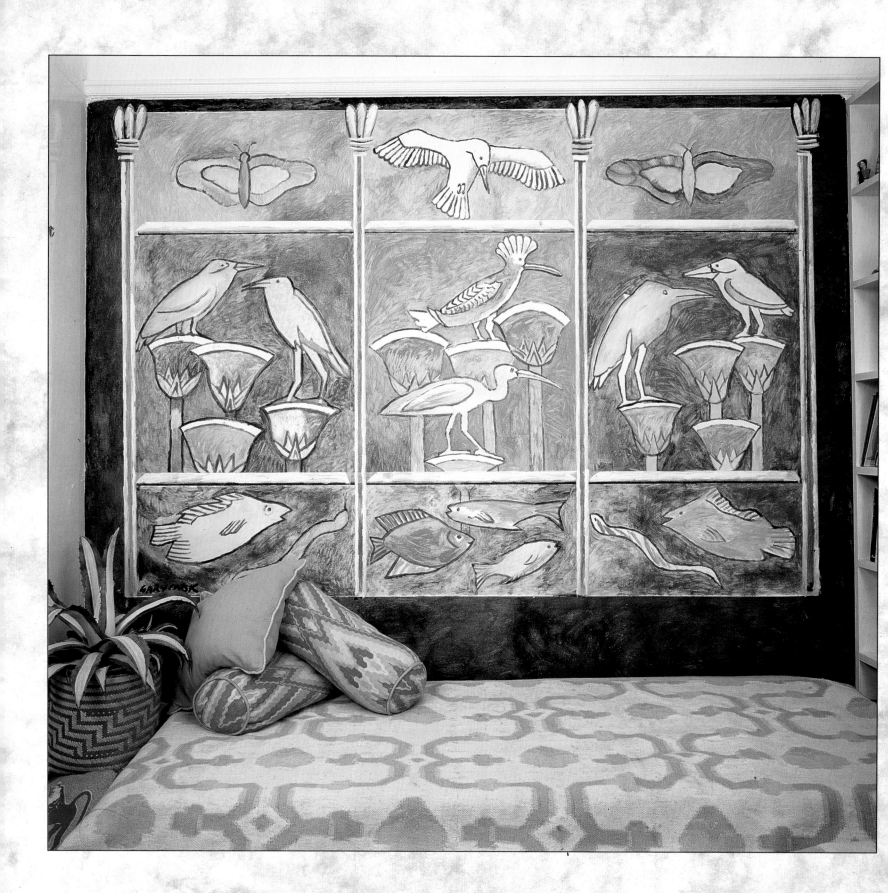

1
DECORATIVE MURALS

Not all murals create an illusion of space beyond the surface of the wall. Some compositions, in fact, aim to emphasize the flatness of the wall and keep the eye on the surface rather than attempting to 'break through'. Such a design often suggests itself as complimentary to the existing architecture. By painting a trompe l'oeil view, say through a window or door, the artist is duping the viewer into believing that there is space beyond the wall surface. As a result, the architectural arrangement of a room can be distorted, destroying the underlying strength of a load-bearing wall or creating a disproportionate number of windows and doors for the size of the room. Sometimes, too, an extension of the real space is not required, and the mural is needed to emphasize the architectural limits of the room.

This is more often the case with exteriors of buildings, where a mural that destroys the arrangement of the architecture by visually 'breaking through' a solid external wall can undermine not only the laws of gravity but also the original intentions of the architect. Of course, this is sometimes the intention of the artist. But the exterior of a building is more public and what are considered more heretical decisions need to be taken with care – even though sticking to tradition and creating an environment that is nice and easy to live with is not necessarily the aim of an artist.

There are three main types of flat murals. In the first, the compositions are representational, but no attempt is made to place the figures or objects in an illusory space. Certain aspects of composition are avoided, such as perspective and modelling. The colours are kept flat with no gradations caused by lighting or aerial perspective. Other tricks of the trade employed by the artist to give an impression of receding space are also forsaken, such as the overlapping of objects and the diminishing size of like things over distance.

This in turn leads to concentration on other details for effect. The mural demonstrated here relies on the quality of the outline, and therefore pattern, and also on the colour. It is not surprising to find that the design has its origins in Egyptian art, which, as the historical introduction illustrates (see page 8), concentrated on the powers of outline and colour.

The second category of flat mural can be described as surface trompe l'oeil. An illusion of reality is painted on a flat surface, but, again, this surface is not 'pierced' by the composition. Sometimes a plain flat wall is revamped with painted architectural decoration, such as intricate panelling, stone friezes, and marble insets. Some of these can be seen in the chapter covering mural finishes (see page 143). Alternatively, more technically demanding illusions can be created by 'covering' the wall with something else – a Gobelins tapestry, Persian rug, Japanese screen or a large 'Constable'. What they all have in common is that the eye stops at the paint surface and is not encouraged to break through into an imaginery space beyond.

The third type is the abstract mural. This is often an extension of colour decoration rather than an abstract composition in its own right. Freed from the in-built boundaries of an easel painting, an abstract composition can be difficult to place within an architectural setting. But with careful consideration of the design, the results can be remarkable, even giving a still, two-dimensional composition the disquieting ability to appear mobile on the surface plane, while encroaching on the third dimension.

As demonstrated in the following project, such murals invite a simple approach that is most suited to the beginner. You can follow these proposals precisely or branch out at any given point to give your work a personal touch. Otherwise, follow the method described, but use your own design or one you have developed from a number of sources, collaged together.

The vibrant mural demonstrated here decorates a well-used bedsitting room. Although it is not a large room, there is a good-sized window, so it was decided that another view would only make a muddle of the room's proportions. It was felt that the mural should make the room cosy rather than opening it out; and yet this was not to be an excuse for anything dull.

The artist decided to base his design on a combination of images from Ancient Egyptian low stone reliefs showing swamp scenes from King Userkaf's cult temple, and fish from the Sixth Dynasty tomb of Princess Sesh-seshet Idut, both at Saqqara. The elements in the original were traced and redistributed symmetrically over the composition, which is divided like a tryptych into three vertical panels and then again into three, horizontally. For such a design, it is sometimes useful to cut out the main elements of the composition so that they can be moved around and tried out in various positions.

The wall is in fairly good condition and had been previously painted with pale yellow matt emulsion. For the mural itself, simple, inexpensive household vinyl matt emulsion paint was used throughout. It will survive as long as the occupant will need it and probably longer. The colours were based on those used in Egyptian tomb painting, and were picked from the paint manufacturer's sample colour cards.

A style of painting was chosen that would emphasize the origins of the design. The rough, uneven painting technique gives an impression of an ancient wall painting that has survived thousands of years. A flat, matt style would not have been as effective and would have produced a more formal image unsuitable for this room. Furthermore, this particular technique is simple and almost relaxing to carry out – not even a steady hand is required.

The site was prepared by moving the furniture away from the wall and covering the bookcase on the right with an old sheet. The carpet was fitted, so a heavy dust sheet (available from DIY stores) was laid across it, making sure it came well up to the skirting board.

TRANSFERRING THE DESIGN

It was decided to place the design in the centre of the wall space, with a border all round. The strong, simple design could have been copied freehand from the sketch, but it was decided that a better and quicker result could be achieved by using the squaring up method to transfer the design from paper to wall. The wall is squared up to correspond to a similar grid drawn

MATERIALS
- 35-fl oz (1-litre) pots of vinyl matt emulsion: lemon yellow, burnt orange, terra cotta brown, clear blue, dark grey-green, asparagus green, pale grey-green, black and white (the judicious mixing of colours could eliminate the need for some of these colours)
- Small decorators' brush
- Medium flat artists' brush
- Bucket of water
- Tape measure
- Narrow-width masking tape
- Plumb line
- Hard pencil, charcoal or chalk
- Soft eraser
- Household abrasive cream or powder
- Rags or kitchen paper
- Dust sheet

Here, the design for this Egyptian inspired mural is squared up ready for you to transfer to your wall. When drawing up the grid on your wall, enlarge each square shown on the drawing so that it fits the space available.

over the design (see drawing). The composition can then easily be transferred square by square.

Some artists square up the wall by drawing a grid with charcoal or chalk, but with large areas this can be tricky work. Time can be saved by chalking a length of string, holding it taut along the proposed grid line and then 'twanging' it to mark the wall. On this occasion,

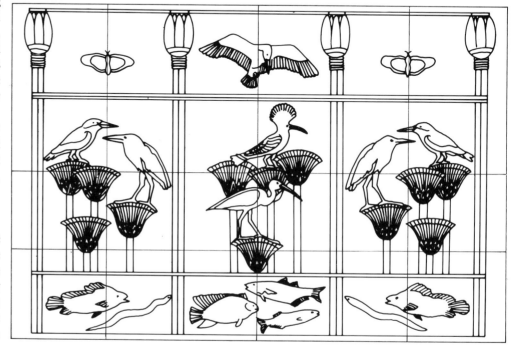

while the plumb line hangs true. Essentially, however, it is the eye that must be the final judge. Grids cannot always be mathematically precise as they often have to be adjusted to the asymmetrical walls of old houses. Here, the top edge of the mural design has to be parallel to the picture rail even though in this Victorian house it is unlikely to be a true horizontal. Similarly, the side verticals need to be parallel to the cupboard on one side and the book case (protected by a sheet) on the other. Any divergence from the true vertical or horizontal must be gradually dispersed over the height or width of the mural. Now, the horizontal lines are added by measuring off 15-inch (37.5-cm) intervals down the sides edges of the design and again running the tape between them.

2. Transfer the design to the wall square by square. Numbering the intersecting lines (not shown in the drawing) makes it easy to keep track of where you are. Starting with a principle element of the composition, gauge its position by where it lies within the relevant square and how its form intersects that square. Here, the bird on the right of the mural is drawn on the wall. The design shows that its beak crosses the left-hand vertical halfway down, and its tail intersects the right-hand vertical three-quarters of the way down. Pencil in a mark at these points if it helps, then confidently join the two, following the outline in the design. Use a hard pencil (a soft one will be worn down

however, the grid is indicated with masking tape, which is quick to apply and clean.

First measure the wall to find the centre with a tape measure and mark it at the top and bottom. Now, pull out the masking tape, stretch it between these two points and tear it to break it. Do not press the tape down; simply anchor it top and bottom. The borders of the design, measuring 90 inches × 60 inches (225 cm × 150 cm), are measured and marked with masking tape. The grid is to be made up of 15-inch (37.5-cm) squares, but for a more detailed design (or for those who need more precise guidance) these could have been smaller. Next, mark off 15-inch (37.5-cm) intervals along the top and bottom boundary, then run the tape vertically between these points. Then stand back and use your eye to judge if they look straight. Now is the time to change them if they are not.

1. If you are not sure, use a plumb line to check your verticals (a piece of string tied to a heavy symmetrical object such as a fork will do equally well). If a spare pair of hands is available, as here, you can shift the tape

by the hard wall in no time), charcoal, or even a brush and paint. Try to avoid being overpowered by the grid system: use it as a guide, but aim to keep the flow of outlines, quickly and confidently sketching them in. Don't worry if the tape comes away as you draw. Stick it back in place when you next pause.

3. Stand back and take a calculated look at the design. Has it come across as you intended? Even after the careful preparation of a composition, it is often only at this stage that a weakness can be spotted. Sometimes, for instance, the scale is seen to be inappropriate once it is viewed in the context of the room, so the principle elements have to be increased in size. If necessary, the

relevant pencil lines can be rubbed off with an eraser or a damp cloth and a little household abrasive cream. Rinse off any cream before you re-draw. Once the design has been altered to your satisfaction, it is time to start painting.

BORDER

4. Before the masking tape is removed, the border is painted black. The artist is adamant that this rather drastic tone is necessary to make the design stand out. Time proves him right, but it is reassuring to know that it can be easily painted over if it does not work. A small, stiff decorators' brush, which would be considered unusable by many, was carefully chosen for this part of the painting. The paint is applied from the tin, a little at

a time. It is painted on in a stroke and then literally scrubbed into the surface of the wall. No attempt is made to conceal brushmarks or irregularities; in fact, they are positively encouraged.

DIVISIONAL LINES

5. The main divisional lines are also painted black. They are painted with straight, neat edges with the help of the masking tape, which is applied to the wall as described above. In the last stages of this mural, these lines were found to be too stark and were therefore painted over with a lighter shade of green. However, the method used here is worth recording. First, all but the relevant strips of masking tape are removed. They were not fixed with any pressure, so they come away easily without pulling off any paint. Now, second strips of masking tape are run across the wall, ½ inch (1 cm) from the main horizontals. These are fixed with more care so that the paint does not seep underneath the tape, spoiling the neat edges. While the paint is still tacky, but before it has dried, remove the masking tape. Here, both pieces are pulled away together. Try to do this smoothly without jerking it. If, despite your trouble, the tape brings away some paint with it, the uneven painting technique used throughout this mural will disguise such blemishes. With a flat, matt paint surface it would be necessary to build up the missing

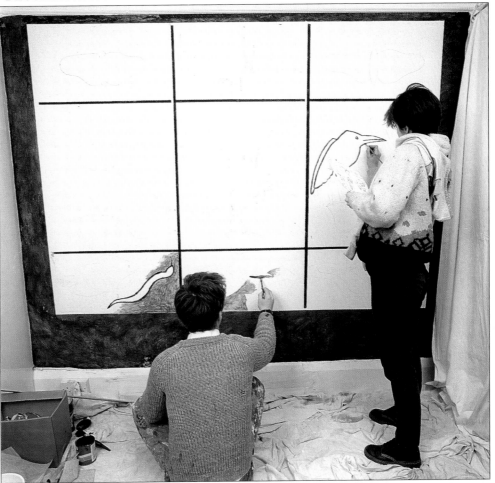

paint by filling in the indentation, which can be a time-consuming occupation.

6. The vertical dividing lines are painted in, following the same procedure. The black paint is applied between the two strips of tape quickly, using as little pressure as possible. Do not use too much paint or make it too dilute; otherwise it will find its way under the tape and cause a blurred edge.

BACKGROUND

7. Now, for the interesting part of the mural painting; and why not enlist the help of a friend? Facing a large expanse of wall on your own can dampen the spirits. If two are painting at the same time, make sure you are

working as far apart as possible. It is easy to tread on a carefully mixed palette of paint or flick paint where you did not intend. Here, there is a sensible division of duties. While one starts to fill in the background colour, the other paints in the ouline. This division avoids both having to dip brushes in the same pot of paint. Note that the design is still referred to at this stage. If trestles and boards are involved when two or more people are painting, take care not to overload them. It is safer to have one person up and the other down unless there are two separate constructions. Fixed scaffolding will take more people, but do take advice on safety from the professionals who erect it. When more than one person is painting, it is also wise to have a well-prepared design including ideas about colour. Otherwise, with too many people involved in decisions, the painting can turn out to be a mess. It is easier to cope with a number of ideas at the design stage than at the painting stage – although it helps to have an elected arbiter who has the final say.

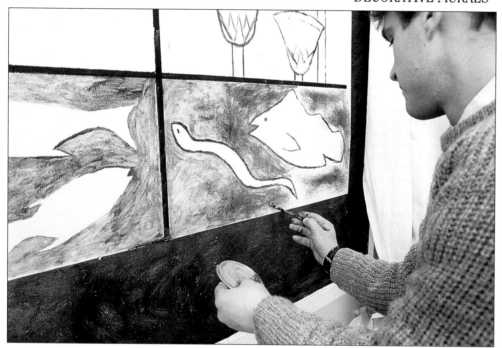

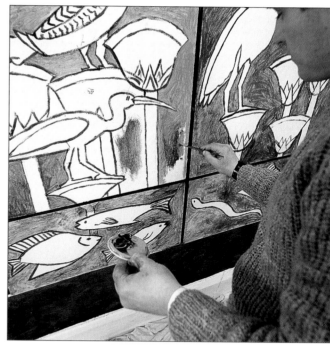

8. The technique for filling in the background is similar to that for the border. A short-haired, flat brush (sometimes called a 'bright') is chosen – again for its particularly worn appearance. This technique is destined to ruin your brush, so don't waste a good, or expensive, one. The lid of the paint tin is used as a palette. (Don't worry, the paint in the tin will not dry out in the time taken to paint this section of the mural.) A little of the terra cotta is spooned on the lid with some black. First, with a dry brush and very little paint, the black is scrubbed patchily on the wall. Spread the paint as far as it will go (as can be seen to the right of the fish). Next, a mixture of the terra cotta and black is applied over the black with a quick hatching stroke, from side to side. The black paint shows through the brown, giving the surface a feeling of depth. Like a child's painting, the brush marks follow the forms of the fish, giving an impression of a moving, living surface.

9. Fill in the backgrounds of the mid-sections of the panels using the same method. As can be seen here, the outline has been applied sketchily with a dry brush and a little paint. The background paint is taken up to the outline, but there is no problem about overpainting at times as the black shows through. On the whole, in these mid-sections, the paint is kept cleaner with less black added. The visible brush marks make the paint surface vibrant.

FLORA AND FAUNA

10. Now, colour in the main forms. Here, the artist concentrates on the Egyptian swamp flora. Reverting to the brown/black used in the background for the fish, he

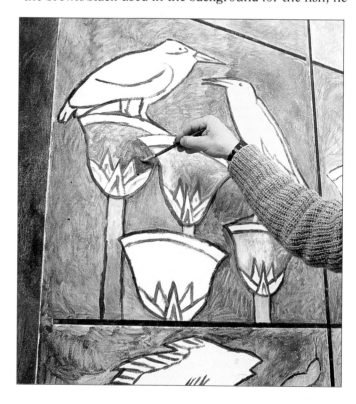

fills in the colour, taking it up to the outline. Then, to distress the paint a little, the area is rubbed with a rag (or kitchen paper) to reveal the light base coat as can be seen on the reed-head on the right. This achieves the effect of a deteriorating paint surface associated with ancient wall paintings.

11. Now the Egyptian fauna is brought to life, and again solid colour is avoided. The paint is kept thin and brushed on with confident strokes, keeping the brush as dry as possible so that the stroke is sketchy and undefined. This means the brush is dipped frequently into the paint allowing only a little to adhere to the bristles at one time. The base coat is allowed to show through so that the mural does not become too dark overall. It is easier to reduce the areas of light than add them. This method of highlighting is also in keeping with the informality and lightness of touch of this mural that constitutes its charm.

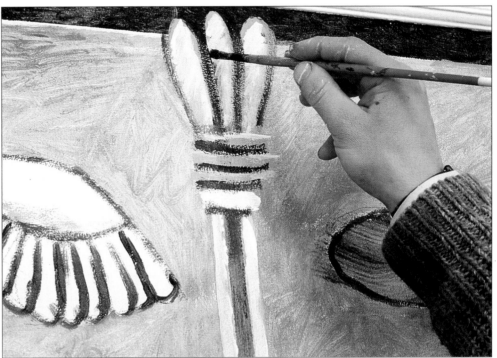

12. Standing back to assess the progress of the mural, it is found that the intersecting black lines, so carefully painted at the earlier stage, are too harsh and overpowering. They also appear too clear among the looser style of the painting in general. These lines are painted over with sea-green to give a dark jade green (demonstrating the covering power of emulsion), and a white

line is painted freehand down each side to lighten the general tone of the mural. Finally, the intersecting bud capitals are touched up with black paint. Note how the white paint for these capitals has covered the black of the borders with no problems. Emulsion is a very versatile paint.

FINISHED MURAL

The completed mural achieves what it set out to do. It forms a vibrant focus to the room, yet its informal manner of execution ensures a cosy atmosphere. The lack of uniformity in the treatment of like things and in the colours themselves adds a depth of interest to the painting. The eye cannot take anything for granted; every detail has to be assessed individually. The artist could afford to be more adventurous with the colouring of the birds and fish, avoiding symmetry, as the balance has already been established by the symmetry of the composition and the background colours.

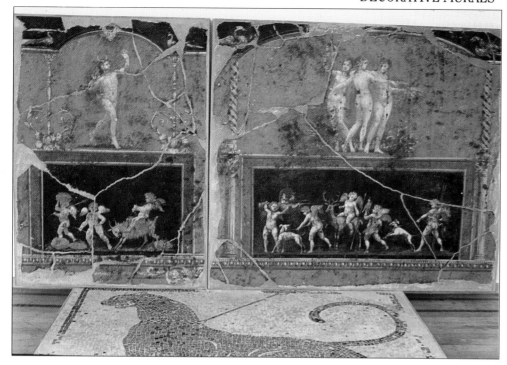

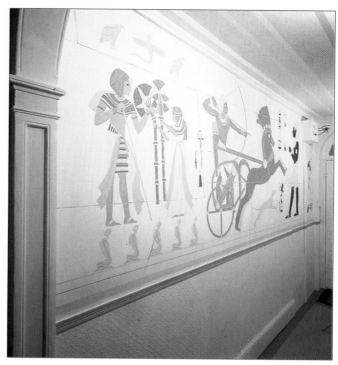

Above Pompeian pastiches need not be painted wall-to-wall, they can be more simply contained on panels of hardboard, as shown here. Having created an unblemished image with acrylic paint, the artist distressed it, sponging and spattering paint, sanding and generally vandalizing his work. The artist described it as a 'difficult stage', but obviously an invigorating one too. The mosaic is made from pieces of linoleum tiling.

Above Egyptian figures and hieroglyphs combine to give a focus of interest to this otherwise ordinary hallway – even incorporating the fuse box. In direct contrast with the project illustrated in the previous pages, the finish here is flat and slick, simply a more formal, but equally valid, interpretation of similar source material. Vinyl matt emulsion was used, coupled with a steady hand to achieve the crisp outlines.

This richly painted room is the work of specialists in historical pastiche. Foresaking the bolder brushstrokes of the Ancients for a more precise formality of line, this Third Style Pompeian wall scheme remains faithful to originals in both colour and detail, and uses acrylics, oils and emulsions to achieve this effect. These diverse media were unified with final layers of oil glaze and mid-sheen varnish.

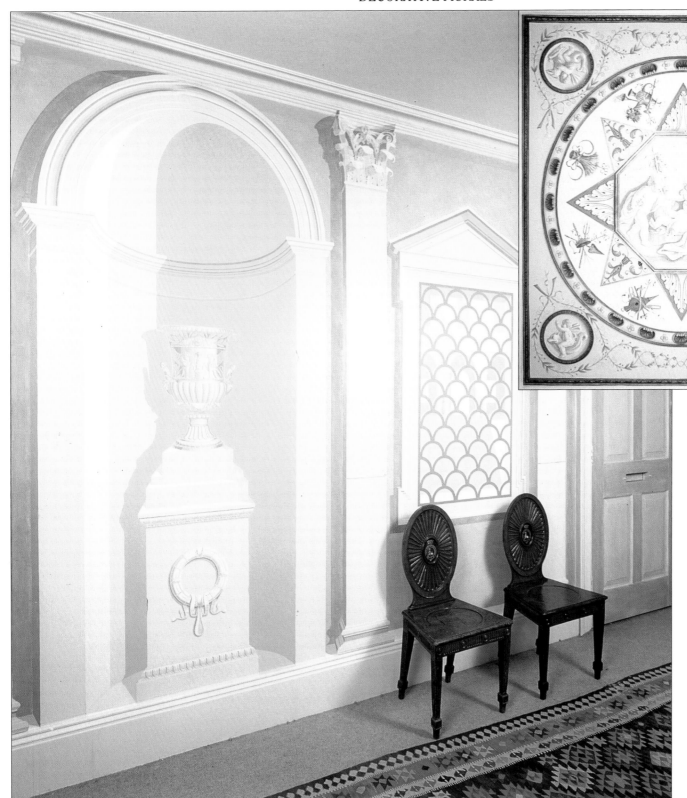

Above This light and airy Rococo-style ceiling decoration for a New York apartment was executed in artists' oils and acrylics with gold leaf on a made-to-measure canvas. Such a formula means that painting can be carried out off-site, avoiding the back- and neck-breaking performance necessitated by overhead painting.

A featureless hallway attains classical grandeur with this mural treatment, complete with Corinthian pillasters and a niched urn. The artist keeps the variations in tone in the stonework to a minimum, using emulsion paint straight from the pot. The minimal fixed architectural features – door frame, coping and skirting board – are neatly incorporated into the design.

A decorative frieze such as this, which has Roman antecedents, can imbue a sense of architectural richness to an otherwise impoverished setting. Repetitive shapes were cut out of clear draughting film, which was then used with acrylic paints like a stencil. More lyrical passages, like the cornucopia and head, were tackled freehand.

The strong abstract shapes in this mural make it a fitting background for this physical assault course in the Aldgate, London, swimming pool and gym complex. The energy expended in this area is reflected, and yet contained, in the walls of the room by this lively mural, painted in emulsion paints and protected with matt varnish.

Such ornate decoration requires careful planning coupled with precision in execution. It is a demonstration of an eclectic approach, picking out individual features from a mass of sources throughout history. For the repetitive designs, the artist used stencils and templates with acrylic paints to give a clean, matt finish that will withstand the ravages of time.

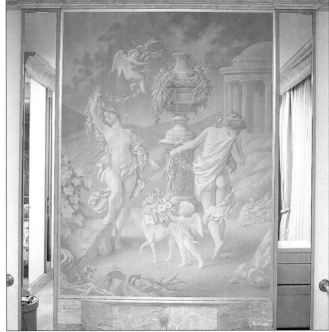

The movement in this classical scene of garlanded graces and putti belies the unnatural cool, grey, moonlit colours and flat finish. Executed in oils, this canvas panel looks entirely appropriate for its site – a neo-classical bathroom. Here, there has been no attempt to create an illusion of real space beyond the wall plane; the panel, as the artist intended, is linked with its surroundings but does not manipulate it.

Above The mural magic exhibited here has 'covered' an unsightly, built-in cupboard in a L-shaped hall with a seventeenth-century tapestry hanging. Executed in acrylic paint on the wooden doors, the design incorporates a trompe l'oeil skirting board to unite it with the rest of the room.

Right This still-life fantasy is designed to tumble down alongside the stream of people who usually populate this stairway at Brixton Station, London. The subject matter reflects the jostling of a busy station and the ethnic origins of local inhabitants, and also sets the style for this mural.

Above For those troubled by the concomitant problems of design, take comfort from this successful scheme based on a squared design. The subtle differences in colour between the squares was achieved by the use of stained squares of wood glued to the wall, but this effect could be easily imitated with delicate washes of paint.

Left This refreshingly airy mural, painted in a Victorian hall and stairway, demonstrates how abstract designs do not have to be flat or static. The configuration, based on plans and elevations of the Villa Savoie by Le Corbusier, achieves a wealth of textures with an admirable economy of line.

The boarded, pitched attic of this barn necessitated a bold, uncomplicated design that could be clearly seen from below, and gave the artist an opportunity to create a sprawling jungle scene in the naive style of Henri Rousseau. Painted in acrylics, these could have been applied straight to the wooden planks without preparation, but here the surface was made smoother by giving the boards two coats of acrylic undercoat first. *Right* The detail of the cheetah demonstrates how the image has been distilled to a clear outline with the minimum of detailing.

Murals on the exterior of buildings can meddle with the intentions of the architect if they pierce the wall with an illusion of space. On the other hand, this mural at the Newham Centre, London, of a joyful saxophonist, represented in two dimensions, enforces the surface plane of the wall. And he could not fail to lighten the step of any passer-by.

Part of an extensive and highly successful trompe l'oeil mural in the entrance hall of St Stephen's Hospital, Fulham, London, this detail shows how a bare wall can be 'decorated' and 'furnished' with the help of brush, paints and, of course, a good helping of talent. Closer observation reveals the economy of detail and the fluent yet loose brushwork, executed in oil on a canvas panel, which has produced this fully believable image.

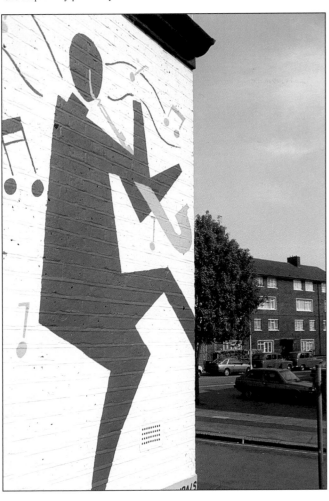

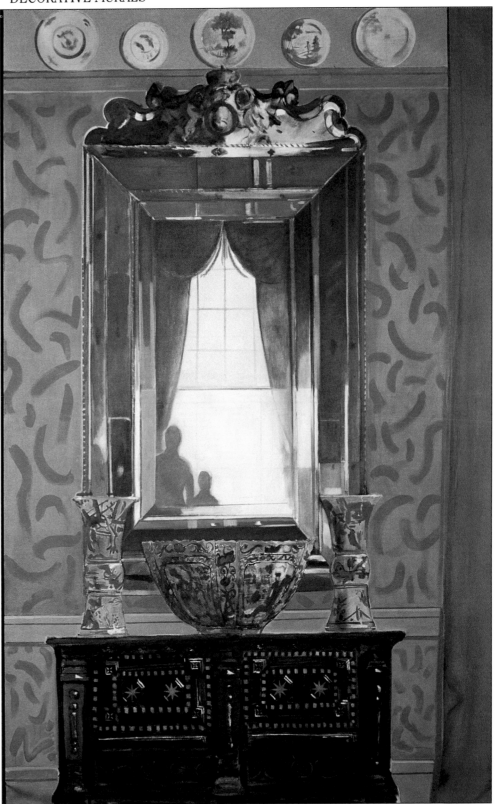

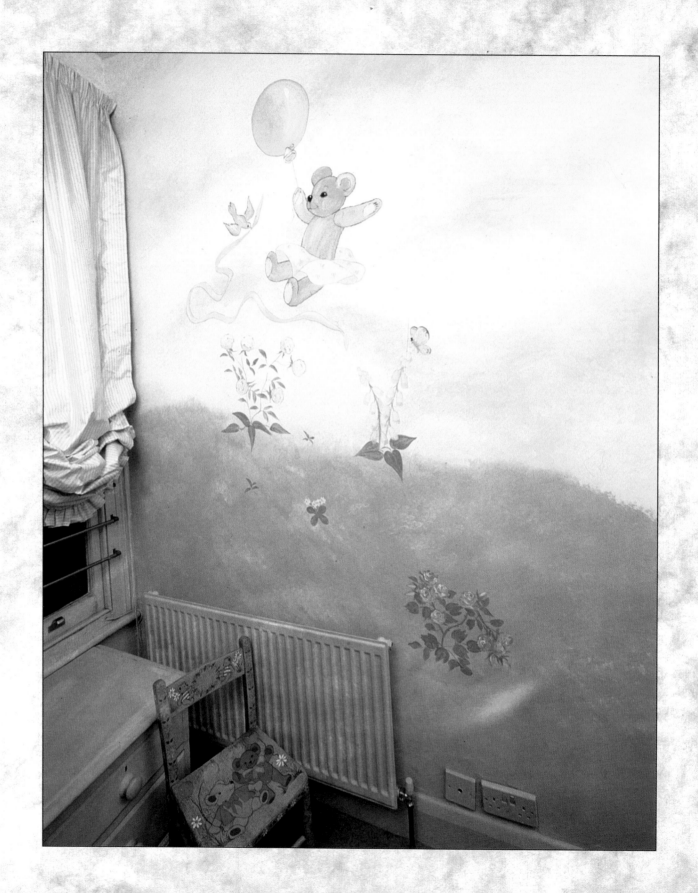

2
MURALS FOR CHILDREN

A child's room is a good place to try out your mural talents because children are often less critical than adults. In addition, children are usually more enthusiastic about your proposals and the finished product – whatever the standard of achievement.

A mural for a child's room is often more effective if kept simple. Once a backdrop has been painted, as shown in this project, it can be filled with whatever takes the child's fancy. The antics of a favourite cartoon character can easily be copied by the tracing and squaring up method described in the first project. Don't forget, however, that children's favourite characters are soon replaced in their affections, (say, the following week), as new crazes take over, so be wary of their whims. Older children can be hard task-masters, so get them involved in the ideas stage, if not the painting as well. Having come to an agreement over the design, stipulate that you will only tolerate *silent* observation or *practical* assistance (this advice applies equally to adults, but it is sometimes more difficult to enforce).

If your invitation of practical assistance is accepted, you will have to be prepared to accept the child's standards and artistic suggestions. This can be fun if you are both prepared to compromise. Children are rarely happy in the role of assistant, compliantly filling in the areas you have outlined; they have ideas too and are not in the least intimidated by the size of the wall. There is one other slight problem with small children. Once they have been encouraged to paint a mural on one wall, they may find it difficult to understand that not all walls are there to be decorated in the same way – so beware!

Involving children in painting can invite accidents, so keep them on the ground if possible; ladders, trestles and so on are too risky if your attention and theirs is elsewhere. Use water-thinned paints, which are safer, and remember that some pigments are poisonous. If the area to be covered is not too large, Pelikan Plaka paints (casein emulsion) are supplied in useful-sized pots. They are water-thinned and non-toxic. Protect clothing, and make sure you and the furniture are protected too as you may find the paint tends to fly.

Finally, do not get carried away by the legend that primary colours in a child's rooms are essential. A mural painted in primary colours could easily be overwhelming and even oppressive.

The background for this mural, with its stippled sky and ground, helps give the room a dream-like quality which is effective even before any details have been added. The room can be painted up to this stage, using whatever colours you choose – and then details can be added when you have time. The background here would equally have suited a painting that included rockets and robots. In this mural, colourful figures from fantasy and real-life are chosen – a teddy bear, a butterfly, a bluebird, with balloon and flowers. They give the picture a definite children's book flavour. If you do not feel confident enough to paint particular characters, stencil collections are available, allowing you to choose, say, sets of animals which can be stencilled over the background colours.

The nursery painted here is small, so pastel colours were chosen to keep the room light. For a more dramatic background, in a larger room or one for older children, stronger colours can be used. The long and narrow dimensions of this room have also influenced the scale of the characters depicted. The figures are not too big, and this has the effect of increasing the apparent size of the room.

A combination of paints was chosen for this project. Vinyl matt emulsion is used for the background sky and grass as it is a large area and this paint is strong and economical. For the more detailed painting of the characters, artists' acrylics seemed the natural choice. This combination will not last for ever, but it will certainly last as long as the young occupier's taste for nursery characters.

BACKGROUND

The two-tone effect used for the background is an excellent means of disguising a less-than-perfect surface. For this mural, the newly plastered wall was first painted with two coats of white vinyl matt emulsion. The first coat was thinned with 25 per cent water so that it was more easily absorbed by the plaster. The second coat was applied at full strength.

1. Sky The sky and grass of the background cover the walls and the ceiling. However, the method used is so quick that the time taken to paint them barely exceeded the time it would have taken to give them a flat coat of emulsion – and it was definitely more interesting to do. When the ceiling is incorporated into a mural, always paint that first, then work down the walls. A stepladder, firmly fixed in place, was used here to reach the ceiling and high areas.

2. The cloudy effect of the sky is done with a stippling

MATERIALS
- 35-fl oz (1-litre) pots of vinyl matt emulsion: pale blue, white and pale green.
- Tubes of acrylic: light magenta, bronze yellow, raw sienna, mars black, raw umber, mauve-blue, Turner's yellow, dark chrome oxide green, and emerald green (these are mixed with white emulsion for the details)
- Decorators' brushes: 2-inch (5-cm) and 4-inch (10-cm)
- Artists' brushes: medium flat, medium filbert and small round
- Palette for mixing colours

Right Although this successful nursery design developed as it was painted, it is often helpful to sketch out your ideas beforehand, linking the individual elements and creating some sort of balance between them. Here, the characters are scattered across the wall and then cleverly linked with the ribbon.

technique. This is achieved with a well-used decorator's brush, held in the right hand, which is first dipped into blue vinyl matt emulsion, and spread in an uneven patch on the wall.

3. A similar decorator's brush, loaded with white emulsion is then taken in the left hand and stippled over and into the blue with a rapid stabbing motion. The uneven cloud formation is created by a twisting movement of the wrist.

This procedure is continued until the paint begins to dry, and the stippling motion creates a vapour-like effect. The technique is continued along and up the wall until the whole area is covered. It is important to stand back every now and then to check the work. Do not

worry if there is a patch which does not seem quite right. It is merely a case of painting it correctly over the top. This stippling motion is very hard on your brush and will cause hairs to splay. In fact, an old brush which has already splayed out is perfect for the job. Alternatively, a similar but not identical effect can be achieved with a sponge dipped in paint. Any drips can be wiped off with a damp sponge or rag. If you find them after they have dried, try scraping them off with a knife or, alternatively, remove by lightly rubbing with fine sandpaper or wire wool.

4. *Grass* A similar technique is used for the grass, this time with green and white paint. Here the colours are merged together to achieve a more even distribution of colour. The radiator is incorporated into the overall scheme. In this case, the radiator was painted with vinyl emulsion, but this may cause problems. Extreme heat can cause peeling and cracking, so ask your dealer for advice on suitable alternatives.

5. Balloon The balloon is painted free-hand with a 2-inch (5-cm) decorator's brush. When painting directly in this way, without a preliminary drawing, it is necessary to work boldly – any lack of confidence will be reflected in the result. Using a decorator's brush will help you to 'think big' and to use more expansive strokes than usual.

For the balloon, acrylic paint (light magenta) is mixed with white emulsion and a little water. The

painter relies on the shape and size of the brush to create the circular shapes, painting first one side of a balloon and then the other. A steady hand is needed to achieve such sweeping curves; increasing pressure applied to the rotating brush will help produce an even, balloon-shaped curve. However, do not worry about making a mistake. The paint can be washed off immediately with a wet sponge. Nor is the crispness of the shape important. This can be tidied up later when the outline is added.

To build up confidence, practise on some newspaper first – an old roll of wallpaper or lining paper is a useful alternative. Then, if your practice run produces a perfect outline, this can always be cut out and traced round with a pencil directly on the wall. If you still feel you need to pencil in the outline before painting, tie the pencil to a piece of string; hold the string down at the centre of the intended balloon shape with your thumb; then draw a circle using the length of string as the

radius. Alternatively, if you decide to repeat the image, cut out a template for the balloon as described on page 49, and trace round this with a pencil on the wall.

The largest brush is used to fill in the colour of the balloon, and a small dab of paint is added at the bottom to represent the neck. Next a highlight is painted on the side of the balloon, adding an important illusion of three-dimensional form. This is applied with a smaller, round artists' brush and white paint, which is then worked into the flat pink. If the pink has already started to dry, this can be sprayed with water from a plant spray atomizer.

6. Bear The outline of the bear is now painted in with a flat brush. The painter uses the squared, flat bristles to achieve an effect similar to that of an italic pen, painting both wide and narrow lines. However, if you do not trust your skill in this matter, the bear can be traced, squared up and transferred to the wall using the method described in the previous project. Otherwise,

draw the bear on the wall in charcoal or pencil before starting to paint. The bear colour is mixed from pure acrylic paint, bronze yellow, raw sienna and a little white emulsion. Again, any mistakes can be easily wiped off with a sponge.

The artist's palette used here is an old china plate. Ceramic dishes and plastic or ceramic palettes are far better for mixing acrylics than the traditional wooden palettes. Acrylic can be scraped off smooth, non-porous

surfaces, but cannot be removed from wood. This artist, however, mixes new colours on top of old dried paint, making the china plate look rather like an abstract expressionist painting!

Next, the bear is painted, the brush being pulled smoothly round the contours of the body of the bear. The visible brush marks help describe the shape and form of the bear. Lighter patches, made by adding white to the bear colour, are painted on the ears and paws.

7. Pink skirt Moving on to the frilly tutu, the painter starts by mixing two tones of pink. These are made by adding different quantities of white emulsion to the basic balloon colour magenta pink. The skirt is painted with broad strokes to give the impression of swirling material.

The underside of the skirt is painted in the deep pink tone, the combination of the two pink shades creating a wonderful impression of flouncing skirt. Finally, decorative pink bows are dotted randomly over the skirt –

a touch of teddy bear haute couture!

8. Smaller details are added with a small round brush. The eyes and nose are painted in mars black, and then, to give the bear definition and prominence, and to tidy up the contours, the outline is delineated using denser acrylic paint (mainly raw umber mixed with a little black and white) and a small round brush. This all-important line is very useful for tidying up a ragged contour. It needs to be executed quickly with a light touch. The paint should be dense but not too dry. Try adding some acrylic flow medium if the addition of water makes the mixture too fluid. Do not worry if the line is not uniform; it should be broken and slightly fuzzy to indicate the texture of the bear. Like all good bears, she is given paw patches and claw stitches.

Now for the final, all-important details; the bear is given a kind expression and the eye is softened with a brown lid. Then, to bring her to life, a spot of white highlight is lightly touched on the eye and nose. In the

background the balloon string can be seen – a broken line made with repeated touches of a fine brush tip.

FINISHING TOUCHES

With the main part of the mural now complete, it is time to add all-important detail. The resident of the bedroom has definite ideas about this, and the artist is working under strict instructions! Ideas for such details can be gleaned from picture books, natural history magazines and other sources. Butterflies are a timeless favourite, and these colourful creatures can always be relied upon to add a dash of flare and colour. Together, the painter and occupant decide on a selection of colourful additions to the mural – butterfly, bluebird, flowers and ribbons.

The treatment of all the smaller elements is basically similar to that of the bear. Flat shapes are first blocked in, in this case without any preliminary drawing. Details are added and, finally, the contours are tidied up

Below Walls are often marred by fixed light switches, wall sockets and radiators, which seem to exist only to test the ingenuity of the muralist. In such a mural as this, they can be camouflaged by painting over them with the base colour and decorating them in the same style as the rest of the wall.

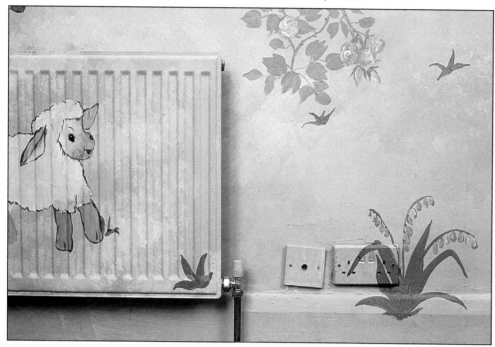

and defined with a darker outline. Very small elements do not usually require the added emphasis of an outline.

9. Flowers An easy-to-follow system is devised for the flowers. The foxgloves and roses are simplified to a degree, but they are still recognizable. Most of the shapes are created by the natural strokes of the brush.

First, the leaves and stalks are painted with flat green, a diluted mixture of dark chrome oxide green,

emerald green and white. Ridges and veins are then added in a thick, undiluted mixture of the same colour. This gives form and character to the foliage.

Next, the flowers are added, their rounded, natural forms coming from the flowing strokes of a medium filbert brush. To form the foxglove bell, the artist starts by blocking in the shape with light magenta and a touch of white. A lighter shade of the same colour is painted on top of this, the darker edges being allowed to peep through. Because they are a decorative rather than a dominant element, the flowers are not given an outline.

10. Bluebird With a few fluid strokes of diluted mauve-blue, the bluebird is positioned on a patch of white cloud. The body is painted, and then, like the bear, is given a glittering eye and a dark outline.

11. Ribbon Finally, the scattered elements of the composition are linked with a fluttering yellow ribbon painted in a mixture of Turner's yellow and white. Again, it is the broad stroke of a flat brush that enables

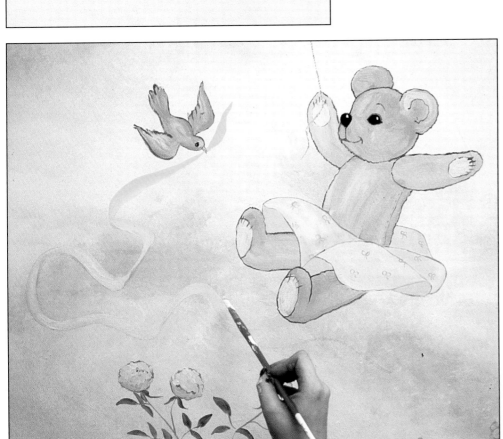

ribbon in pencil first. If you stop to re-load the brush, simply start painting again from where you left off. Any joins that are less than perfect can be worked together afterwards. Here, the ribbon is given added interest with some highlights on the raised curves, made by adding more white paint to the basic yellow, and working it in. The outline of the ribbon is smooth to indicate the texture and form.

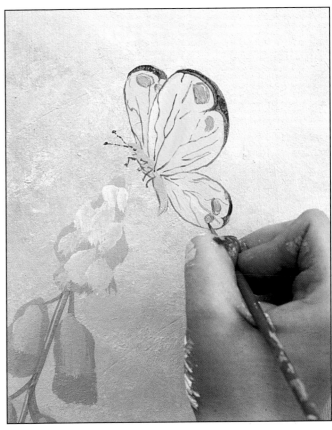

12. Butterfly Following the basic procedure – shape first, followed by detail, then outline – the artist paints the butterfly using a mixture of Turner's yellow and white. A small round brush is used for the tiny details on the wings and for the butterfly's face and body.

FINISHED MURAL

Not surprisingly, the finished room delights its young occupant, who immediately outlines plans for the decoration of the rest of the house! As you can see, the small chest of drawers in the bedroom has been given the same treatment as the grass. The inclusion of furniture in the overall theme helps unify a room, and is especially neat and effective in a small space.

the artist to paint the flowing ribbon with a consistent width. The narrow twists are achieved by turning the brush and painting with the narrow edge of the bristles. In this way, the various elements in the composition are deftly linked by one twining, twisting form.

To maintain the constant flow of colour necessary for such effects, the brush must be well charged with fairly fluid paint – it may be helpful to plot the path of the

A further dimension is added to a London schoolyard with this glimpse of a fairy castle through an enchanted wood, a backdrop against which the children can act out their fantasies. The artist has taken care to incorporate the existing real features, the foreground trees, into the mural, providing an easy link between reality and illusion. The pathway then leads the eye into the background, creating an illusion of space. The execution of the mural has been kept simple as it has been painted directly on brick. It helps to add a few extra local layers of undercoat where brushwork needs to be more detailed.

A mural project need not involve acres of paintwork as this example shows. The result is amusing and decorative, a mural that complements the room not overpowers it. The mural design enforces the unseen architectural support necessary for the opening between the two rooms, and the giraffe echoes the slope of the ceiling on the left. Executed in acrylics, with a coat of varnish, this mural will withstand any knocks it will get in this much-used rumpus room.

An attic bedroom is transformed into a cosy Beatrix Potter rabbit burrow featuring Peter Rabbit, family and friends. The same subject matter decorates the child-sized furniture. Using a base coat of trade eggshell, the scenes were added in artists' oils. These are found by some muralists to provide a softer image, which is thought to be appropriate for such nursery scenes.

The vibrancy of this safari mural is achieved through the swirling brushwork and the depth of colour found in the Flashe range of indelible gouache paints. Although primary colours are much in evidence here, the effect is not in any way overwhelming or oppressive simply because the colours are applied so loosely. The tiger lying in wait on the left makes full use of the built-in cupboard, neatly incorporating it into the design.

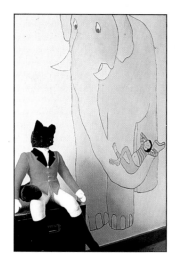

Above This kind elephant is painted in a style that is quickly executed and yet will give infinite pleasure. Once the outline has been painted, the form is simply filled in. Using acrylic paints means that mistakes can be easily wiped off with a damp cloth before they dry and yet the finished mural will be up to the wear and tear expected in the nursery.

A wall of built-in cupboards can cause problems when decorating a room – you cannot place furniture against them or hang them with paintings. Here, the difficulties have been overcome by camouflaging them with a happy scene of a thatched cottage with its friendly animal inhabitants. The wooden doors make an excellent surface to paint on. They were prepared first with vinyl matt emulsion paint and then painted with acrylics. Soft colours and a loose brushwork ensure that the finished painting is not too overpowering.

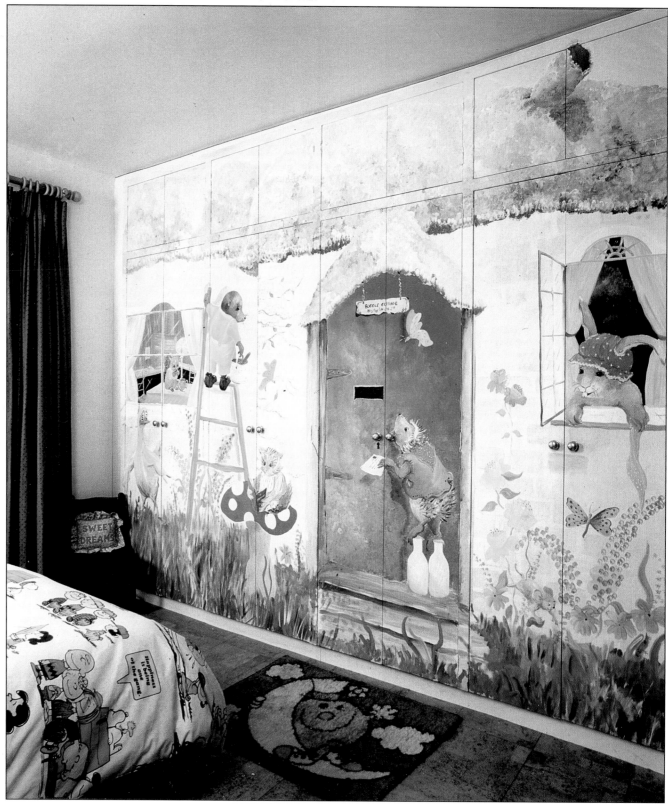

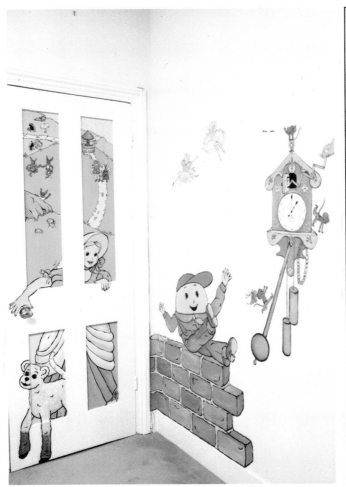

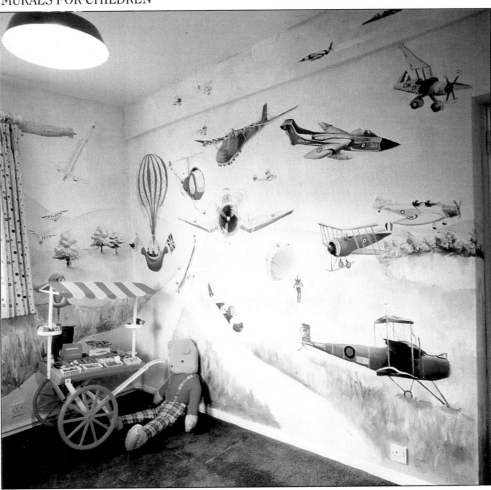

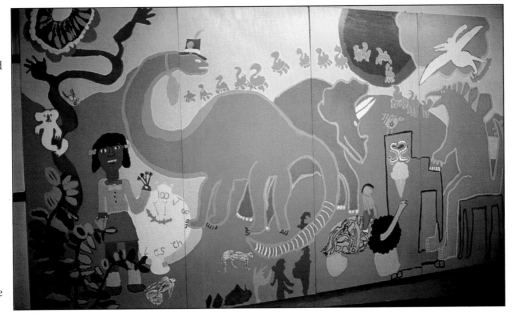

Above Nursery rhymes form the subject matter for this children's room painted in acrylic paints over vinyl matt emulsion. The standard panelled door has been cleverly painted so that Bo Peep can reach through to turn the handle. A cartoon style can be easily copied and is simple and quick to execute.

This colourful school mural of dancing dinosaurs in Chicago, Illinois, was designed and painted by children with the guidance of a mural artist. The flat areas of bright colour and contrasting outlines is a suitable technique for children.

Above It is easy to see what is the prevailing interest of the occupant of this bedroom. Against a simple background, these different forms of air transport combine to make a decorative display. Each element has been carefully copied from photographs and magazine articles. As a result, what would be a control tower's nightmare becomes a small boy's delight, inspiring happy dreams.

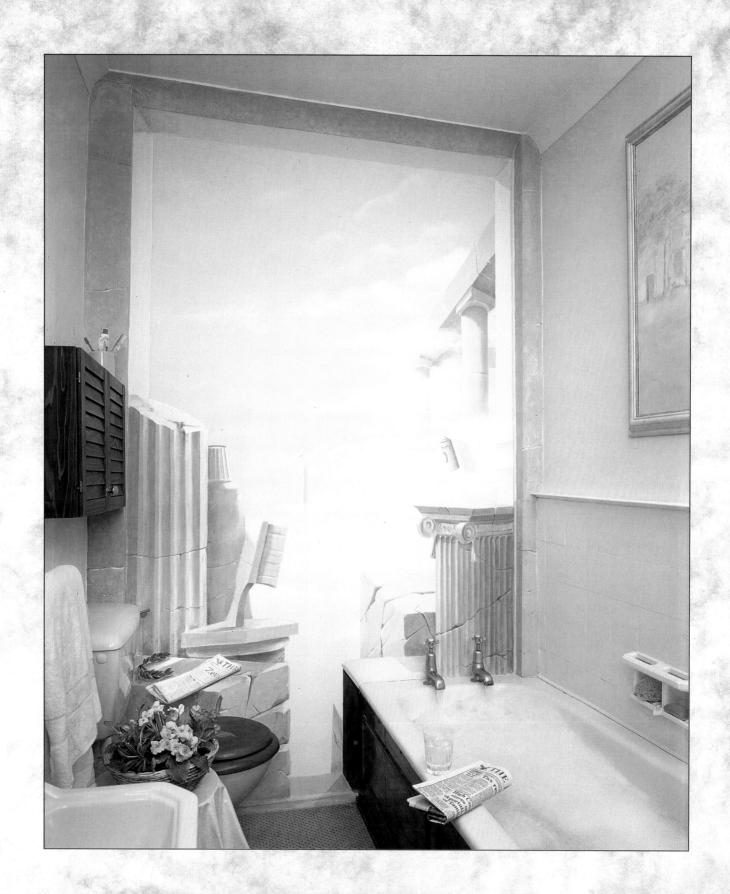

3
SURREAL & FANTASTIC

Traditionally, Surrealism questioned the lack of distinction between the reality of life and the illusion, highlighting those things that hover between the two. The Surrealist Movement, which was founded in 1924 by the French poet André Breton, set about to explore the subconscious through the study of dreams, myths and fantasies, represented in all branches of the arts by a universal language of symbols. Today, the concept of a surreal painting has a much wider meaning, but it still involves the elements of fantasy, mystery and the distortion, rather than misrepresentation, of reality.

The element of illusion and the distortion of reality that is often present in a trompe l'oeil painting makes it surreal as a concept. It is an easy step to exaggerate this aspect and indulge your wit and fantasies. This does not necessarily involve complicated techniques: think of the simplicity and stylization of the paintings by René Magritte. It is more a case of learning the tricks of the trade – the ways of projecting a dream-like quality by applying a well-used vocabulary, such as distorted perspectives, bright unnatural light from unexplained sources, and a disturbing irrationality.

The trompe l'oeil style of painting reflects the 'unpainterly' technique of the early Surreal painters too. The paint is applied to produce a surface that is as flat as possible; no brushstoke or impasto is encouraged, and the surface should be matt and non-reflective.

As the following project demonstrates, surreal fantasies are easily incorporated into a skyscape. Alternatively, a low horizon promotes the idea of an infinite, dream-like landscape, similar to the deserts painted by Salvador Dali. Such a setting is then ready for the elements of the composition. A taste of the surreal can be projected by placing unlikely objects together, or by intermixing odd features. Light, too, is important, and can greatly contribute to a feeling of displacement. A powerful flat light that increases the tonal contrast throughout will promote a sense of the unreal.

Finally, witty touches can be added, such as blowing curtains or a falling vase, which can give life to an otherwise deadpan composition. Such unexplained movement may not be noticed by the viewer at first glance, but will tease the mind long after the initial impression has faded.

This mural was inspired by the bathroom it was destined to dominate. It depicts 'The Toilet of the Gods' (to match that of Venus). Round this idea, a dreamlike theme unfolds, the more the mural is studied.

At first glance, it appears to be a serene, unprovocative, classical scene apart from the super-real shaving-foam cannister. On closer observation, you realize that what you thought were columns are in fact a stone toothbrush and paste tube. You notice the smaller life-like details – the newspaper and laurel wreath – which float into the dream. Then, we focus on the colonnade on the right to find it is irrationally founded in the misty clouds. This plays on the disturbing contrast between the heavy weight of the stone and the intangibility of the clouds. The dramatic perspective (which is even more unnerving, viewed from the bath) leads the eye to the unexplained, perhaps inexplicable, obelisk floating in the distance. This distortion of reality gives the subject drama and movement which is sometimes lacking in the straight apeing of the truth.

The bathroom had been painted in matt emulsion

Even the most carefully thought out mural design may need to be altered once it is on the wall, particularly the perspective. For this bathroom mural, a rough sketch was made before work started, but the illusionistic extension of the side of the bath was perfected on site, moving the line until it 'looked right'.

MATERIALS
- Acrylic paints (2 × 10 fl oz/30 ml pots): white and sky blue.
- Tubes of acrylic: raw umber, yellow ochre, lemon yellow, red oxide, light green, Hooker's green, Payne's grey and ivory black.
- Decorators' brushes: 2-inch (5-cm) and 3-inch (7.5-cm)
- Artists' brushes: medium flat, medium filbert, small and medium rounds
- Foil dishes and plastic kettlesfor mixing paint
- 1-yard (1-metre rule)
- Soft pencil
- Water spray

paint which was found to be in excellent condition, showing no deterioration. This was washed down with sugar soap to clean off any accumulated grime, rinsed and left to dry out. Hot baths were discouraged before painting to allow the wall to dry out properly, and during painting to prevent any condensation retarding the drying time.

Household emulsion paint, particularly those cheaper brands containing cellulose thickeners, absorb moisture which eventually destroys the paint surface. For a bathroom, where there is considerable condensation, a stronger paint is generally required. For this project artists' acrylics were used.

SKY

The surreal sky was painted first, using a technique similar to that of a graded wash – successive applications of increasingly paler bands of blue were applied, merging into one another to create an area of colour, gradating from dark to light.

To start with, a quantity of sky blue acrylic paint – enough to cover the wall – was spooned into a paint kettle and diluted with a little water. Starting at the top of the wall, use a 3-inch (7.5-cm) decorators' brush (or whatever size brush you can handle easily), paint with smooth, even strokes to a depth of about 2 feet (60 cm). The brush will retain quite a lot of paint, but do not overload it or the colour will drip down on the wall below. Start off gently, gradually increasing the pressure on the brush in order to extract all the paint. Cover as much of the wall with one stroke as is comfortable. Work the paint in sideways, finishing with a light stroke to smooth out the brushmarks.

1. Working quickly, because acrylic paint dries fast, add a spoon of white paint to the blue, and mix this thoroughly. This process can be speeded up with a stirrer attachment for an electric drill. A stirrer is particularly useful if you have a large area to cover and therefore more paint to mix, but take care not to take it out of the paint whilst still in action, otherwise everything in sight will get painted.

2. Next, the slightly paler blue paint is applied to the wall, merging it into the darker band above, by working the colours together with the brush. If the darker paint is drying out, spray the two bands along the join with a water spray – the type used for plants – filled with clean water, and then work the two colours together. Remember that acrylic paint dries slightly darker, so do not be alarmed if the new band of paint appears lighter than expected when first applied. Repeat this process of adding progressively lighter bands of colour and working them in until the wall is covered. To speed up the operation, it sometimes helps to have an extra pair of hands to do the mixing of the paint while you do the painting.

3. *Clouds* Now, for the clouds, which are added with the

same brush, using a dry brush technique. For this technique to be effective, the painting surface must be dry, but with acrylics this will not take long. Using a clean, dry brush, dip the tip into the white paint and wipe off any excess on the side of the pot. Work the paint over the blue sky with a quick jabbing motion until the paint begins to dry and the colour spreads, forming the vaporous contours of the clouds. The trick is to use very little paint and quick confident strokes so that the clouds are light and the blue of the sky beneath shows through.

The clouds are painted at random over the blue until the skyscape is ready for the fun to begin. At this stage you can branch off to create a surreal fantasy of your own imagination. Literally, the sky is the limit.

ARCHITECTURE

The next stage of the mural is the classical stonework. Here the composition was drawn on the sky background with pencil. The artist followed a rough design, but

positioned the elements by eye, changing and manipulating these 'on site' to create a balance of form, colour and tone, suitable to the proportions of the room. Even when the original sketches are done on site, as they were in this case, alterations are often necessary when a sketch is scaled up.

As you can see in the finished painting, the side of the bath seemingly extends into the picture space. This piece of illusionistic trickery was contrived by trial and error, the artist observing carefully from the chosen viewpoint, returning to the wall to draw the receding line, and then standing back immediately to check this from the viewpoint. This particular detail cannot be seen from the bathroom door, so there is no problem of distortion from that important angle. However, there is a potential problem from another vital vantage point – from within the bath itself where the mural will be viewed at leisure. Because the eye-level from the bath is so much lower than that of a standing position, some distortion is inevitable. Fortunately, the surreal subject matter allows for some visual discrepencies, but take care not to push credibility too far, or your mural will simply look unconvincing. This is why it is essential to stand back constantly from your work in order to assess its progress.

STONEWORK

4. As with much surrealist painting, the lighting in this mural is unnatural and bright. This frequently has the effect of reducing gradations of colour which, in normal lighting conditions, we see quite easily. But here the artist wants to exaggerate this effect in the modelling of the stonework, by emphasizing the effect of the light and shadows on the stonework. To do this, three shades of stone colour are mixed – a mid-tone, highlight and shadow – from white mixed with raw umber and yellow ochre.

Enough of each tone was mixed to complete the job. It is surprisingly difficult to remix exactly the same colour, especially with acrylics, because they dry slightly darker. By using these colours throughout the mural, you are sure of a consistency in the levels of tone. If the colours you mix are similar (and they nearly always are), it helps to mark the dishes as they are easily confused. Foil dishes used for freezing are useful because they are light to carry and, if you need to stop, they can be covered with cling film to keep the paint fresh. Otherwise tip a little clean water over the surface of the paint in the dish and pour this off when work resumes.

5. Now, the main areas of stone are blocked in with the mid-tone colour. The paint for this operation is diluted with water and applied with a large brush. Blocking in is done quickly and lightly, without too much trouble

being taken to stay within outlines. Try to cover the area you are painting with as smooth a layer of paint as possible. It is better to avoid building up edges of paint at this point, because they may catch the light and spoil the illusion. Start at the top so that any drips can be wiped off the wall below. The blocking in gives you a good idea of how the mural is going to look. Now is the time to stand back and appraise your work for balance, and to check the general range of colours. Here, the range is very narrow, but that is intentional. Sometimes the blocking in colours are painted over at a later stage, and are thus used more like an undercoat. More often,

they act as the base colour for transparent glazes or stippling.

One word of warning about the blocking in stage – it is a bad time to let others see your work. One of the problems about mural painting is that it is often difficult to paint in privacy. The mural painter must learn to harden the heart against unsolicited advice, or take a leaf from Michelangelo's book and lock the doors.

Next, the highlights and shadows are added with the premixed paint. These are applied as diluted washes of colour over the base tone. Successive layers can be added until the effect and depth of detail is achieved. Here, you have to be careful not to overwork one area of the painting in contrast with the rest. It is worth keeping all the stonework at the same level of development, trying not to allow yourself to get carried away by one particular element. The ruins form the background and do not need to be highly detailed.

6. The flutes on the left hand column were drawn in using a rule, and then modelled in paint over the base tone. The narrow bands are left in the base tone, and on the wide bands a dark-toned shadow is painted down the right hand side, a highlight down the left. The two tones are blended in the middle. (Further ideas about painting stonework can be found on pages 148–9).

7. The colonnade in the middle distance on the right-hand side is drawn in dramatic perspective, the original sketch being used as an approximate guide. The stonework is painted as before – blocking in and then adding shadow and highlights. Here, the shadow tone is worked in down the side of the column.

The tidy outline of the column was achieved with a steady hand, and by charging a long flat brush with sufficient paint to complete the whole line. The little finger was used to steady the hand and to maintain an even distance from the wall. Using masking tape for such a task can be tricky when painting directly on the wall as the tape invariably pulls off the paint layer below, which then has to be laboriously built up again. Painting straight lines takes practice but do not be too much of a perfectionist: viewed from further away small

Before painting the ruined fluted column on the right (see overleaf), guidelines were also drawn in with a pencil and rule first. Here, however, each strip is painted with a dark-toned shadow on the left hand side and a highlight down the right, and again blended slightly down the centre where they meet.

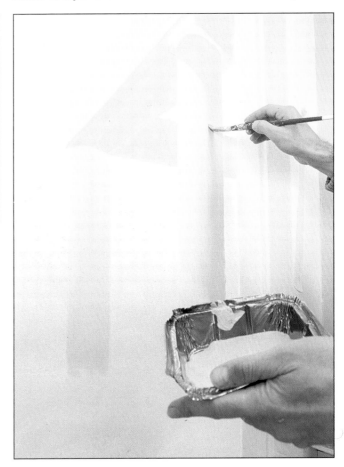

irregularities will not be visible. And remember it is essential to be confident and maintain a light touch. You can always wipe off any diversions from the straight line with a damp cloth if unsuccessful the first time.

MISTY CLOUDS

8. Further clouds are now added as before with a dry brush, enforcing the ethereal quality of the scene. These clouds become the 'foundations' of the colonnade, casting shadows on the architecture to heighten the sense of realism. they can also be judiciously exploited to cover any 'small irregularities' in your painting. Note how thin the layer of paint is and how

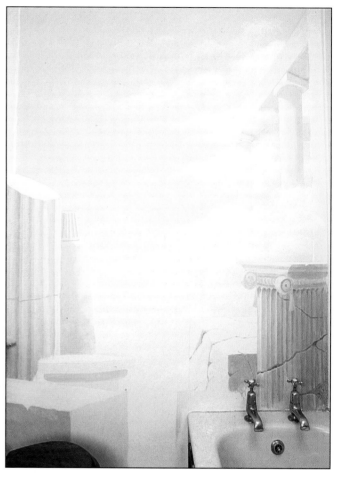

the underdrawing shows through on the capital. This cannot be seen once you step back; it is better to maintain a lightness of touch than overwork your painting.

SMALLER DETAILS

9. Now, the stage is set and the storyline is ready to be filled out with some intriguing details. This is a chance to show off you still-life skills. If they are non-existent, do not worry; these small details are not essential, and other, less precise, distractions can always be woven into the tale.

10. To give credibility to this classical, ruined stonework, random cracks are added with a small round

brush. These are first painted with dilute raw umber, roughly following the indentations of the fluting in the column. The width of this line is varied by altering the pressure on the brush until if finally tails off. Little extra dabs of raw umber are added at relevant points.

11. Now, this fissure is given the illusion of depth with the addition of the highlight tone alongside the raw umber. Again, this is an irregular stroke.

12. The newspaper of the gods was blocked in with a dilute wash of white with a touch of raw umber. The print is suggested with Payne's grey and white for a blurred effect. The painter then uses a soft pencil to etch the headlines into the still damp paint. The name of the paper is carefully picked out in the typeface of a better-known paper read by lesser mortals, lending an air of authenticity. This again was carried out using a soft pencil. If you intend to wash the mural regularly, the pencil marking will need to be varnished to fix it. Use spray varnish as brushing the varnish on may blur the pencil image.

FINISHED MURAL

The laurel wreath of victory associated with the Greek gods (see finished mural) is added with a medium round brush dipped in Hooker's Green, painting each side of the leaf in turn. Again, the addition of the shadow allows it to appear to rest on the ruined column. Shadows explain a great deal about the light which throws them, the object which casts them, and the surface they are cast upon. Here, the light is dramatic, the object filigree, and the surface rough. the shadow is therefore dark because of the light, but undefined because of the object and surface.

A neat, but disturbing, trick is played with the shaving-foam cannister which seems to stand out from the mural. This illusion is achieved by painting the cannister in high contrast – note the metal cap, which is painted almost entirely in pure white and black. Care is taken, too with the lettering on the can which can be seen in stark detail. The illusion is made more convincing by the addition of a shadow on what we all know is a flat picture surface, but which we have been deluded into thinking is a view of a classical scene. This deliberately and perversely contradicts the illusion of landscape on which it is superimposed. The artist is laughing at his own talent. Again, the shadow, which is relatively hard-edged and dark, is determined by the light, object and surface.

The full glory of the Olympian saga can now be appreciated. You will notice in the finished scene that it has been given a discreet focal point in the form of an inexplicable obelisk floating on a distant cloud. Daily ablutions in this bathroom can now be taken as if perched on Mount Olympus, sharing such a mundane daily performance with the heroes of the past.

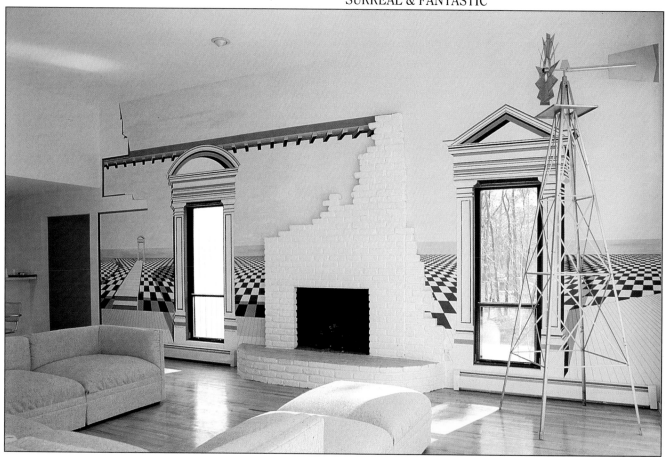

It is not only imaginary space that is distorted here through a combination of vanishing points and dramatic perspectives. Reality too is given a new look with a ruined fireplace and a freestanding windmill. This combination of reality and fantasy challenges the observer to reassess normality.

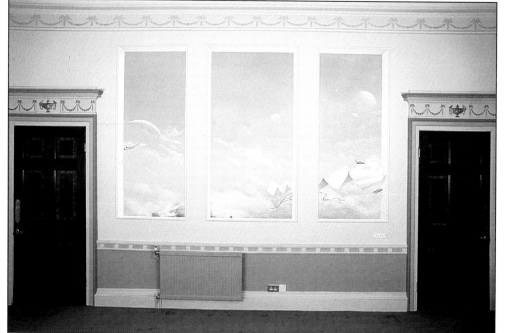

A tongue-in-cheek interpretation of the interchange of ideas as manipulated by those in public relations has been painted on this boardroom wall. The setting in outer space provides a light and airy background for the individual items, and the clean-cut openings isolate yet complement the paintings. The result is to give the room, with its delicate Adam decoration, a more contemporary air.
This was executed on a vinyl matt emulsion base with acrylic paints.

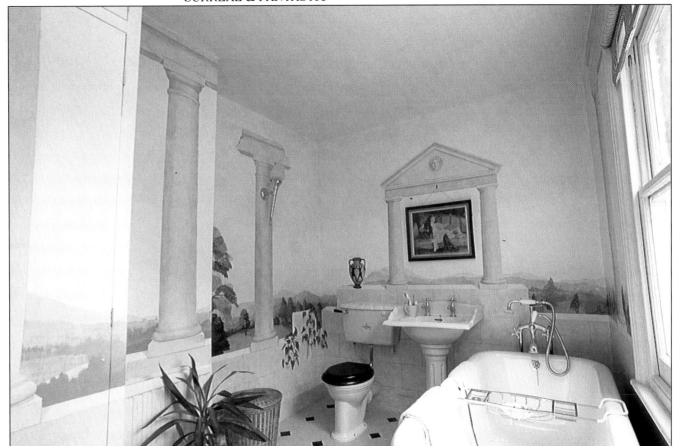

This classical bathroom is given a surreal twist through the witty inclusion of the room's fixtures and fittings. An Olympic torch wall-light appears to be affixed to a column, while a print is suspended from the architrave of an arch. Beyond this crumbling structure of classical architecture, a dreamy view of the local countryside can be contemplated from the bath. To compound the illusion from this position, the eye-level is deliberately low.

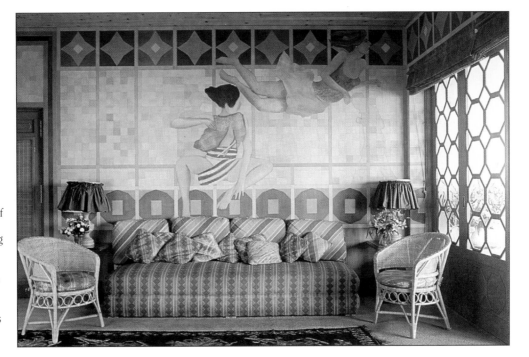

Not all murals are painted on the wall or on panels as can be seen in this beach bar. The figures here have been cut out of sheets of plywood and then painted with acrylic before being glued in place. The small surrounding squares and octagonal shapes (reflecting the window frame) were added in the same way. The result, reminiscent in form of Chagall's work, provides a suitably dreamlike setting.

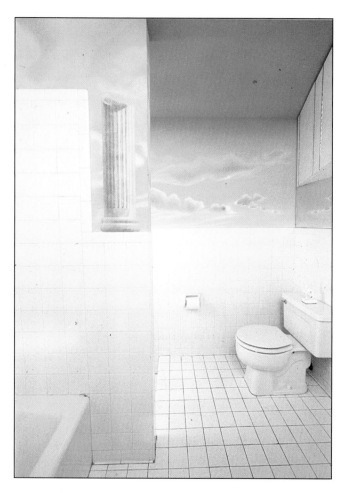

A simple surreal skyscrape provides an element of amusement in this otherwise clinical bathroom, the white tiles becoming the interior face of a 'wall' on which a broken fluted column rests.

What better way to view a mural than from a circular spa bath, here seen overlooking an empty ocean launch-pad ready to be peopled by the imagination. The stylized representation of the architecture in white, grey and black ignores reality and provides an effective contrast with the painted illusion beyond.

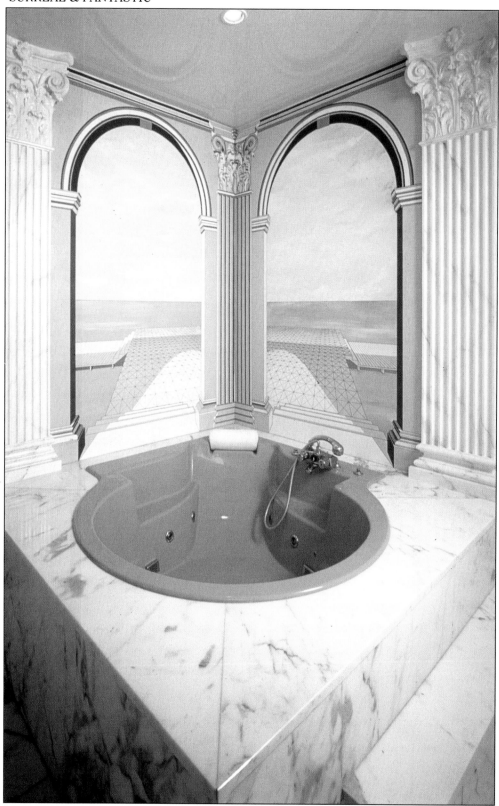

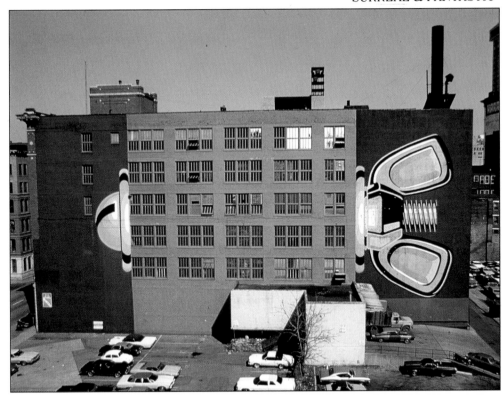

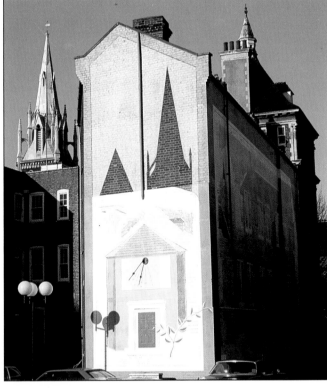

Above This wing-nut, ostensibly holding the building together, has transformed a drab façade in Cincinnati, Ohio, into a city monument. The flanks were primed with sealant (masonry hardener) and an undercoat of 2.5:1 mixture of Glidden's primer to Emulsa Bond applied. Referring to 'a meticulous paint-by-number pattern', the design was executed in Glidden's Bulletin colours.

An art historians' version of 'Kilroy woz here', this street mural depicting Picasso's challenging stare could not fail to affect those who use this parking lot in San Diego, California. Painted in a flurry of colours, the piercing black eyes effectively draw the attention away from the barren landscape.

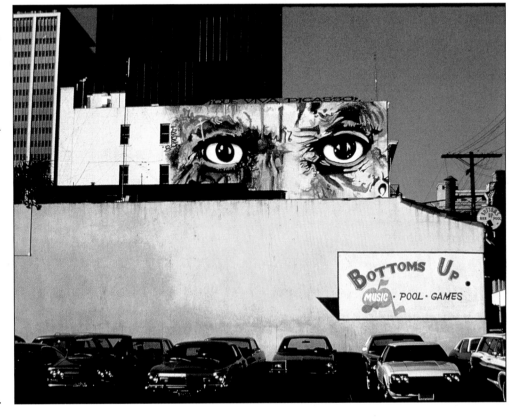

Above Such an oddly-shaped end of a building would be a challenge for any muralist. The design is carefully conceived, taking into account integral features, such as the drainpipe, and the surrounding architecture. Painted in exterior masonry paint, the architectural plans for a small classical building are 'pinned' by the drainpipe to the building.

Above Painted to decorate a large reception area, this panel is a 'send-up' of the tawdry plant life that usually graces such areas. Here, however, the palm and its container appear to be carved from the same polished granite that in reality lines the walls of the room. Acrylic on canvas panel.

A poem entitled *Venus in the Kitchen* inspired this whimsical idea for a kitchen mural. The Roman goddess, turning her back on her planet and an inter-galactic baldachin, gives an unusual and dramatic focus to a fundamentally domestic, work-like area. Although the design was conceived for this particular site, it was painted in the artist's studio in acrylics on a canvas panel made-to-measure for the space and then transferred to its destination.

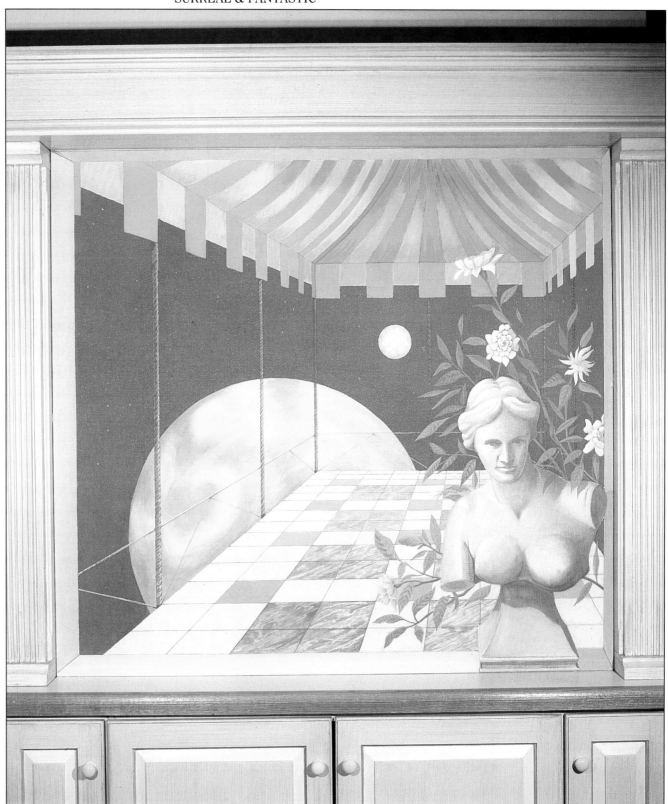

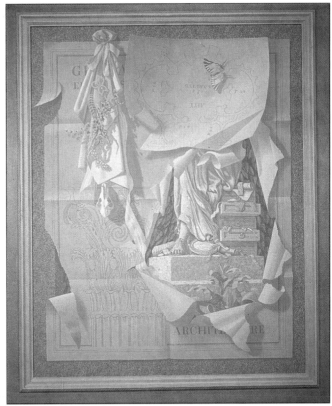

Such a carefully conceived idea, executed with equally delicate precision, warrants not only admiration but also careful study. This trompe l'oeil panel manipulates space by breaking out from the picture plane as well as in to it: successive layers are revealed to us like the unwrapping of a present. The pale, almost monochrome, colours make the deception all the more remarkable. Acrylic on canvas.

Above Even close scrutiny of this inspired photomural will not unveil its innermost secrets. The artist has combined a gamut of paint effects executed with all kinds of applicators, and has included a liberal mixture of op-art ephemera. Eventually, this assemblage 'portrait' of Superman was photographed, mounted and installed in place.

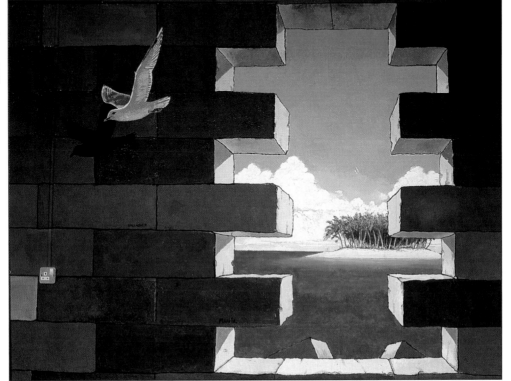

A gentle parody on prison life, this escapist vision was executed by some artistic inmates of Reading Prison. To incorporate the mural into its surroundings, the size and shape of the real bricks was used. Over an emulsion base on a breeze-block wall, this vision of imprisonment and freedom was painted with polymer paints stretched out with white emulsion.

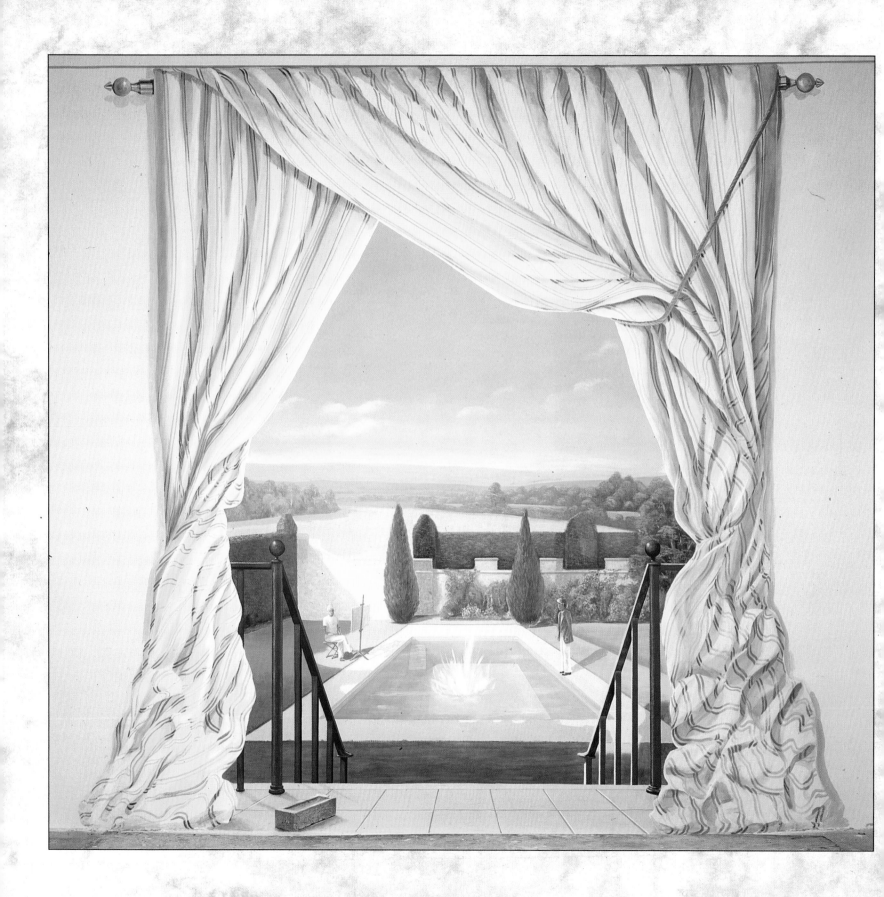

4

SPATIAL ILLUSION

Playing visual tricks is a central part of mural painting. With the careful use of perspective, and painstaking representation of objects, it is possible to create an illusion on a grand scale. You can dupe the viewers into thinking they are stepping up to a huge window overlooking an exotic view, standing at the edge of a wood, strolling on a beach or hesitating on the threshold of some mythical world of fantasy.

The technique employed is centuries old. It is known as trompe l'oeil, or deceiving the eye. In some ways it is not very different from what is for many artists the central purpose of painting: to create an illusion of three-dimensional reality on a two-dimensional surface. But there are ways in which it has developed along its own separate course. For instance, the illusionist painter is not concerned so much with displaying the qualities of the paint itself. An oil painting sometimes expresses obvious delight at the richness of the paint, the direction and sweep of the brushstrokes. Water-colour paints, too, are often exploited by artists to bring out the subtle glow of their transparency and illustrate the effects of spontaneous brushwork. With the trompe l'oeil painter, the medium is important but only as a vehicle – it is the illusion that counts.

Achieving this requires careful attention to perspective, colour and tonal unity, clever integration with the surroundings, unified light sources and a flat, matt, clean paint surface. Perhaps the most important skill is a grasp of the basic perspective and the way it can be used to extend the architecture of a room (see pages 46–7). The artist is often helped, rather than hindered, by the discipline of the existing architecture; its painted extension into the mural is a natural bridge from reality into fantasy. The eye seems surprisingly ready to give the benefit of the doubt to a painted continuation of the real world.

Not surprisingly, some things are easier to paint than others. Many artists keep still-life collections of objects, a traditionally rich vein of inspiration, which can be used in paintings or murals (see page 130).

The limitations of the style and its aims are least apparent where the visual trick played is easiest to believe – or least likely to be disbelieved. Yet such is the skill of some painters that the image really does deceive the eye, at least for a while. It is in the moment of discovery of the trick that, paradoxically, trompe l'oeil often has its greatest charm. After all, total deception might satisfy the painter's pride, but would go un-noticed by the viewer. The pleasure of trompe l'oeil is like that of a conjuring trick, where the fun is in spotting the sleight of hand, and then conjecturing on how this was achieved.

The greater the distance between viewpoint and painting, the greater the painting's credibility. A slavish rendering of reality, however, is perhaps less amusing than a realistic depiction of unreality, to the extent that the viewer is invited to believe the unbelievable. You may be surprised at the many steps that the eye is prepared to take down a cleverly painted primrose path.

A sophisticated trompe l'oeil undeniably requires a high degree of artistic skill. But this should not deter the beginner from trying his hand, especially if he begins with the easier ideas and objects. What is of equal value is the ability to look critically at the way objects and landscapes present themselves to the eye, and then the way the eye draws conclusions about the spatial relationships of the things it sees. Trial and error will reveal what is possible here.

The project demonstrated here requires more technical skill than the previous three. Yet, as the mural unfolds, you will see how the individual elements are reduced and simplified. The illusion of recession in this project is achieved through a combination of techniques. It is based on simple perspective structure, yet the scene is clearly divided into the foreground, middle ground and background – each level taking the eye deeper into the imaginary space.

The wall for the proposed mural forms the end not only of a narrow pool house, but also of the pool itself, which meanders the length of the room like a river. The artist spent some time working on sketches while sitting in front of the proposed mural site. But even so, the final sketch, crystalizing his various thoughts, was used more as a starting point, a guide. For example piercing the whole wall with a window would have interfered with the real windows to the left. It also would have emphasized the low ceiling in the room, which the eventual mural does not, because it is higher than it is wide.

In the real room, natural light floods in from the glass doors to the left of the mural, and this governed the source of the light for the mural. But, as the mural was also to be viewed at night, it was decided to paint the curtains, which are based on the actual material used elsewhere in the room, in high contrast, as if there were spotlights overhead. This brings the illusion into line with the reality. The viewpoint for the mural is tricky because, although the mural is first seen from the right hand side, it will probably be more carefully considered from the comfort of the pool in front of it. Consequently, it is this viewpoint which is chosen, although the shadows cast by the balcony railings across the floor, shown in the original sketch, would have distracted the eye from the clear perspective of the balcony paving stones.

The wall had been recently plastered, but over an old wall. The plaster was given ample time to dry out and then two coats of off white vinyl matt emulsion were applied, the first one diluted with 25 per cent water. A combination of paints was used for the mural – emulsion for the background and for blocking in colours, and acrylics for the detailed painting.

A common procedure is followed in this mural. The artist does not start painting at the top of the mural and work down because the composition is so clearly divided between the foreground curtains, the middle ground garden and the landscape view. After setting the scene with some swift underpainting, he works on the

MATERIALS
- 35-fl oz (1-litre) pots of vinyl matt emulsion: pale yellow, sky blue, pale green, stone and white
- Tubes of acrylic: lemon yellow, yellow ochre, burnt umber, ivory black, Payne's grey, light green and Hooker's green
- A selection of artists' and decorators' brushes
- Foil dishes for mixing paint
- Water bucket
- 1-yard (1-metre) rule
- Soft pencil
- Spirit level
- Sponge

curtains, taking them to an almost finished state. Then he turns his attention to the view and works forwards to the garden in the middle ground. Finally, he adds the finer details to the whole scene.

The finished mural shows the window opening,

The artist worked on site to evolve his ideas for the mural, eventually producing this sketch. In the course of the painting, however, this design was superceded. As can be seen, the balcony railings have been replaced with unseen steps, punctuated by iron bannisters, that lead the eye down into the garden.

voluptuously framed with billowing curtains which give the otherwise frozen scene a sense of movement. Outside the window, there appears to be a terrace and our imagination easily makes the link with the middle ground, through the iron bannister railings which punctuate the unseen steps down into the garden. Again, you need only look at the sketch, which the artist has chosen to alter in this respect, to see what a neat, yet effective, idea this is.

This landscape is then divided into the closer cultivated garden with swimming pool, and the distant landscape beyond that. The recession of the landscape is given credibility through aerial perspective (see page 47) and we make the visual leap with the help of the cyprus trees, which are as graphic as arrows in directing the eye to the distant hills.

UNDERPAINTING

1. The problem of making the first mark is quickly overcome here with the underpainting. With the sketch in front of him, the artist deftly paints in the fluid folds of the curtains, using a mixture of acrylic paints – Payne's grey, ivory black and white, heavily diluted with water. The beauty of this method, working with the brush in one hand and a clean wet sponge is that any mistakes can be quickly wiped away without interrupting the fluidity of the composition.

2. This underpainting sets the scene and establishes the scale of the work. Now, some areas of colour – the curtains, sky and horizon line – are blocked in to give a more comprehensive idea of the composition. The artist has to remember not to step back into the swimming pool to appraise his work.

Before blocking in these areas, however, the artist carefully measured up the horizon using a 1-yard (1-metre) rule. You would be wise, at this point, to check that the floor is level before you calculate the position of your horizon; if it is not, the viewer will feel disoriented, as though on a listing ship. But also get used to relying on your own judgement, which will nearly always spot these discrepencies. When you have drawn in the horizon, check it again with a spirit level.

Notice here the horizon compared with the height of the artist. As the mural will also be viewed from below, in the swimming pool, a compromise eye level is reached. This decision is also influenced by the fact that the room is not very high; a normal horizon of about 5 feet (150 cm) would emphasize the low ceiling.

Now, the mid-tone, a deeper yellow, is mixed by adding lemon yellow to the basic yellow. The diluted colour is applied with bold strokes in a thin layer along the folds so that no edge of paint is built up. Constant reference is made to the sample of cloth, seen here in the background, which is eventually to be used to tent the actual pool room.

4. The darker yellow shadows, mixed by adding a touch of cobalt blue to the mid-tone yellow, have been worked along the folds of the material indicated by the underpainting. Now, the highlights, the mid-tone colour with a dash of white, are added in the same way.

CURTAINS

3. The method used here for modelling the folds of the cloth is similar to that used for the architecture in the surreal project. First, a base coat is blocked in, but here, instead of the mid-tone, the lighter tone is used; the underpainting can still be seen through the paint and acts as a guideline for the folds.

5. The stripes of the cloth are thinly glazed over this structure of folds, using the width of the brush well-charged with paint to maintain continuity. This requires a steady hand and an even stroke. The paint, a mixture of cobalt blue and white, is well diluted so that

the various levels of the underpainting show through. Less dilute paint is used where the stripes fall on shadows. These stripes greatly enforce the three-dimensionality of the folds, but, what appears to be a very complicated task, is in fact simplified to a degree.

MIDDLE GROUND

6. Having worked up the curtains to a relatively high degree of finish, the artist turns to the middle ground. Note, however, that the curtains are not completely finished, as it will only be possible to judge the tightness of the contrast required when the rest of the painting has been worked on further. First, the terrace and the swimming pool are carefully drawn up using a rule and pencil – there is no point in using paint for transferring this more geometric part of the design because the design does not call for a fluid outline. The swimming pool in the mural will appear as an extension of the real one. Then, the middle ground is further blocked in with dilute paint. Note the deliberate lack of attention to finish at this stage.

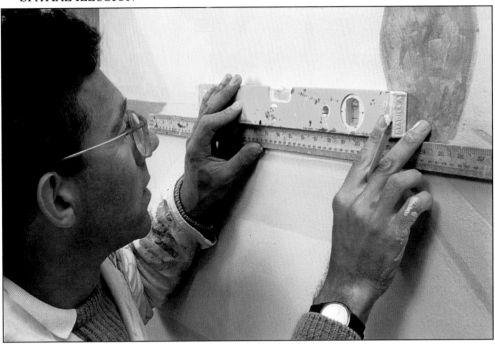

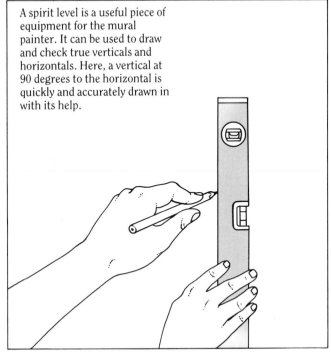

A spirit level is a useful piece of equipment for the mural painter. It can be used to draw and check true verticals and horizontals. Here, a vertical at 90 degrees to the horizontal is quickly and accurately drawn in with its help.

7. Spirit levels have a number of uses in mural painting. Here, the horizontal lines of the swimming pool are checked by placing the ruler along the line and balancing the spirit level on top. Vertical lines can be checked either with the spirit level or with a plumb line.

It is not necessary to buy a plumb line; if you tie a kitchen fork on the end of a piece of string, it will be easy to judge if there is any divergence from the vertical by letting the string hang down the wall.

8. Painting straight lines is a recognized problem for

most people. For painting lines, rather than edges, you might find it helpful to use a ruler. Here, the receding lines of the paving slabs on the balcony are being painted with a brush and ruler. The ruler is held ¼ inch (5 mm) away from the wall surface with the left hand, and the brush is held at a sharp angle to the picture surface with the right hand, enabling the metal ferrule

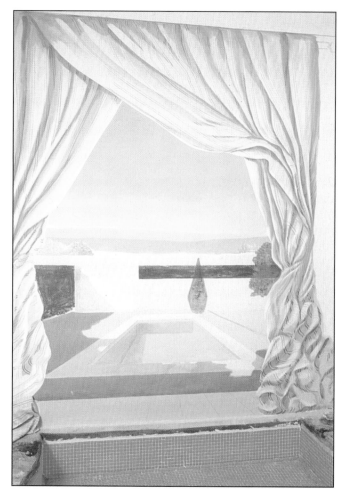

of the brush to be pushed against the edge of the ruler. If you press against the ruler with the bristle part of the brush it will bend with the pressure and the line will be difficult to control. Slight pressure irregularities are encouraged for a more life-like line.

9. The bones of the mural are now apparent, but it still needs bringing to life. The sky has been worked up, the wash becoming paler towards the horizon. In the background hills, the effect of atmospheric perspective reduces the colour to two shades of muted blue. This method of creating recession in a painting is further developed in the next stage of the painting when increased detail and depth of tone are added in the foreground of the mural.

LANDSCAPE

10. Now, the artist returns to complete the background landscape. The background line of trees and shrubs has been built up with an initial thin base coat of cobalt

SPATIAL ILLUSION

blue, dioxazine purple and white, applied with a 2-inch (5-cm) decorators' brush. Next, successive layers of dry brush stippling were applied to form the contours of the trees – chrome green, followed by yellow ochre.

11. In this detail, the delicate contours of the trees are added with a medium flat dry brush – superimposed stabs of dry colour are carefully applied with the brush tip to leave the imprint of the individual hairs.

GARDEN

12. The artist now turns to the cultivated garden. The dark yew hedges and Cyprus trees were developed with superimposed layers of dilute paint applied with tiny strokes of a small round brush – Hooker's green, followed by a mixture of pale green and white.

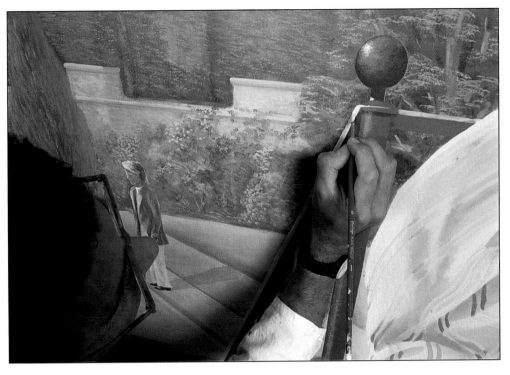

The flower border was built up in the same way as the trees, using a medium round brush. The pale, bleached-looking colours – different greens and pastel shades – are arranged in clumps like a border, yet there is no attempt to represent any recognizable flowers. Take care to keep this area lightly worked; it is very easy to put in too much detail. The flowers need more detail than the background trees, but not as much as the foreground railings. A useful self-imposed measure to curb a natural desire to pursue detail is to restrict yourself to a few appropriate brushes. This means using

decorators' brushes and large artists' brushes for the background; medium sized artists' brushes for the middle ground; and small round ones for the finishing touches in the foreground.

A more detailed look at the David Hockney portrait (see finished mural) illustrates this point well. Although it appears to be worked in great detail, closer observation reveals that this is not actually the case. Although we receive a convincing impression of facial features, these are suggested in the broadest terms. However, more care has been taken with the famous glasses as they are a distinguishing Hockney feature.

Balcony railings In reality these would be painted with black gloss paint. But pure black tends to work against the illusion of depth – black objects seem to sit on the surface of the picture, and even to jump out at the viewer – so dark grey is used instead. The chosen paint, however, is dense and opaque and completely covers the colours beneath. Highlights are added in pale grey, and some final reflective glints of pure white are touched in with a small round brush to indicate a glossy finish.

FINISHING TOUCHES

The addition of the Hockney pastiche in the middle ground (see finished mural) grew from the swimming pool theme that this British artist has so frequently portrayed in his work. This gentle joke does not dominate the scene and is only analyzed on closer observation. Note how the red jacket of the figure on the right, even though it is not a bright red, draws the eye. Red is a powerful and advancing colour. Although this figure is nearly parallel to David Hockney, his red jacket makes him appear closer to the viewer. The water in the pool is painted with layers of dilute washes of pure colour, with only a surface bloom of dry pale blue to indicate the disturbed surface of the water. This was blurred with a finger after application. The splash was added with a very small round brush and neat white paint, care being taken not to build it up too much. The lawn fades towards the background, giving the impression of a hot, atmospheric day.

Finally, the brick was painted in the foreground, following the techniques for painting stone and brick-work outlined in the Paint Effects section (see pages 148–9). Note the artistic licence used on the balcony where the railings conveniently cast an unexplained shadow to link up with the brick. This brick is the artist's invitation to make further – and bigger – splashes in the painted pool or perhaps to smash the illusion if you dare.

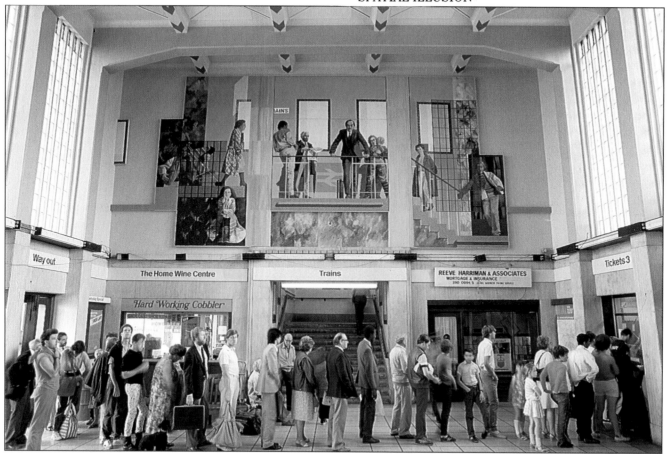

Surbiton railway station, London, boasts an impressive mural executed in acrylics, which creates an illusion of space and a focus of interest where previously only a plain wall existed. Reflecting its surroundings, the stone pillasters in the main lobby are continued up into the mural, and the stairway reappears in the painting as it might logically in reality.

Below If you had boldly knocked out this wall a century ago, you would have been rewarded with this view down the River Thames. Sadly, progress stands in the way of it today, so it has been recorded instead in this clever illusion of reality. Painted with acrylics on marine plywood panels, the artist started work in the studio and then completed the panels *in situ*.

This detail from the mural scheme in the Royal Academy Restaurant, London, represents the view into the courtyard of Burlington House as can be seen in reality upstairs. Such a window 'opening' aimed to overcome any feelings of claustrophobia in what was deemed to be a dark and dingy basement room. The walls were in bad condition and could only bear the weight of light panels. Canvas was therefore marouflaged to laminated wood, using acrylic paint as an adhesive. Acrylic paints were also used to complete the murals.

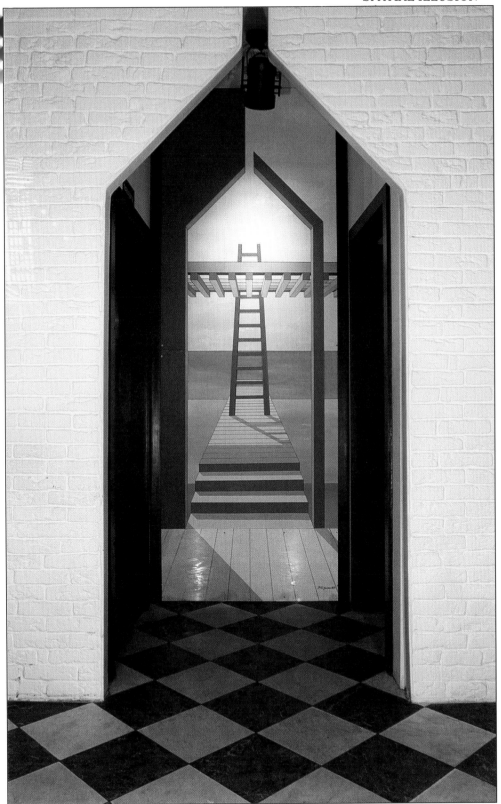

Above Sipping cocktails on board an ocean-going liner is a long haul from a London restaurant. Here, however, the artist has managed to effect the atmosphere of such a feat of escapism with a very simple scheme. The dark blue sky of the ceiling is carried over to the walls, thus strengthening the impression of a dusky Tropical evening and minimizing the architecture.

Careful lighting ensures that this deceptive mural is seen at its best. Even though the artist makes no attempt to ape the real world, clever perspective ensures that the viewer nevertheless believes implicitly in the existence of space beyond the painted surface.

103

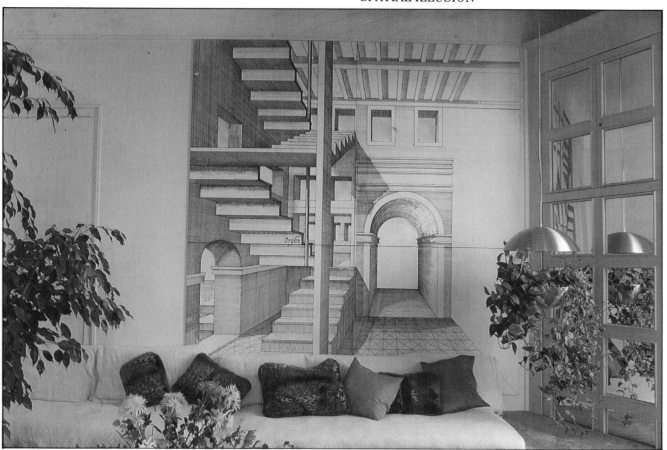

Left At first glance, this mural seems reminiscent of a Renaissance perspective drawing. On closer examination, however, the curious twists of the architecture, particularly the staircase, seem more like the careful manipulations of a work by the surrealist painter Escher. Painted on a panel that has then been fixed to the wall, it is undoubtedly the artist's skilful use of perspective that effectively gives the illusion of receding space and appears to enlarge the room. The pale colouring gives the mural a cool, reflective quality in keeping with the decorative simplicity of the rest of the room. A simplified version of this mural, omitting some of the more technically exacting features such as the patterned flooring, would also be effective, since it is the initial impression of classical calm that first strikes the viewer.

Right This mural, designed for a garden room, again draws on a classical theme, but here the mood is quite different. The glory of the past is in ruins, and the garden creeps in and over what remains. Note how much simpler the perspective design is compared to the above mural; the crumbling stonework in the foreground effectively pushes back the garden scene beyond, and also frames it. This simple device is used again on the recessed wall to the right; a clever way of overcoming the problem of unifying a wall that is broken by a chimney breast. The near right-hand wall contains the simplest elements of the mural; the stonework is 'broken' by the remains of a fresco, while the luxuriant ivy provides a focal point.

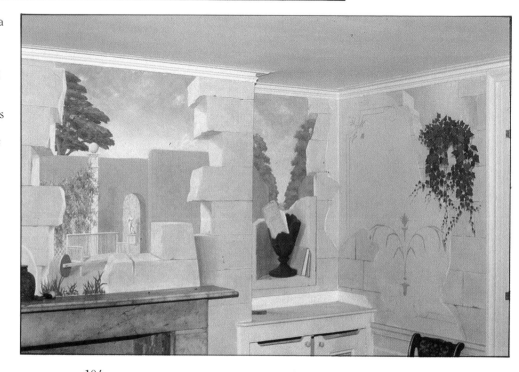

Left A charming interior is seen beyond glass-fronted doors in this dining room. Take another look, for this is an excellent example of just how effective a skilful trompe l'oeil can be. For a moment, it really does 'deceive the eye'. A frame like this is a useful device for the beginner, and it need not be anything as complex as shown here; a simple window or arch would serve equally as well.

Above Although murals are usually associated with painting on walls, there is no reason why they should not be painted on other surfaces too. Here, a door invites you to step into a calm, contemplative scene. The elements of this mural are simple: the eye is drawn to the columned arch by the strong receding lines of the pool, and then to the sky beyond.

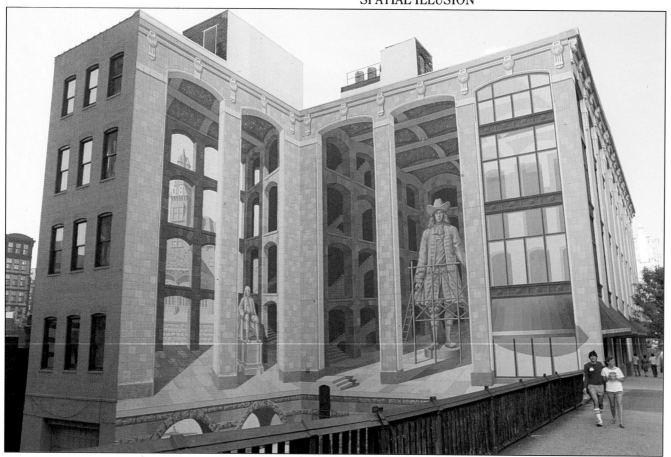

Mural design in the monumental mould has given this Philadelphian building a remarkable inner complexity. The real street façade on the right sets the scene for the right flank of painted windows, the awning and the cornice. After that, the artist's breadth of vision takes over, cleverly manipulating space to produce an intricate yet credible construction. Executed in Keim silicate paints, this mural in the grand style should survive for many generations.

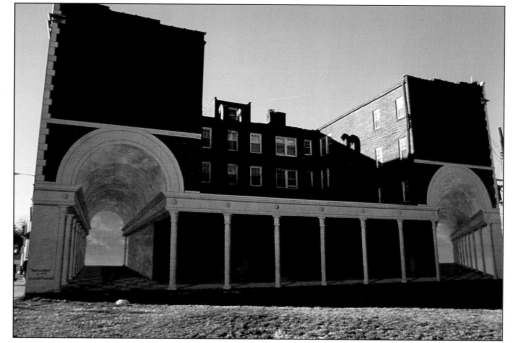

Sometimes the impossible can be achieved with a coat of paint. Here, two barrel vaults tunnel their way through this solid building, no doubt causing anguish to any passing architect who casts them a glance. However, the light at the end of the tunnel serves to remind us that this is, after all, but an illusion.

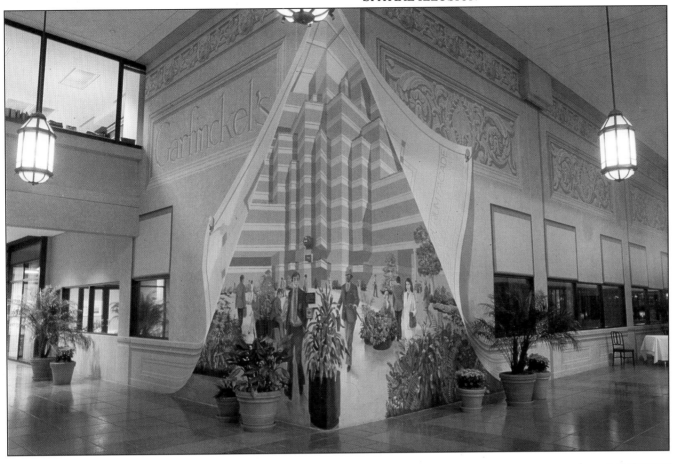

Whilst construction of this building in Metropolitan Square, Washington D.C., was in progress, this painted fence hid the unsightly process from the public gaze. Executed in acrylic on wooden panels, the façades are peeled back to reveal a vision of what will eventually be reality. Urns of flowers mark the boundary between truth and artifice, and perhaps also serve to prevent the short-sighted from attempting to step into this visual deception.

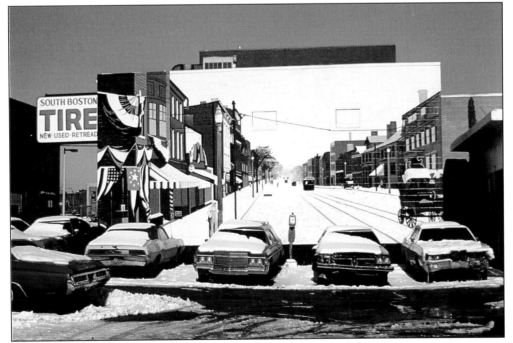

To complement the illusion, all that is needed is a fresh fall of snow for this Boston, Massachusetts, street mural depicting the West Broadway Trolley. In the summer months, however, this plausible winter scene may offer a public service by cooling down rising temperatures.

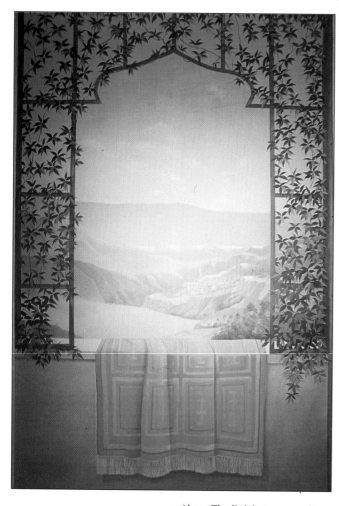

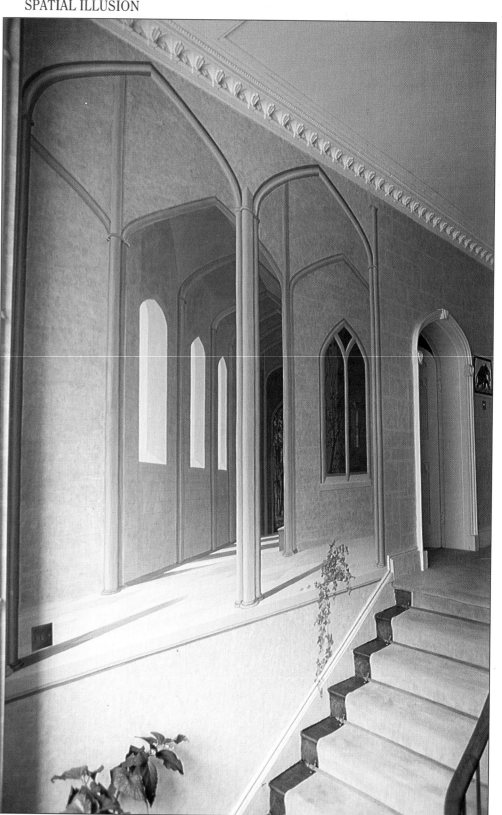

Above The link between reality and the painted desert landscape in this mural is provided by the arched trellis intertwined with a climbing plant. Also aiding the illusion is the rug, which relates to one in the room itself. Acrylic on canvas.

A pattern or shape found in the existing architecture which is then repeated in the mural helps the eye and mind make the leap from reality into the illusion. Here, the door arch is taken as the starting point for an intricate architectural composition. Acrylic on plaster.

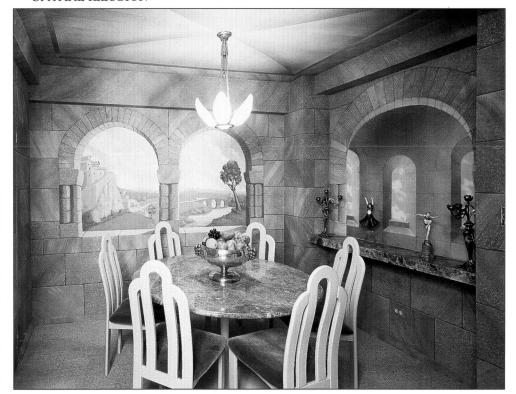

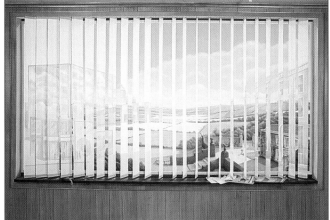

Above An enclosed lobby was given a focus of attention, light and a view when this mural was installed. In addition, it is promotional, reflecting the work of the London firm of estate agents who commissioned the mural: facets of city residential and office properties glimpsed on the slats of the blind and country housing seen in the distance. The stretched canvas painted in acrylics was set into the wall to aid the illusion.

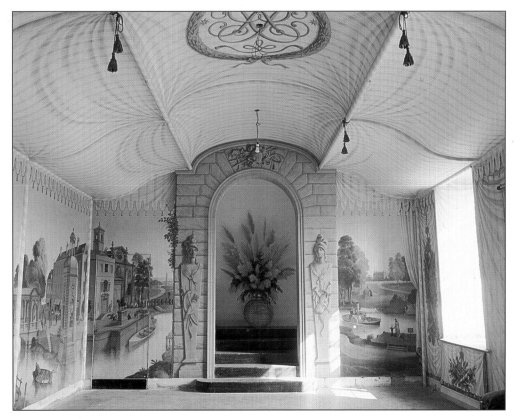

Above An enclosed city dining room becomes, with a lining of seamless canvas marouflaged to the wall, a cloistered tower room with a bird's-eye view over a medieval hill town and landscape. The shafts of painted sunlight on the stone sills bring necessary light and warmth into this stone room where even the grey marble table and shelf fit into the scheme.

In this delightful room painted by Rex Whistler in 1933, a striped baldachin is pulled back to reveal a busy river scene. The heavy rusticated stonework of the trompe l'oeil arch contrasts with the weightless rippling of the painted canopy. In addition, details, such as the real tassels hanging from the ceiling, conspire to deceive the viewer. The mural is lit as if from the real windows on the right, as can be seen on the stonework and reliefs of the archway.

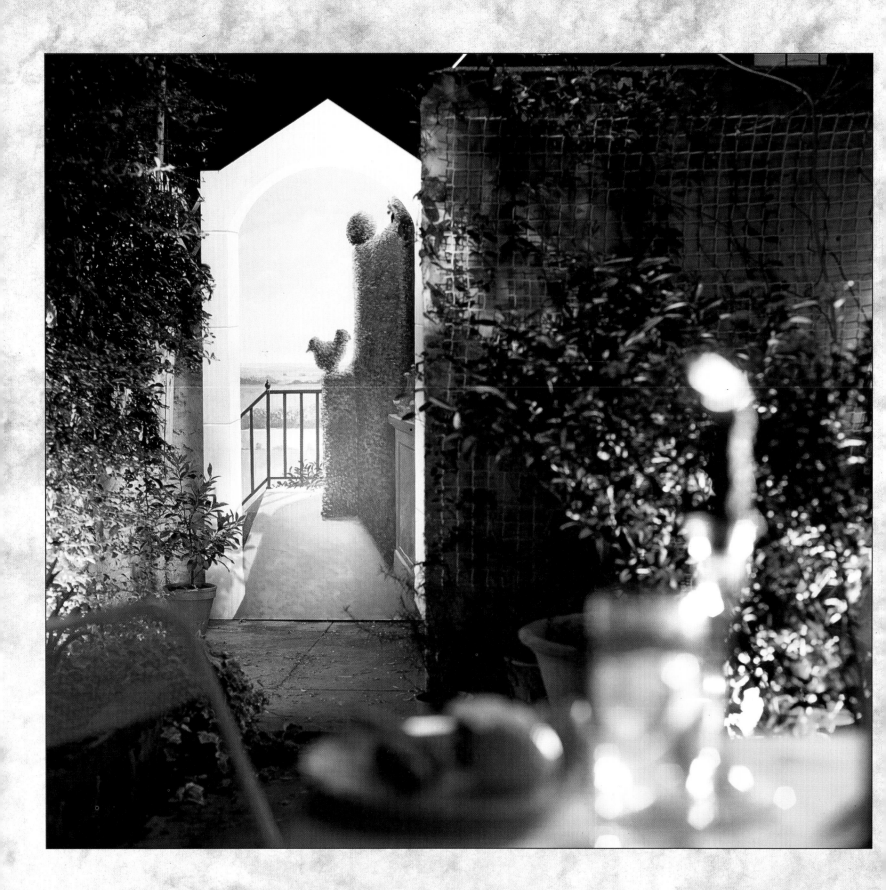

5
EXTERIORS & GARDENS

A garden mural is a wonderful opportunity to indulge in capricious ideas. A small, enclosed back yard, with a little imagination and some simple painting, can be transformed into the terrace of a country house, from which rolling acres can be glimpsed through an archway. With such a focal point, the ugly backs of the neighbouring row of houses somehow sink into the background.

Such a mural can overcome the abruptness of many city gardens, in which the soul feels incarcerated. It can positively extend the cramped space that city living forces on us. Dark and dingy basements, which look out on small wells of enclosed space, can be given a new outlook on life. With clever lighting, a mural in such a situation can change the whole mood of the interior space, both at night and during the day.

A mural in the garden, apart from visually extending the space, can also help the lazy gardener. It can give you an immaculate manicured 'lawn' and stock your 'border' with armfuls of flowers all the year round. Moreover, why be restricted to plants suitable for the climate. Here is an opportunity to 'plant' orchids from the tropical rain forests or rare succulents.

Murals painted outside must be able to cope with the assault of the weather and pollution, both of which stack the odds against them. Most garden walls are free-standing and therefore open to the weather on all sides, making it easy for the rain to permeate between the paint film and the wall. The silicate-based dry fresco paints produced by Keim are almost impregnable, but they are expensive and they require the wall to be rendered. Even then, there is no guarantee that the render will adhere for ever on a free-standing wall.

One way round the problem is to paint on a wooden panel, or panels, instead of painting directly on the wall. Working in this way, you will avoid the risk of efflorescence or alkaline deposits (see page 22). Marine plywood is remakably resilient and not too expensive, and has been developed for outside use. This panel can be fixed to the wall (see page 158) ready to be painted, or completed in the warmth and comfort of an interior site before being transferred outside.

The urban murals featured on the pages following the step-by-step project are really the big brothers of these garden murals. But in many ways they serve the same purpose, that of distracting the eye from the constraints of the city – be it lack of space or vegetation, or an abundance of squalor.

Exterior murals, because they are so often seen from a distance, call for more simplification than interior ones. This applies not only to the style of painting, but also to the composition itself. In this project, painted for a small, paved, city back yard, the simple eye-catching design is intended to be seen at night, mainly by floodlight. The outlines are therefore bold, and detail is kept to a minimum.

The mural not only visually extends the garden, but it has the added advantage of apparently raising the height of the wall, thereby blocking out more of the overbearing terrace of houses beyond it. The contrast between the actual view and the one depicted in the mural cannot be ignored, and is indeed part of the tongue-in-cheek 'joke' of the subject matter. At night, however, the background houses are conveniently inked out by nature so that full indulgence in the fantasy can be experienced.

It was decided to use pure artists' acrylic paint for this project. These paints have been developed for exterior artistic use and they are suitable for painting on wood. The area covered was not extensive, so regular-sized tubes of paint were sufficient. The panel, when in position, is very open to the elements from all sides. Two coats of acrylic primer were applied, making sure that the sawn edges, and both the back and the front of the panel were evenly covered. The first coat was diluted with 25 per cent water so that it was well absorbed by the wood. Once this was dry, the second coat was applied full strength. Alternatively, acrylic medium could have been used to protect the back of the panel.

The panel was painted to the mid-way stage *in situ* in the garden, thus enabling the artist to assimilate the feeling of the site into the composition. The next stage was then completed in the comfort of an inside room, where the variable weather could not interfere. Finally, the panel was moved back into position for the finishing touches.

THE SITE

1. The garden, seen here in its 'before' state, is viewed through French windows from a dining room. Imagine you are the artist and this is your first glimpse of the proposed site for a mural. First, it can be noted that in fact this standpoint is the principle viewpoint. Now, look at the shape of the garden. The small brick shed in the corner of the yard forms a narrow extension on the left. This extension has a back wall which is begging for a mural. The eye is naturally channelled into this

MATERIALS
- Marine plywood, 6 feet × 4 feet (180 cm × 120 cm)
- Acrylic primer
- Tubes of acrylic: sky blue, white, Hooker's green, light green, raw umber and ivory black
- Small decorators' brush
- Artists' brushes: medium round, medium filbert, small flat
- Palette
- Rule (length of wood 2 inches × 1 inch × 48 inches/5 cm × 2.5 cm × 120 cm)
- String
- Pencil
- Sheet of polythene used as ground sheet

corridor but, meeting with a blank wall, quickly passes on to look at something else. The wall is low at this point, so painting directly on it is not an option. The height, despite the addition of the trellis, also allows the houses in the background to encroach visually. So the mural has to be made higher with a panel, and must provide a visually distracting view. All these points should be taken into account when planning your composition, so that it will eventually reflect the natural aspects of the site and become part of it.

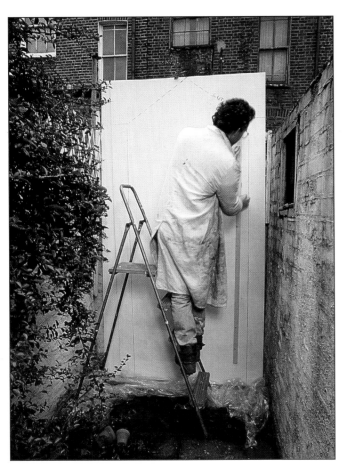

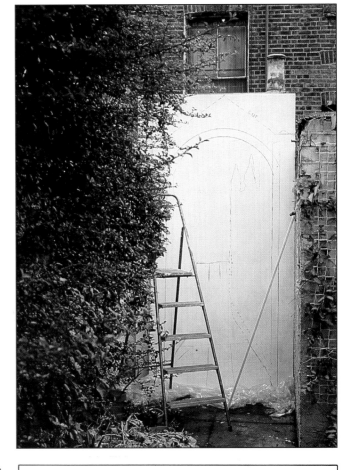

UNDERDRAWING

2. The panel has been moved into place, and now the basic outline of the planned composition is roughly drawn up with a pencil. A length of wood is used as a straight edge. The paving stones are protected from dripping paint by a sheet of polythene, available from DIY shops. Precious flowers can be covered in the same way if necessary. One of the problems of increasing the height of the site was the discrepency between the height of the brick shed on the right, and the height necessary for the archway to have reasonable proportions. Any smaller, and the archway would seem low when viewed from the garden. The discrepency has been solved in the painted outline of the archway, which gives the archway maximum height and yet links up with the shed. This shape is later sawn off.

3. Here, the composition has been sketched in. The curved top of the archway has been drawn with a pencil tied to a piece of string. For this, you will find it helpful to etch a groove with a craft knife or blade near the lead end of the pencil so that the string stays in place. Draw

Circles and arcs can be drawn on the wall with a pencil attached to a length of string. To keep the string in place, cut a groove round the pencil close to the lead end before tying it on. Place your thumb on the string at the centre, pull the string tight with the pencil and inscribe the arc. For a rough surface, use charcoal or even a paintbrush.

a line down the centre of the panel; the centre of the arc will lie on this line. Next, draw a horizontal line at right angles to the vertical so that the spot where the two lines intersect is equidistant to the top of the arch and to the two sides. Now, place your thumb on the string at the intersecting point so that the pencil reaches the proposed top of the arch. Keeping your thumb firmly on

the string at the centre, draw round the arc. Move up 3 inches (7.5 cm) and draw the second, inside, edge of the archway. If you do not want to use this method, do not be deterred. The same result can be reached by trial and error, relying on your eye for accuracy. However, with this simple device, any sized arc or circle can be drawn on any surface. With larger curves you may need two people – one to hold the string and the other to draw.

UNDERPAINTING

4. The next stage is to block in the colours of the main elements to get an idea of the balance of the composition. The colours will be kept on the bright side, with high tonal contrast because the mural will be seen mainly at night by floodlight. The sky, a mixture of sky blue and white, has been roughly filled in down as far as the intended horizon. Now, the base colour of the yew hedge on the right is applied with a small decorator's brush. Before the paint has time to dry, it is worked

around on the surface of the panel. The artist produces an interesting texture by applying pressure to the brush and then releasing it. Edges are left irregular and blurred. This green base colour consists of Hooker's green and a little ivory black diluted with water. Hooker's green is a very useful ready-mixed landscape green, but it is known to be fugitive, its colour changing slightly over a period of time. For a mural that is expected to last indefinitely, an artist would therefore mix a natural green from permanent blues and yellows. Phthalocyanine green is the permanent alternative, but it is a far more strident, and has a very intense colour that needs using with care.

5. Now, attention is turned to the background view and the iron railings. Initially, the railings were sketched in merely to give an impression of how the composition was developing. At this stage, the railings are carefully measured up and pencilled in, ensuring that they are true verticals and horizontals. If necessary, check these with a spirit level.

6. At the halfway stage, the mural is coming along well. The dark green geometric shape of the hedge effectively directs the eye into the picture space. Already the viewer is duped into believing that there really are rolling acres beyond this garden wall. To break up the

above, the upper facet of the groove will be in the shadow (dark grey); the lower one will be highlighted (white). The paint is applied with a medium round brush. You will notice that the work so far has been executed quickly and without much attention to finish. A mural such as this is meant to give an impression of extended space and to generally set the scene, but it is not meant to dominate the scene. So a sketchy, impressionistic style is considered suitable.

8. Before painting in the ironwork, the background landscape was very loosely painted, first with a small decorator's brush, and then with a smaller artists' flat brush. An impression of far-off hills can be seen in the

purely linear composition, and to relieve the harsh monotony of the hedge, some softer topiary shapes have been added. The pale grey colour for the stonework (a mixture of white with the smallest amounts of ivory black and raw umber) was chosen to link up with the painted areas in the garden. For the irridescent shadow down the inside of the arch, the sky colour was added to the grey. Before retreating to continue painting in the comfort of a room inside, the background landscape and the stone terrace were sketched in.

SMALLER DETAILS

7. Now to work up some of the smaller details, starting with the archway stonework. The sides of the arch were measured up and divided into sections, and three parallel lines drawn to represent the groove where two sections of stone meet. These lines are horizontal in the forward plane and run towards the vanishing point on the inside of the arch. As the light is coming from

Acrylic paint, which is fast drying, can be kept fresh on your palette or dish with a quick spray of clean water from an atomizer as used for spraying plants.

distance. The pale green landscape towards the fore-ground is interrupted by banks of trees and shrubs, loosely worked in three shades of green. By comparing this background landscape with that in Project 4 (see page 100) – which is essentially the same view – the full difference between the two styles can be appreciated.

One is very loose, the other tight. The treatment of the ironwork also underlines the contrasting approaches of these two projects. Here, you will find no attempt has been made to model the railings, except for the decorative pointed bauble. It is this that attracts the eye, which digests the information and then applies it to the rest of the railings. It is therefore surprising to realize that these railings are so flat and simple. Further work has been carried out on the yew hedge. Successive layers of increasingly lighter green paint have been lightly dabbed on, with particular attention being paid to the topiary bird.

9. Now, it is time to stand back once again and appraise the progress of your work. This is not always as easy as it sounds. Painting is often a tension-building process with high demands on one's concentration. Constant study of the work from close quarters makes it difficult to assess progress objectively, even when you stand

back from it. However, the necessary objectivity can be obtained by using a mirror to view your work. Seeing the reflected image of a painting gives the artist the opportunity to view the work impartially, and to see it as others do. Here, the artist is using a small hand mirror, which is kept in the pocket of his overalls and used constantly to check progress.

10. Having used the mirror to check the overall tonal values in the mural, it is decided that the hedge, where the deepest shadows are very dark, should be given a balancing highlight. This is applied with a small, short, flat brush, the paint being lightly dabbed round the edge of the bird. It can be seen here that the successive layers of paint have given the hedge a texture and depth of colour which is very convincing. No attempt is made to mix the various colours. They remain as blobs of colour when viewed from close quarters. With the benefit of some distance, however, the eye merges these

direct the eye towards the descending stairway, which can be glimpsed on the left. These steps are important as they are effectively the way into the illusionary landscape. The mind is very practical and likes to follow a designated route into a painted scene. If it hesitates, it will become confused and lose its way. Note how the shadows cast by the railings are sharp-edged compared with the more blurred outline of the hedge shadows. This blurred effect is made by rubbing the finger along the edge before the paint dries.

12. Again, to soften the harsh linear composition in this

colours to produce an overall colour. The greater the distance between the mural and the viewer, the larger these dabs of paint can afford to be.

11. Some visual interest is given to the stone terrace by the addition of shadows cast by the railings. These shadows have a compositional function because they

mural, a climbing plant is painted creeping up over the edge of the terrace. The leaves are painted, using the natural shape of a medium filbert brush. Vary the colour, direction, size and shape of such leaves, to immitate the random patterns of nature. Nevertheless, even though there is no doubt that this is a climbing plant, the leaves are very generalized, representing no plant in particular.

FINISHED MURAL

The mural is finished and fixed into place and, lo and behold, it achieves the intended effect. It provides a focus for the garden without being overpowering. Seen here at night, the landscape looks real at first, and the limits of the garden are extended. Furthermore, having accepted this information, the viewer will be reluctant to reassess the situation, so the illusion will linger even after the ruse has been rumbled.

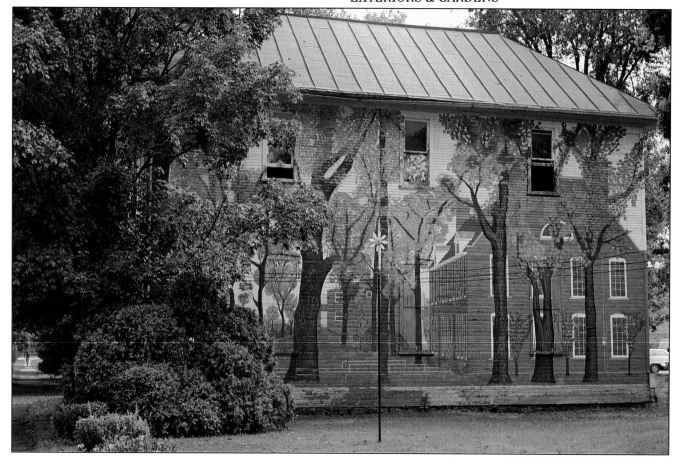

What can be done with a faceless building of no architectural merit that is blotting the landscape? The answer is, of course, to paint the façade from top to bottom with a simple yet impressive mural and thereby merge it into its rural surroundings. Executed directly on brick, which is rough and ungiving, the large-scale design had to be kept simple with delicate details kept to a minimum.

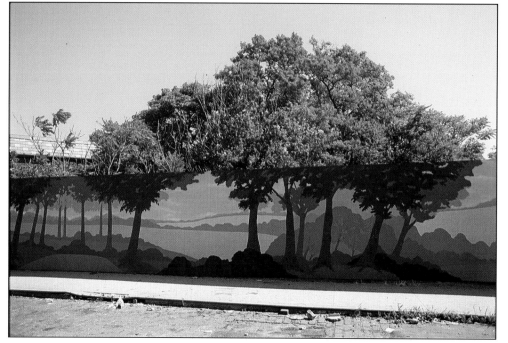

Such hoardings have become the accepted province of mural artists. But this example, which runs round a city park, is a perfect example of matching up reality with painted fantasy. Such an idea could equally well grace the end wall or fence of a small garden. The size of the mural has forced the artist to simplify the composition into overlapping areas of flat colour, but this gives an adequate sense of recession.

Above An unsightly shed could be seen as the final straw in an already confined back yard. Here, an amusing solution has been reached by superimposing on the façade a facing of marine plywood painted with acrylics to represent the pride of the stable yard.

Why stare out of your basement at a blank wall when you can let your spirit soar out into such an illusion of grandeur at this. Viewed through the mullions of a real window, this mural is painted on an exterior wall opposite. Strong, even lighting makes it appear as though sunlight emanates from the painting.

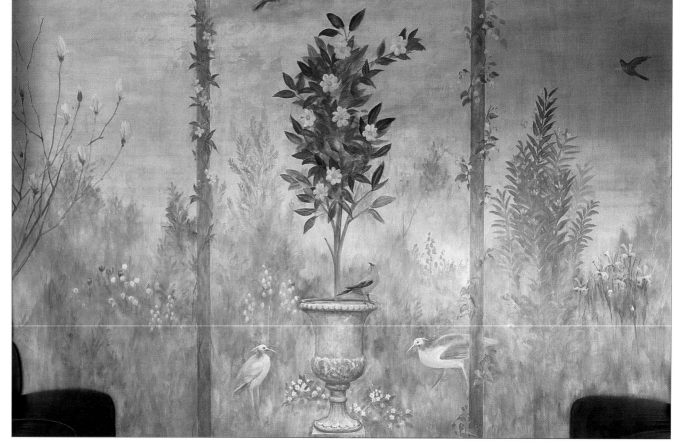

Inspired by a Roman wall painting, of about 25 AD, from Livia's Room in the villa of her husband, Emperor Augustus, (see page 10), the design for this garden scene has been adapted for the room it decorates. Garlanded pillars divide up the space, giving it greater structure than the more ethereal original. Note in this pastiche the chosen area of closely observed flora – magnolias, camelias, irises – which have a more contemporary following than those flowers depicted in the original.

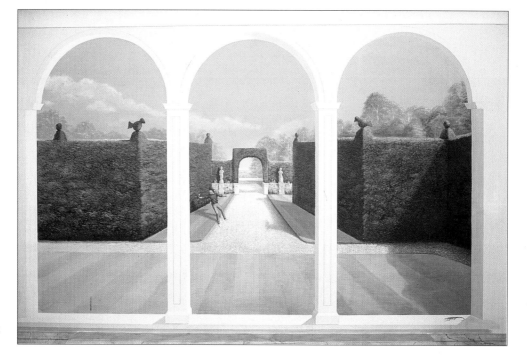

The scent of new-mown grass emanating from this vision of a formal garden helps to relieve the oppression of a city apartment. The simple arches frame a view that at first glance appears peaceful. The all-important double-take occurs when the observer spots the leaping figure in the central arch, the peace is shattered and immediately the attention is grasped. Painted in acrylic on plaster prepared with vinyl matt emulsion.

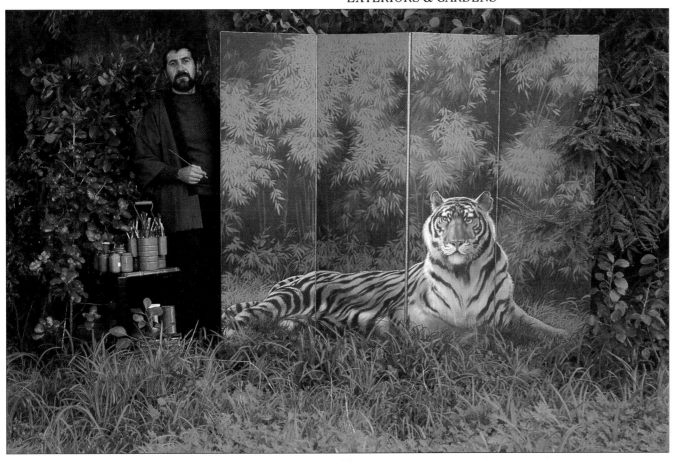

Who needs flowers in the garden when you can have a tame tiger instead? This magnificent feline, painted in acrylics on a canvas folding screen, merges into the background of a lush garden. In fact, the materials used will confine him to the house, but a similar construction made of cradled marine plywood could withstand the forces of the elements and help turn a cultivated garden into a wild game park.

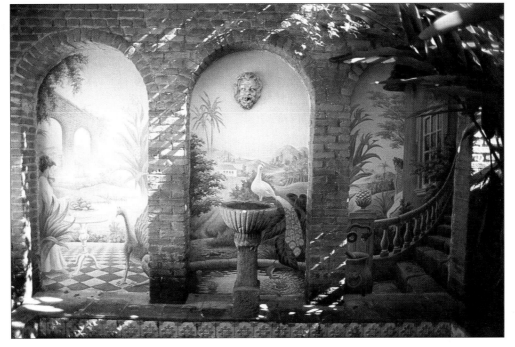

A trompe l'oeil mural can be said to be a success when it takes a while to sort out what is real from the painted illusion. In this tiny back yard, illusionistically extended by some clever painting, the artist has incorporated stone arches, a font and a stone mask into his Eastern fantasy. Each archway contains a different scene visually linked by the common background. After preparatory work, acrylic paints were used to complete the mural.

A design for the Waterfall Room in the Paradise Garden. Harewood House, Yorkshire, executed in pencil, ink and watercolour, successfully projects the artist's intentions for an interior landscape. Such a plan includes more than ideas for the wall decoration (eventually completed in indelible gouache). By bringing in the artist at the design stage of a project or, even better, when the architect is working on initial plans, the creative elements can work together towards a single, invariably more cohesive end.

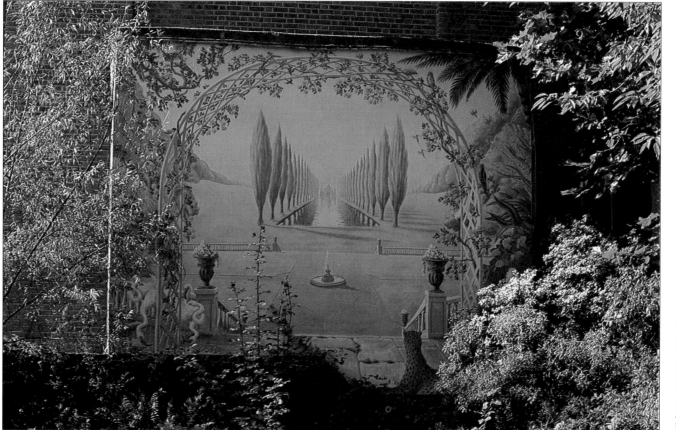

The severe limitations of a London garden are overcome here with this view of the Taj Mahal. A stretch of water punctuated by trees is seen through a pergola, directing the eye without hesitation into the far distance and encouraging the imagination to escape the real boundaries. Painted in acrylic on wood, this mural will be enjoyed for years to come.

This bold design structured in a series of arches was painted in with emulsion paint; tonal gradation was added to certain features, such as the keystone reliefs, by cutting templates and spraying lightly with grey atomized car-paint.

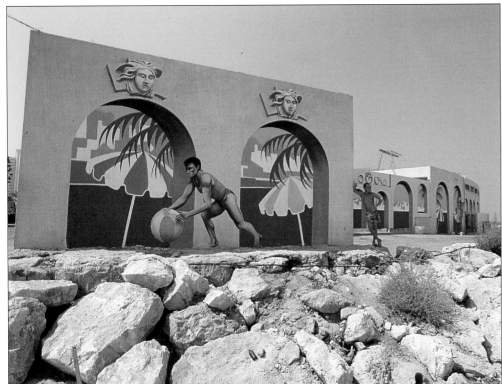

Left This dreamy terrace in its mountain location is in effect a small enclosed interior room viewed through a dividing screen of French windows. The illusion is sustained by painting the room in its entirety – even covering the doors – and by clever lighting. Such a painting must be simplified for the sake of time, but small areas of high focus work can be incorporated.

An enclosed garden is treated to a dreamlike landscape. The pots of evergreens either side of the painted archway and the carefully cut trellis around it both serve to strengthen the illusion of an opening to another place.

6
SMALL-SCALE MURALS

A number of smaller murals are looked at here – more approachable for some people, or just easier to fit into an under-utilized space for others. These might be suggested by an architectural or decorative feature such as the two fireplaces shown in the ideas section. Alternatively, like the chimney boards or capricci, they are the modern equivalents of a more traditional form of art. What you will see in the following pages is a less than homogeneous group of murals gathered together for one reason only, namely that they are small, ranging from trompe l'oeil friezes to simple classical window pediments painted on plywood.

It is the impressive scale of much mural painting that so often frightens off keen artists who might otherwise try their hand at it. Yet, as can be seen in the following pages, size is not necessarily intrinsic to the art. Even though these murals are smaller, nevertheless they can still be defined as murals in that they are incorporated into the architecture of the room. This is as true of painted shutters as of chimney boards. The main categories of mural described in previous projects also apply here. Small murals can be flat, decorative, trompe l'oeil, surreal, and so on, as can be seen from the pages of ideas following the two step-by-step projects.

One project demonstrates a traditionally rich vein of interest in mural painting – a collection of still-life 'objects of interest'. Such a mural can be tailored to your abilities and space – a simple corbel with a single object perched on it, or a more complicated arrangement to show off your talents. In the project shown here, the objects are placed on book shelves, but they can just as easily be presented on the shelves of a kitchen dresser or in a stone niche.

Items such as these can sometimes build up a 'portrait' of a particular person, and can often be more telling by association than by a direct visual likeness. The collection can include favourite books, much loved objects, or paintings which are coveted yet beyond one's reach; it is a chance, at last, to 'possess' on your shelves the exquisite Greek vase you saw in the British Museum. Or the shelves can be laden with articles inspired by the function of the room – breakfast china on dresser shelves, for instance.

This exhibition of still-life could provide a typical background for the more traditional style of portrait. But in this case, the true subject of the portrait is not included, although he often appears in real life against this trompe l'oeil background.

The Urn

The first of the two smaller projects demonstrated here is a neat idea to overcome the problem of a window interrupting a mural view. Here, in a dining room, the artist depicts a fantasy which combines a tropical West Indian scene with a background view of London's parks. Painting on a blind was considered, but it was felt that the contrast with the surface of the walls would spoil the continuity of the illusion. Rebuilding the shutters, which sadly had been removed, was an option that was overridden due to expense. Then, finally, the idea of inserting a painted, stretched canvas into the window frame when the room was used at night was arrived at as the most practical answer to the problem.

The canvas was measured according to instructions on page 24, and stretched and primed by a professional. Oil paints were used because they were considered suitable for the canvas and strong enough to put up with the wear and tear of the practical usage of the mural. Oil paints, however, take much longer to dry than acrylics, and this influenced the artist's decision to start painting the mural in his studio, only transferring it to its destined window frame for the last third of the painting.

Even though the artist is using oil paints, he does not take advantage of their painterly possibilities – he still aims for a flat, matt surface, tending to use more additional turpentine than oil. Again, the paint is applied very thinly and, for the sky, the primed canvas is more stained than painted. Instead of applying superimposed flat glazes or washes of colour to model form, here the artist tends to work colours together on the canvas as the paints will not dry for a few hours. In some parts, a glazing technique is used as well.

DRAWING OF URN

The urn itself was based on the combination of an eighteenth-century drawing and a photograph of a lordly pot in a London garden. The artist used these very much as a guide and inspiration. The eye level is low because the main viewing position is assumed to be from a seated position at the dining table. First, the canvas was measured up to find the central vertical line, which was then pencilled in. Next, the canvas was divided horizontally in half, and then into quarters. The problem with reconstructing such a shape on so large a scale is that it is easy to end up with a lop-sided urn, so

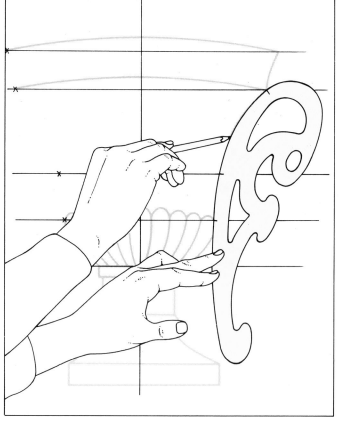

Right The artist carefully constructs one side of the urn and then copies it for the other, plotting the shape with measurements from the vertical axis along horizontal divisions. A suitable curve was found on a set of French curves for the body of the urn and marked off on the plastic for reproducing on the other side. *Above* Another curve was found for the belly of the urn to reproduce the flutes.

great attention must be paid to precision when taking measurements.

1. Repeating curves can be tricky, so the artist has carefully divided up the canvas, as described above. French curves were used to help reproduce the curved sides of the urn. Another part of the French curve

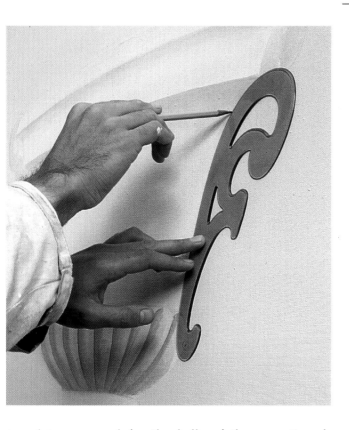

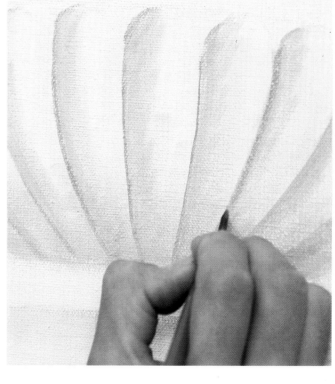

template was used for the belly of the urn. French curves are usually made of clear plastic and can be bought in sets of various sizes. They are very useful for reproducing curves when copying drawings and photographs as there are so many degrees of curve that the appropriate one can nearly always be found. An alternative method for drawing up the urn would be to draw one side and then trace it. The traced outline is then cut to make a template which is used to produce the other side. The squaring-up method described in Project 1 (see page 54–5) would have been equally suitable.

For the sky, the artist used a small amount of cobalt blue paint mixed in a earthenware bowl with turpentine to a liquid consistency. A clean piece of soft cotton rag was dipped into this and rubbed gently on the canvas in a circular motion. This produced an even covering of very thin paint which stained the priming layer. Towards the horizon the colour is reduced. This staining technique creates a flat area of colour which has great luminosity and depth despite the thinness of the paint layer.

2. To depict the modelled form of the stone urn, the paint was first applied, then mixed and worked directly on the canvas, a mixture of burnt sienna, raw umber,

yellow ochre and white (this mixture was also used in varying tones for the base outline and shadow). The slow drying time of the oil paints makes this possible. Here, a small sable brush is used to delineate the shell flutes using diluted raw umber.

BASE

3. Masking tape is used to achieve the clean edge of the stone base, first for the outline, and then for the shadow of the panel in relief. Masking tape does not necessarily have to produce a hard edge. As shown here, if a thin layer of paint is applied the line will be clean but not too hard. This invaluable tape can be used on canvas as long as the weave is tight and the texture smooth. If you are using a loosely woven canvas, even with priming, the tape will not adhere efficiently, and the paint will seep underneath. Masking tape can be bought in various widths to suit your needs, but here the standard width is chosen to lessen the risk of accidently brushing colour right across the tape and marking the other side. As emphasized in Project 1, it is important not to put tape over a newly painted area until you are sure that this is completely dry. Problems can also occur if the paint layer is thick – the paint can easily be pulled off with the masking tape. Apply the tape carefully and do

not press down too hard. However, if the tape is too loosely applied, the paint may seep underneath, and spoil the edge. Next, the shadow line on the base of the urn was painted in with a small round brush. Take care not to overwork the paint on the tape as the bristles of your brush may find their way underneath. Very dilute paint also tends to seep under the tape. An application of thick paint, on the other hand, will leave a hard edge proud of the canvas, which is not always the effect required – particularly in mural painting.

4. Now, very gently and slowly, pull away the masking tape, to reveal what should be a neat edge to the base panel. To stop the tape pulling away suddenly with distastrous results, it is wise to place the other hand

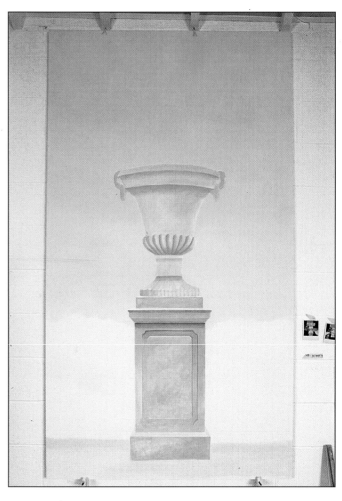

gently on the tape below the pulling hand. Problems can occur if the paint is left to dry before removing the tape, particularly if the paint layer is thick. If the worst occurs and small patches of paint do come away, then you will have to touch up the patch, painstakingly rebuilding the various layers of paint with a very small artists' brush.

5. Now, the stone base of the urn is ready for further treatment. To simulate the ageing process, follow the guidelines given on painting stonework in Project 7. The various stages, including spattering and adding pits and cracks, were laid in layers.

The urn can now be seen before the finishing touches were added, and the mural was finally transferred into position. The polaroid photographs, used as a reference, are taped to the wall next to the panel. At this stage, the urn is ready to be filled with anything of your choice. Alternatively, it can be left as it is – a simple, decorative image that is, nevertheless, still effective.

FRUIT

Before the canvas is mounted in its window frame, the urn is generously filled with a cornucopia of West Indian fruit. This tropical feast was actually harvested from the markets of West London to provide stimulus for the image. The mouthwatering collection of exotic fruit was arranged in a basket by the artist, who used them more as a general reference for colour, shape and texture than for their precise arrangement.

6. First, the artist blocks in these approximate shapes and colours to try to arrive at a satisfactory arrangement for the urn in particular, and for the composition in general. The base paint is applied thinly and roughly, with constant reference to the real life arrangement. The initial form is then described; the paint is first applied with a stippling motion, before being further worked on the canvas. This is left to dry overnight.

The colours used for the fruit are: bananas – chrome yellow and white, with burnt umber for the darker tone;

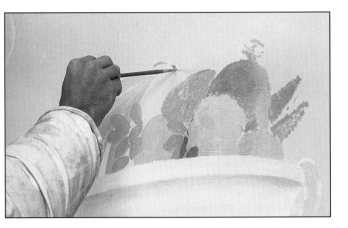

mango – chrome yellow, madder brown and cadmium red; figs – alizarin crimson, French ultramarine and burnt umber, with a mixture of raw umber and white for the highlights; the green fruit are a mixture of monestial green, Payne's grey and white.

7. The next stage is further modelling of the fruit by building up the tone. This is done by working the light and shade over the base colours. A glazing technique is used in places, allowing the base colours to show through this thin, transparent film of paint. This application of paint in thin layers gives a three-dimensional effect. For this technique, the paint is thinned with turpentine. More conventionally, it is thinned with glazing medium that gives the glaze a more glowing resonance. Glazes made by adding linseed oil alone cannot be trusted to stay put.

8. By now the individual characteristics and textures of these very different fruit – some shiny and smooth, others rough and prickly – become more distinct. Yet again, care must be taken not to overwork the fruit, particularly as this mural is being painted in the studio, where there is a tendency to focus the attention on the painting in hand rather than seeing it in the wider context of the room. Once the canvas has been transferred to its position in the window frame, it will be easier to assess it in relation to the rest of the room. Lighting is crucial, and different levels can considerably influence tonal variations in a painting – it is easy to work up tone, but more difficult to knock it back.

FINISHED MURAL

It is only when the canvas is transported to its destination and fitted into place in the window frame that the finishing touches are added in the context of the surrounding murals. The image is visually incorporated into the room by the continuation of the tropical vegetation and the background distant landscape. In the finished painting, an effective solution has been found to the problem of night-time viewing in this tropical fantasy. But such a project would be equally stunning if isolated in a conventionally decorated room.

Book Shelves

The trompe l'oeil book shelves painted in this project were tailored to fit into a rather difficult area which is both a lobby and a bar area. The function of the mural was to give a focal point to this space, thereby making it work as a useful part of the house, rather than what it had come to be regarded – as an apology of an area which was neither one thing nor the other.

The object on the shelves were chosen to reflect the idiosyncracies of a particular person – a love of literature, large Chinese jars, and a quirky sense of humour which enjoyed the destruction of the much-coveted objected, finally 'possessed'.

The shattering jar and the flying book – the cause of the devastation – provide more than a character sketch. By capturing the moment of impact, the artist has instilled tremendous drama and a sense of movement into this composition which, as a category of murals, more commonly reflects its usual description of 'still-life'. 'Still' it may be, but such as adjective could not be used to describe the viewer's imagination, which unconsciously – and perhaps involuntarily – completes the shattering process set in action by the image.

The design of this mural developed as work progressed and, once the initial structure had been established

Below The perspective construction of the shelves and books for this mural needed some preplanning, as shown here, and the principle viewpoint was taken as being central and close to.

Below, right The books recede towards the vanishing point, yet when seen obliquely from the right they just appear to be leaning sideways, waiting to be tidied up.

MATERIALS
- Deep red vinyl matt emulsion
- Tubes of acrylic: raw umber, red iron oxide, white, raw sienna, yellow ochre, Hooker's green, black, naphthol crimson, burnt sienna and French ultramarine
- Artists' brushes: medium flat, medium round, large flat
- Pencil
- Ruler
- Spirit level

by the painting of the shelves, with suggesions from a number of people involved with the project. Such an arrangement can lead to chaos unless the artist is prepared to establish him or herself as chief editor and the final arbiter of all suggestions tendered.

One of the problems of the design was that this mural could be seen from a number of widely varying viewpoints, both at close quarters and from far away. Here, the problem has been solved to some extent by setting the viewpoint at the position from where the mural will first be viewed – that is, from the doorway to the left of the mural. In fact, viewers will see the mural centrally and from close to by the time they have entered the room and had time to focus on the image.

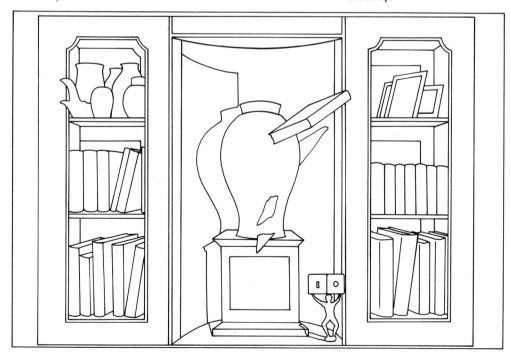

But, to prevent any distortion in the perspective of the bottom shelf of books, the artist has arranged them in disarray; the viewers's mind accepts this fact, and does not question the slight distortion from other viewpoints. There is little dramatic perspective in the vase which is depicted 'head on' to avoid distortion.

SHELVES

The striking red shelves are measured to fit the space exactly, and then drawn on the wall with a pencil and ruler. The only impediment on the wall is a pair of adjoining brass lightswitch plates. It was decided to fit the sets of shelves round these, and to incorporate the plates into the design (see finished mural). The bookcases will be painted to represent Japanese lacquer – in this case, a deep luscious red. The red emulsion paint is not easy to handle as it needs to be used undiluted to achieve the density of colour. The staining power is high, making mistakes difficult to remove. At this stage, brushstrokes which stray from the line are quickly wiped off with a clean finger or with a damp cloth. Here, however, there is no worry about precision, as the edge will be covered with a line representing a judicious strip of beading, as shown in step three. The first of the two coats of red paint is applied as evenly as possible with a medium flat brush.

1. The second coat is stippled on. As can be seen here, the effect of this technique is not obvious at a glance because of the intensity of the red colour. But the result is an increase in the depth of colour, rather like the blurring of a photographic image. It also covers up any uneven brush marks visible in the first coat. The brush needs to be soft-bristled – the older and more worn, the better – so that the stipple mark is dense and undefined. Having established reasonably clean edges with the first

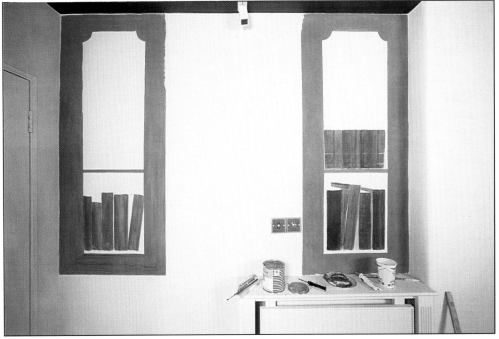

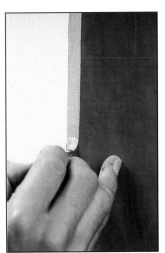

coat, the second coat does not need to be taken right along the edge; it can be stippled up to it.

2. Next, a few books were blocked in using a diluted mixture of raw umber and a touch of red iron oxide to give an idea of the scale and composition. The artist has used various shades of this basic brown mixture for

what are to be leather bindings. The upper shelf here will be at the viewer's eye level, so there will be no perspective view of the pages. The receding orthogonals of the lower shelf books, as explained opposite, can also be logically perceived as books in disarray when viewed off-centre. As if to confirm this alternative view, the artist does not place the books in a neat order.

3. Painting a clean edge is always more difficult when the contrast is greater because irregularities are more noticeable. Black against white is a good example of this. The artist overcomes this problem when painting the bookshelves by edging them with what appears to be a quarter-inch (5-mm) border of gilded wood. This is executed with a flat brush, well-charged with a mixture of acrylic paints – white, raw sienna and yellow ochre. Note that gold paint is not used, as this has a tendency to sit visually on the surface of the wall instead of blending into the spatial illusion. It also reflects the light in a distracting way. To maintain the consistency of width, the little finger is placed on the wall to steady the stroke and maintain an even pressure on the brush. Keep your hand at a constant angle to the wall, compensating as you come down the wall with the joints at your wrist, elbow and shoulder. The trick is to use a confident light stoke with a steady hand. Tail away the stroke if the tension breaks and run in the new stroke gently from the point just above where you broke off. Joins and irregularities can be smoothed over with a

smaller brush once the coat is dry. To practise painting straight lines of an even width, tape enough smooth paper to enable you to finish a full stroke flat on the wall. Practising on a flat table, or at an angle on a board, will not present the same conditions at all.

4. Now, the red area is decorated with a leaf motif using the diluted 'gold' mixture. A medium round brush has been chosen for its long, tapered soft hairs which retain the diluted paint well and effect the required leaf shape. The paint is applied quickly and lightly, picking out the design at random. Some of the leaves are painted with a little extra white added to the mixture to simulate the effect that would be created by the reflection of light on gold paint.

BOOKS

Now, attention is turned to the leather-bound books. Here the texture of well-used leather is expressed with layers of paint, and with scumbling and glazing techniques. For the rougher textured books, a further layer of semi-opaque dry paint is scumbled over the dry base colour by pressing the small flat brush so that the paint is almost scrubbed on. This allows the undercoat to show through patchily and gives the surface a richer,

well-used appearance. For the smoother textured books, an acrylic glaze of dilute paint is painted thinly over the base coat with a broad flat brush. The ridges on the spine are then painted over the top. For the green tones, a mixture of Hooker's green and black is used; burgundy, a mixture of naphthol crimson and burnt sienna; and for the browns, varying mixtures of burnt sienna, raw sienna and red iron oxide.

5. For the highlights, the paint mixture is varied – sometimes it represents the warm glint of gold leaf, sometimes the bluish softer gleaming shine you would expect to see on old leather. To create this gleam of reflected light down the spines of the books, first apply dry white paint in quick strokes from side to side. Then, before the paint dries, rub this from top to bottom with your thumb, or with a cloth, to blur the line. This gives

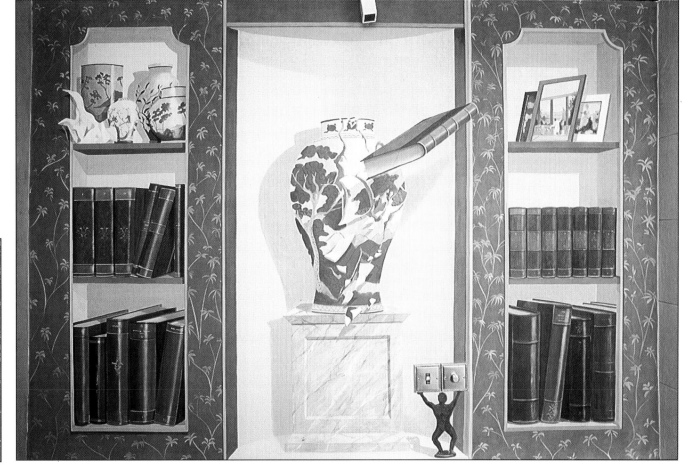

the appearance of a soft, gleaming shine. An intimation of lettering – titles and folio numbers – and other more decorative tooling work in the leather is picked out with two shades of the highlight colour.

6. These variations of size, colour and decoration give the books their individual characteristics. Now, the artist enforces their three-dimensionality by adding the shadows of the books on the shelf. A thin dark, dilute line of shadow is painted between the 'gilded' beading and the red. A mere indication of the receding sides of the shelves is given – this will not produce a distorted vision when seen obliquely from the right.

CHINESE POT

7. This central feature was copied from a catalogue, then illusionistically cracked by the flying book, bringing a welcome smack of drama and movement into what could have been a calm, and perhaps slightly boring, design. The jar was painted 'whole', in French ultra-marine and white and then shattered by painting

in the cracks afterwards. Finally, the falling pieces were added. The plinth was painted using the marbling technique described on pages 144-5.

To make the book appear proud of the picture surface (see finished mural), its tonal contrast is developed to a greater degree than those on the shelves. Its position, cutting in front of both shelves and pot, throws it forward visually. Its painted shadow, added later, dictates the book's position in the perspective scheme.

FINISHED MURAL

8. The finishing touches are added to the mural. The top shelves are filled with porcelain and photographs. Shadows have been added at the back of the shelves and behind the pot, which can now be seen placed in a niche. Finally, to incorporate the double light switches, a small 'bronze' Atlas figure is painted in, apparently supporting them. It is hard to believe that these light switches are in fact fitted on the wall – the illusion of space behind them is so convincing.

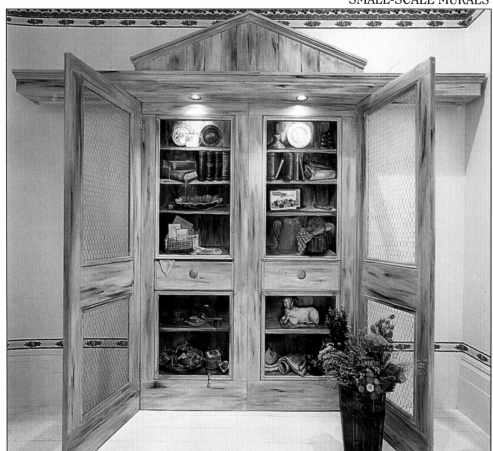

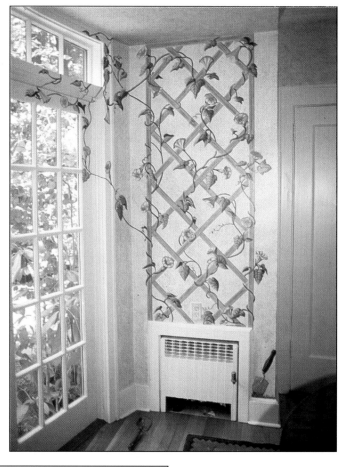

Above A trompe l'oeil cupboard displays some interesting details about its owner, providing a type of collective portrait. We see they like Liquorice All-sorts, sewing and tapestry, and we learn about their taste in tableware and china. So, gradually, an image of this person appears. The final deceit is the pair of wire mesh doors through which the painting is viewed.

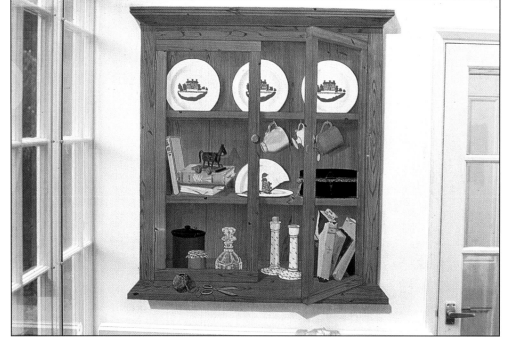

Above This small, decorative mural brings the garden into the house as well as distracting the eye from an ugly heating installation. Over a simple grey trellis, convolvulus trails and climbs, reaching out over the window frame. A nice touch is the trowel embedded in the 'grass' above the skirting board. Painted in acrylics.

A glass-fronted kitchen dresser is packed with objects arranged in a realistic, carefree way – not even omitting the ubiquitous broken plate that lurks in most real cupboards. The carefully observed shadow is painted as though cast by light from the real window on the left. Executed in oils on plaster primed with eggshell.

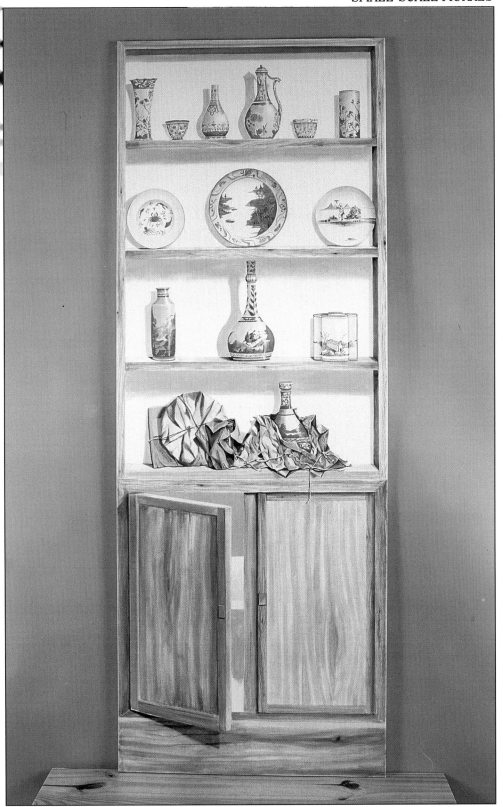

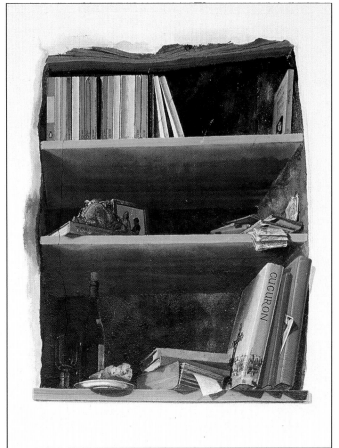

Above With only the help of a paintbrush, a rustic niche is hacked through the plaster to the wall beyond and stocked with simple provender for body and mind. Painted as viewed from below, the objects spill over the shelves. Executed in acrylics on plaster, such delicate treatment is usually not practical for larger projects.

Painted on canvas, this trompe l'oeil dresser, when fixed to the wall, uses the depth of the stretcher and the shadow it casts as part of the illusion. The light source in the painting comes from above, making it easy to hang in any room. Although a still-life in all senses, the wrapped items on the bottom shelf exercise the mind, as do the bare shelves glimpsed through the open door.

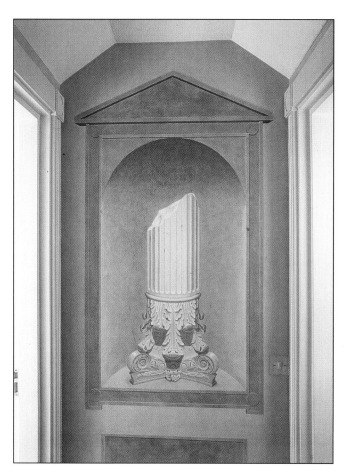

Above A dead end corridor, leading off left and right, is given some meaning with this neat little niche. The necessary dose of double-take is provided by the witty idea of standing the broken Corinthian column on its head – but of course it could stand no other way. Painted in oil on prepared plaster.

Rooms are often ruined by the practical neccessities of a stark parade of wardrobe doors. However, few are ever given such inspired treatment as these, brought to life with a decorative covering of undulating fringes and fluttering ribbons. Executed in acrylic, the soft delicate colours are in keeping with the rest of the bedroom decor.

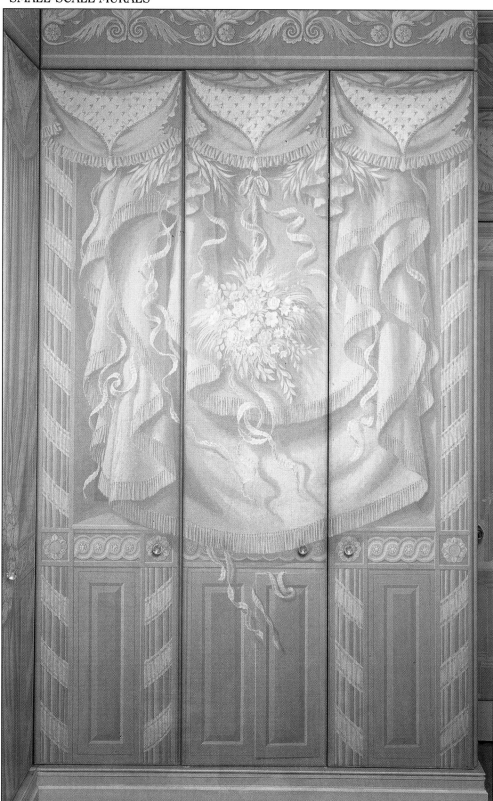

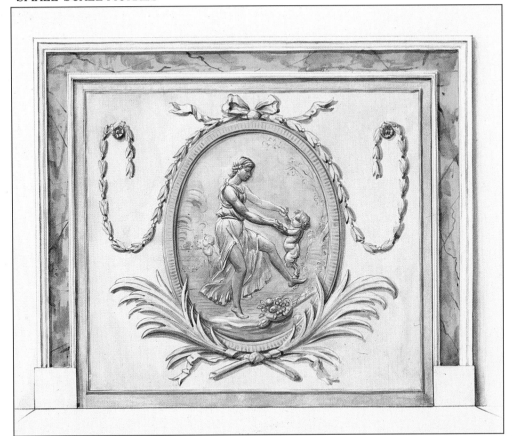

Above A novice muralist might start with a small detail such as this urn, painted to be viewed from below. Here, it rationalizes the painted 'stonework' on which it stands, but it would equally make sense 'balanced' on an existing picture rail. Painted in oil on prepared plaster.

Cupboards are sometimes decorated to hint at what they might contain. Perhaps these traditional musical instruments, painted here in monochrome relief and neatly framed in the door panels, are replicas of what is inside. Although simply executed and reduced down to basics, the result is convincing. Oil on wood.

Above Chimney-boards, fashionable in the seventeenth and eighteenth centuries, were used to block in fireplaces during the summer months. They are not only decorative, they also stop draughts and hold back falling soot. This contemporary design, after 'Clodion', carefully executed in pencil, watercolour and gouache, is a work of art in its own right. The finished article could be executed on a made-to-measure canvas, which would be light to handle, a strong board or a panel of wood.

A trompe l'oeil skylight is a good idea if you need to brighten up a dark room. It is also a means of raising the apparent height of a low ceiling. Executed in acrylic and oil on canvas, this stylized design was inspired by Tiffany. The panel was completed in the artist's studio and then transferred to its position inside an existing moulding on the ceiling, polychromed to match. Painting ceilings is uncomfortable and sometimes dangerous work, so this method is to be recommended. However, if you choose to paint directly on the ceiling, protect eyes and work in short shifts.

Such a delicate decorative frieze would give any room an exclusive look. A stencil can be cut from clear draughting film for repetive shapes like the ceiling border. But the real attraction of this project is the natural course of the freehand trailing plant, which follows the shape of the room. The prepared plaster was painted with a blue-green oil glaze. When this was dry, the details were added in artists' oils.

If you have ever thought you would like a cosy burning fire as a focus for a room, here is a way of providing one without involving you in a fine layer of builder's dust. These two examples are painted directly on the wall with acrylic paint. *Above left* The mantelpiece is real, but the Victorian grate with tile surround and burning coals to welcome you home are painted. *Above* A grander version is given a marble surround, painted darker at the top as if blackened by heat.

Left A case of spot the trompe l'oeil, the split pediment above the Roman blind is a simple piece of plywood, cut to the right shape and painted with acrylics. Such a small project can add amusing and eye-catching details to a room otherwise devoid of architectural merit. Similar cut outs – columns, pelmets, keystone reliefs or cartouches – can be linked in with existing architecture, round windows, doors or plain mirrors.

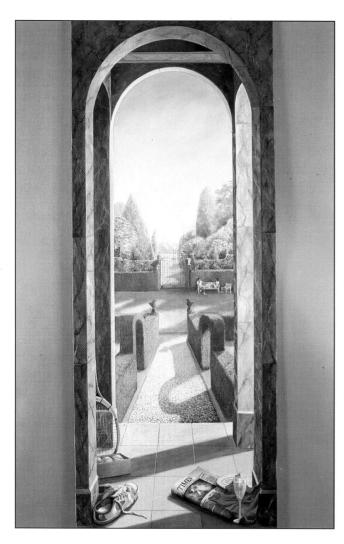

Above Memories of a lazy summer afternoon can be yours all the year round with such an illusionistic mural. Painted on canvas with acrylics, this panel can be fitted into any suitable nook or cranny. The eye is taken down the garden path, its progress impeded by the horizontal shadows that invite you to rest a while and linger over the details.

Such exquisite illusionistic wizardry really needs to be explained, the deception is so complete. Painted shelves are added above the real Dutch tiles, which provide the theme for the objects placed above them. Executed in oils, the delicate treatment of these still-life objects and the clean colours, reminiscent in themselves of the Dutch masters, create a pristine illusion.

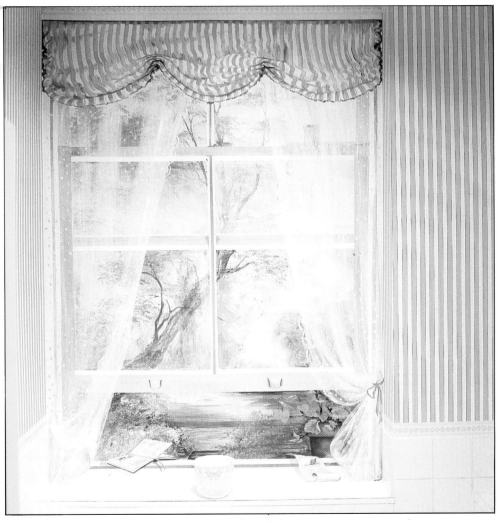

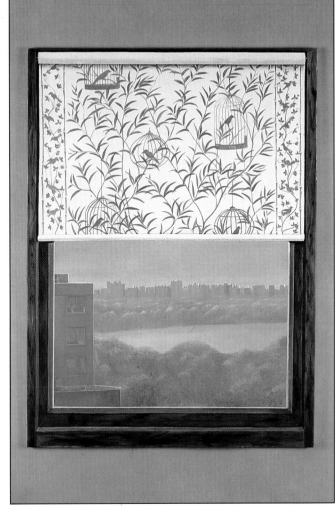

Above In city bathrooms, for decency's sake, windows are usually draped in curtains or the glass is frosted to obstruct the view. Here is a neat alternative, opening out the room and transporting the imagination of those who lie in the bath to a more gentle lifestyle. This mural is painted in acrylics on a stretched canvas fitted into the window opening.

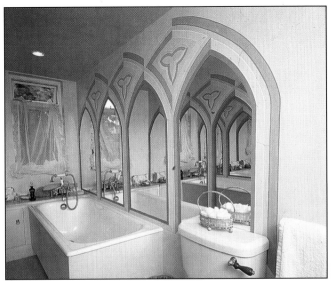

Left This may seem at first glance to be a capricious scheme that is unsuited for inclusion in this section, but it is in fact deceptively simple. Two ranks of four mirrors face each other across a room. Around the mirrors, simple moulded stonework is painted to represent Gothic tracery. As if by magic, this results in a seemingly infinite view of cloister life.

A trompe l'oeil window with a difference, this canvas can be placed on any wall that needs a view. It is particularly relevant, however, to owners of apartments on Park Avenue, New York City, as this painting would give them a much sought after view over Central Park.

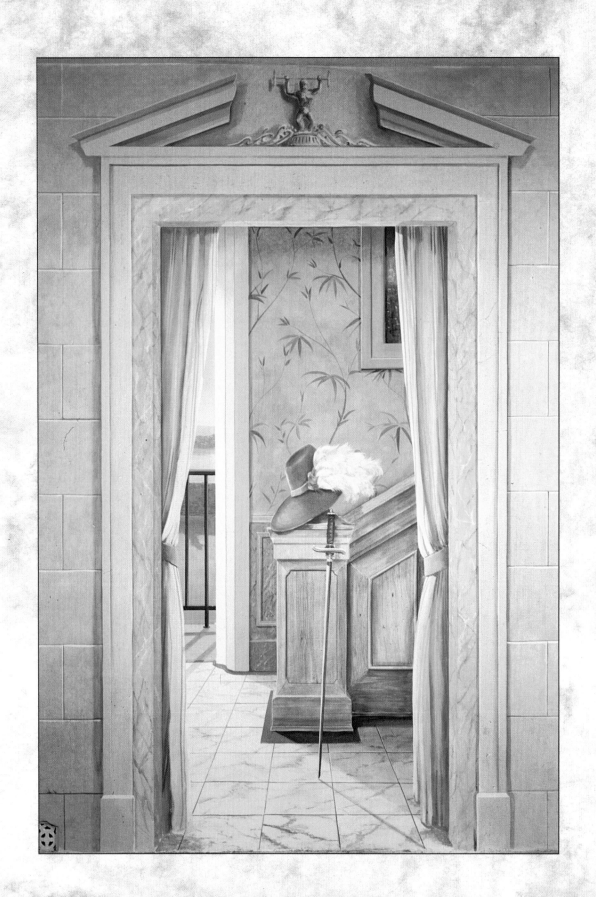

7
PAINT EFFECTS

The world depicted in many murals – trompe l'oeil paintings in particular – is not just a natural world of leaves and flowers and other organic things. It is also filled with carpets, cushions, stripped and painted wood, walls and pillars of stone and brick – the manufactured items that form part of our daily environment. Artists develop skills in how to represent these objects – how to re-create the 'texture' of a thick carpet, for instance, or a grained wood surface; in other words, how to depict the decorations with which we surround ourselves. Walk through the average art gallery and everywhere you will see examples of these painted decorated 'finishes', adorning the rooms in which the figures pose, or decorating the buildings in exterior scenes.

There are adventurous and imaginative ways in which you can create such interior decorative effects with a mural – perhaps by making use of the exotic. You can stud your walls with 'diamonds', cover the floor with rare 'marble' or order 'hand-painted Chinese wallpaper' for the anteroom. But even in the course of more normal work – and especially in trompe l'oeil painting – muralists find themselves representing a wide variety of textures and finishes. Certain settings, particularly those connected with architecture such as stonework, wood and marble, seem to crop up again and again.

Some of the finishes demonstrated in this section may look ambitious, but the techniques become easier to learn once they have been simply demonstrated.

Marbling, for example, is beautiful when well-executed, yet not difficult to do. Stonework, too, can be effectively represented by building up layers of paint, using different techniques to produce the 'texture' of aged stone, complete with pits and cracks. Woodgraining simply needs a light touch and practice. From these techniques, you can go on to experiment, adding more finishes to your repertoire.

The completed mural shown opposite contains a number of finishes, and here simple steps are demonstrated on how to paint some of the more frequently-used of these, rather than working through the mural project step-by-step. As you can see, this trompe l'oeil view across a hallway uses a variety of textures and finishes. Some are not immediately obvious to the viewer; it is only when the mural has been studied closely that the richness of detail is appreciated.

The door frame, constructed of 'stone', is topped with a broken pediment complete with 'sculpted' Atlas and dumbells. Into this doorframe is inset a lining of rose-coloured marble. To avoid producing too cold an effect the doorway is softened with curtains, through which we can see the grey marbled floor, the bleached oak-panelled staircase, and a glimpse of the unusual, blue-green marble stair dado panelling. Against the subdued glory of the 'hand-painted' wallpaper, the artist flourishes a Cavalier hat with exaggerated plummage, which contrasts with the cooler colours and textures in the hallway. As a final touch, the sword brings in the cold glint of steel.

Marbling

Decorative marbling has been used for as long as there have been mural paintings, not only as part of the mural itself, but also to decorate the surrounding area. It has suffered a decline in popularity during recent years, caused by changes in fashion, and is to be found mainly in institutional buildings, where it creates a feeling of pomp. But the technique of marbling has now returned to popularity as part of a more lighthearted, tongue-in-cheek attitude to decorating humble domestic scenes.

As shown on the previous page, while marbling effects can be used in the mural itself, its uses do not stop there. Shelves or skirting boards, wooden chimney pieces or mantels can be marbled to match illusionary marbling in a mural.

The beauty of marbling is that there is no right or wrong way, and you will find that artists' methods differ quite considerably. Almost every mural artist has his or her own personal approach, and no doubt you will arrive at your own. We are not aiming to reproduce faithfully a complicated and delicate product of nature, but merely to give an *impression* of it.

Although you may think your concoction of colours for a particular piece of marbling is mere fantasy, there exists in nature marbles of almost every hue. The configuration of the veins varies tremendously too: sometimes it is a delicate latticework of different colours, sometimes a strong contrast of merging striations. These veins can be interweaved with sections of other minerals in the marble – quartz, mica or graphite.

METHOD

1. The inside of the door frame of this mural is to be a gentle rose-pink marble with brown and white veins. The narrow width of the strip prevents any dramatic streaking, but it is a good example of a manageable area suitable to start practising on. The paint, raw umber and white, is mixed in the light aluminium baking dish. For the first veins, the paint is very dilute and pale, representing the deep veins in the marble. Now, with a small round soft-haired brush, the first veins are lightly and quickly painted with random up and down strokes rather like Bargello tapestry or a fluctuating graph. But, because they represent actual veins, you can trace a vein from its beginning, across the marble, until it disappears, providing the marbled area is large enough.

MATERIALS
- Tubes of acrylic: raw umber, white, red iron oxide and raw sienna
- Artists' brushes: small round and large flat
- Foil dishes for mixing paint
- Rags

Note: acrylic paints were selected here for their matt, non-reflective finish. For an irridescent, luminous finish, such as might be desirable when painting surrounding architectural forms, use a flat, oil-based undercoat and artists' oils.

The technique for painting these veins is described as fidgetting, and this describes it precisely. Don't worry about the precision of this technique; it does not exist. If, however, a particular fidget annoys you, it is easy to remove it with a damp cloth or finger. Professional paint finishers often use feathers to fidget veins because

they ensure a light, broken, blurred line (you cannot press hard on a feather). The vein can be blurred with a rag if it appears too clean.

2. The vein can also be blurred quickly with a finger (acrylic paint dries before you know it), by smearing it slightly down the line, so causing the paint to look more like a stain than a painted mark. This next 'layer' of veins cross the previous ones, and is painted in a denser colour, again a mixture of raw umber and white. Note how the darker striations are less frequent than lighter ones.

3. The marble is next given its colour, applied as a thin layer of paint over the veins, which can be seen through this glaze. The colour used here is a mixture of white,

paint is applied with a broad, flat brush in long, fluid strokes, and finished off with a light stroke to remove brushmarks. Note how the inside edge of the marble inset is painted a darker tone so that it appers as if in shadow. A little raw umber is mixed to the basic pink colour and applied as a glaze, using the method described above.

4. This final step shows the artist applying another layer of veins, this time of a whitish hue (white with a minute amount of raw umber). Criss-crossing randomly over the layers beneath, these streaks are sparser and more delicate and are therefore painted with a smaller brush. Like the others, they receive the same blurring treatment. Stand back and assess your work, checking

red iron oxide and raw sienna, but any colour – brownish red, blue green, yellow – could be used. In the mural on page 142, the marbled dado panelling on the stairway is executed in the same way, with dark blue veins glazed with a bluish-green. Water is added to dilute the paint but, alternatively, matt acrylic medium can be used instead, to prevent the colour getting too runny. Acrylic mediums are milky, but dry clear. The

to see that the overall effect is balanced, bearing in mind that real marble contains an amazing diversity within a single piece.

The marbled detail obviously adds to the overall effect of the finished mural. Note the looser finish applied to the flooring. Marble tiles such as these are often cut from the same block of marble, and therefore repeat the same basic pattern of veins, with slight variations.

Wood Graining

Before trying your hand at the technique of wood graining, it is worth going back to nature and comparing several different types of woods. You will be surprised at the variations. Most noticeable are the colours of the different woods – varying from the very pale yellow of pine to the rose-brown of mahogany. The parallel graining, running down a plank, and occasionally diverging from its course like a river, can also vary considerably. Some woods, like walnut, are dense, and the grains run close together. Others less so. Knots, which appear like islands in these rivers of graining, add further to the overall delicate patterns.

As with the marbling technique, studying the original is not necessarily aimed at making an accurate imitation. The graining demonstrated here gives an impression, the essence of wood, rather than a faithful representation. However, it always helps to go back to the real thing to get the feeling of a material. This also acts as a reminder that nature provides an almost inexhaustible pattern book, and so that there is no right or wrong way to imitate her.

There is no reason why you should use colours only found in nature; some very attractive decorative effects can be achieved with blue, red or green grained woods. Woods stained in these colours are generally popular, and graining gives them an interesting finish.

There are various ways of wood graining, but generally they fall into two main categories. In the first, a juicy glaze of paint is applied to the surface, which is then scraped off, either with a 'comb' cut from card or the edge of a cork, to create the effect of graining. In the second method, demonstrated here, the grains are applied over the base colour of the 'wood' with a brush. This method of wood graining was selected because it suits both the types of paints used and the style of the mural. In the interest of clarity, this demonstration has been done with a wider brush on a larger area of wall.

METHOD

The basic wood colour is painted on as an undercoat. In this case, the wood is very pale – pine or bleached oak, for example – so white vinyl matt emulsion was applied. Next, the paint for the graining is mixed in a foil dish – raw umber with a little water. The brush used here is an ordinary, coarse decorators' bristle brush, but you will need to choose your brush to suit the area you are

MATERIALS
- White vinyl matt emulsion
- Raw umber in acrylic
- Medium-sized decorators' brush
- Artists' brushes: small round and medium flat

graining. For the wood graining in the mural, a medium-sized flat artist's brush was selected. The type of bristle will affect the texture of the graining. For grainier woods, such as oak or pine, where the pattern in the wood is clear and well spaced out, a coarse bristle such as hogs' hair is suitable. Whatever brush you choose, it should be absolutely dry and clean.

1. Dip the very tip of the brush into the paint so that only a tiny amount of paint adheres to it. It is important to hold the brush very gently, yet at the same time retain control over the pressure (as you see here, the artist holds the brush between the thumb and four fingers.) Now, stroke the brush gently down the surface. Only the very tips of the brush hairs should make contact. The hairs themselves will make the graining suitably inconsistent, but you will find that you can encourage these irregularities by altering the pressure very slightly. Paint successive strokes alongside the previous ones without overlapping them. Do not worry if the stroke is lighter or darker overall, such variations are consistent with natural wood.

2. To paint a knot, move the brush to the right in the course of a stroke, as if avoiding an imaginary object,

and then return to the original path. With the next stroke, move the brush to the left as you approach the same spot. Now, take a small round brush loaded with raw umber and add the knot in the centre of this 'island'. Knotting is very sporadic in wood, so resist the temptation to get carried away or your wood will look as though it has an attack of measles.

3. It is difficult to make joins when graining, and therefore wise to divide any painted woodwork into panels or manageable lengths. This area of wood is therefore given a narrow strip of beading to form a central panel. A flat artists' brush of the right width was chosen for this. Next, the frame of wood is painted with the decorators' brush. The brush is not quite wide

enough to cover the width of the frame in one stroke, so two slightly overlapping strokes are applied. A dry brush is then drawn very lightly over the top of the paint to even out the lines. This produces a much denser graining on the frame than on the rest of the painted wood, but this does not matter – in reality, the frame would be made from a different piece of wood.

4. The mitred corner is made by wiping off the paint cleanly at an angle from the corner, with a damp rag. The vertical length of wood can then be painted by placing a ruler along the angle of this mitred corner and brushing up from it. Finally, to tidy up the corner, a fine line of raw umber should be painted along the intersection with a small round brush.

A mitred corner, as may be found in a framed wooden panel or door, is made by wiping off the paint at an angle from the corner with a damp rag. Then, a ruler is placed along this angle, covering the painted part of the frame, and the brush is run up from it to complete the corner.

Stonework

Many murals include architectural features, and therefore stonework frequently is part of the composition. Because of the size of some murals, this can mean vast areas of painted stone, and, as it often dominates the mural, stonework must be regarded as an important element which it is worth taking time over. Fortunately, there are short-cuts, and the techniques demonstrated below will show you how flat colour can be given the texture of aged stone by applying several layers of paint. Used with the method for painting stone outlined in Project 3 (see pages 82-7), an architectural setting – be it classical, medieval or Mogul – can be painted quickly and almost effortlessly.

The colour of the stone is important in setting the tone of the mural. This varies according to the type of stone. It can be a soft yellow, as in many classical scenes; a cold, ecclesiastical grey; or even a pink colour. The colour can be mixed in three different tones, as explained in Project 3, and applied to produce the simple modelling required. The techniques demonstrated here can then be added to these basic colours to age or distress the stone.

In the finished mural, the doorway and broken pediment are painted to represent a pale, creamy stone. From a distance, the overall effect is that of a flat surface, although there is no doubt that it is stone. However, closer inspection reveals that the surface is pitted, and even slightly cracked in places. The effect is successful because it makes you want to put your hand and touch it.

The wall either side of the doorway is painted in a deeper yellow, representing large blocks of stone. This promotes a feeling of grandeur associated with the great English country houses and Renaissance palaces.

METHOD

1. It is useful to begin with to choose a small area to practise on; something like this doorframe is ideal. In a foil dish, mix together a touch of raw umber, white, and a dash of ivory black. Apply this with a small decorators' brush to the strip that is to represent the doorframe. First, apply the colour with long, flat strokes, and then before the paint dries, rework it with a stippling motion; this will effectively break up the surface and give it some texture.

2. While the first coat is drying, dilute some darker

MATERIALS
- Tubes of acrylic: raw umber, white and ivory black
- Small decorators' brush
- Medium round artists' brush
- Sheet of paper
- Old toothbrush
- Foil dish for mixing colours

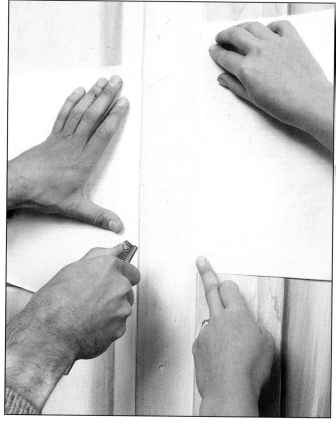

paint with water to a thin consistency. This will be spattered on the stippled coat with an old toothbrush. This process is slightly messy, so make sure the floor is covered before you start. Start by masking off the areas to be spattered. Here, sheets of paper were held by hand on each side of the stone strip. Otherwise, use masking tape to fix the paper. Now, dip only the head of the toothbrush into the paint. Hold the brush 1 inch (2.5 cm) or so away from the wall (the closer the brush to the wall, the denser the spatter) and pull back along the bristles with your thumb so that the paint is flicked on the wall, moving the brush down the wall as you do this. While not glaringly obvious, the spatter of small

spots gives the stone a noticeable texture compared with the unspatterd stone.

3. The next stage is to add some pitting, small holes caused by erosion that appear in the surface of old stone. If you have used the three-tone system for your stonework, you will need the highlight and shadow-tone for pitting. The method is very simple. First, use a medium round brush to dab on a spot of shadow-tone paint. Then, add a touch of highlight to the bottom

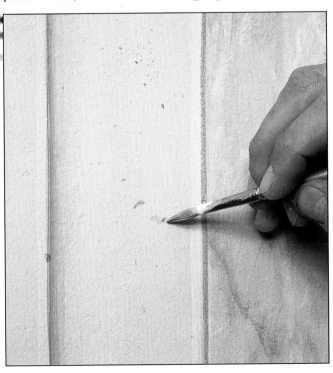

edge of the 'hole' to throw it into relief. It is quite extraordinary how the addition of a few of these pitted holes in the stonework can increase an illusion of reality.

4. Finally, some delicate, hair-line cracks are added. Following the method outlined in Project 3 (see page 84), the dark shadow-tone is painted first, then the highlight tone is added. The build-up of the different tones depends on the depth and type of crack, and on its position: cracks in the foreground should be depicted in some detail; cracks that appear in the background less so. Different stones crack in different ways. Dense, heavy types of stone crack with a sharp edge. Sand-stone, which is crumbly, cracks less cleanly; it also tends to erode quickly, softening the edge still further. A crack usually follows the structure of the stone, so emphasizing its form.

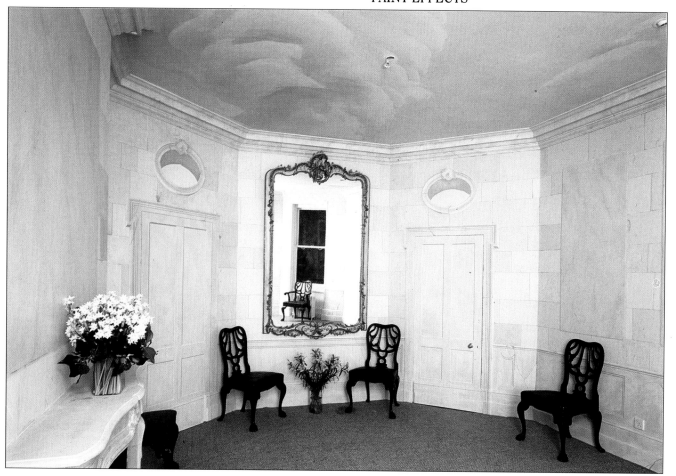

An oddly-shaped room, remarkable only for its uneasy configuration, has been given architectural distinction with this painted stonework. Treated differently, this might have seemed oppressive, but here this is avoided by the warm pinkish colour chosen for the stone and by the lightness of execution. The hint of swirling, fast-moving clouds on the ceiling and the inclusion of an elliptical opening through which the sky can also be glimpsed introduce a further dimension. Painted in PVA/vinyl paint.

The marbling on these lobby pillars was executed in Keim Decor paints for a tough, long-lasting effect. The bold, loose style, with its clearly defined marble striations and unusual combination of colours, complements the utilitarian architecture; a finer, more detailed approach would have been inappropriate here.

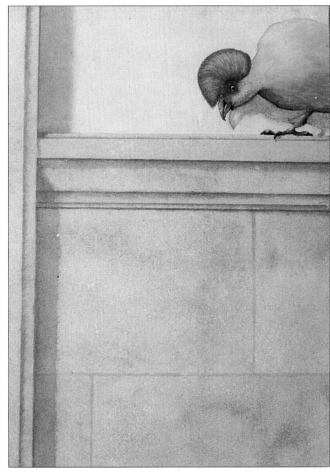

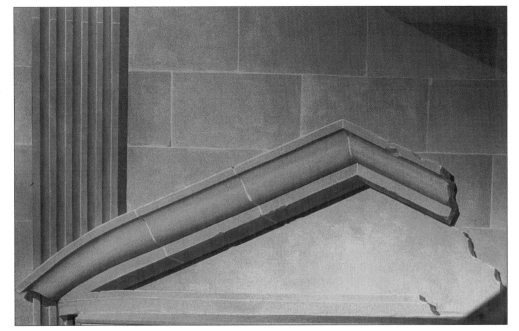

Above The marbled lozenge shown here was painted in artists' oils. Once the paint had dried, the surface was distressed with wire wool to give the marble an aged, faded appearance. Part of a Pompeian-style scheme, the 'crack' running down the 'plaster' strengthens the illusion that this is an ancient paint effect.

Above Over a base coat of eggshell paint, the mortar-grey lines etched in this stonework ledge were marked in using dilute artists' oils. This was followed by an application of a golden-coloured oil glaze to give overall warmth. Finally, transparent reds and browns were stippled at random to texture the stone.

Painted in acrylic, this classical pediment and surrounding stonework is given further impact by the strong contrast between light and shade and the almost dramatic golden colouring. Small details such as chips and breaks in the stonework all contribute to a feeling of age.

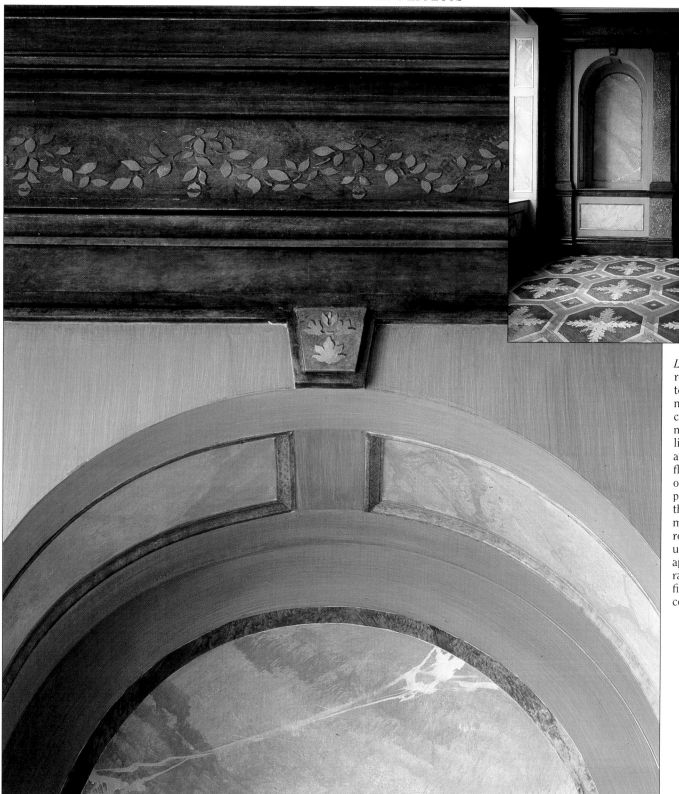

Left The impact of this remarkable room is entirely due to paint effects. The imitation marquetry on the floor was created by using a stencil and masking tape to mark out the lines. Oil-based glazes were applied direct to the sanded floor, followed by several layers of polyurethane varnish for protection. *Above* This detail of the arch clearly shows the marbling used throughout the room. Painted in oils, the artist used a number of paint applicators – brushes, a sponge, rags, newspaper and even fingers – and five or more colours to achieve this effect.

Architectural Features

Mural designs frequently incorporate architectural features, yet it is hard sometimes to track down a suitable source. Indeed, after much searching, when you finally find what you are looking for, it is often only to discover that the details are not clear enough to copy.

Over the next pages, therefore, clearly drawn line illustrations of the classical orders of columns, arches and arch stones, bricks, windows and fanlights have been set out for easy reference and also as a source of ideas. An artist often has his own vision of reality, so these illustrations need not be copied slavishly; they can, for example, be combined in an imaginary pastiche of historical material to produce architectural features of one's own inspiration.

Above This design for a baluster can be embellished or simplified if necessary and then enlarged to the required size. For a balustrade, time can be saved when drawing up the design on the wall if the shape is traced on cardboard, which is then cut out as a template.

Above Getting down to details, here are three different methods of arranging stones round an arch to bond with the surrounding wall.

Right This group of seven arch curves are shown with the correct positionings for compasses when drawing each of them up.

Bricks can be arranged in many patterns. *Left* Some random arrangements or irregular rubble. *Above top* The English Bond method of laying bricks alternates courses of headers and stretchers. *Above* The Flemish Bond method alternates headers and stretchers in the same course.

The Doric order, here from the Theseion, Athens, is the simplest, most austere of the classical orders of columns. Included is the base, shaft, capital, entablature, cornice and low-pitched pediment.

The example of Roman Doric seen here is from the theatre of Marcellus, Rome. The Romans sometimes used columns decoratively rather than structurally, so the shaft is often longer and more slender.

Similar to the general proportions and basic shape of the Roman Doric order, the Tuscan Doric column is a simpler, more rustic variation. It is distinguished by its lack of carved work.

The Ionic order was contemporary with the Doric, here taken from the temple on the Ilissus, Athens. Richly decorated, the Ionic column has a less angular, more graceful design than the Doric.

The Corinthian order was developed from the Ionic. For the architect and muralist, the Corinthian capital is more versatile as it offers the same aspect from wherever it is viewed.

A well-proportioned Georgian Gothic window would make an elegant feature.

It is worth looking out for ideas for window styles, through which trompe l'oeil scenes can be viewed. The style chosen can help set the scene. *Above* A typical French window with shutters.

Left This typical Victorian window demonstrates their love of texture and pattern in architecture. *Above* Known as a Venetian window, this more formal presentation is linked with visions of ballrooms or grand hallways. The size can be manipulated by adding extra window panes.

Right Georgian fanlight patterns over doors, or as part of windows or wrought ironwork, can add a decorative touch to a mural design.

FINISHING TOUCHES

Now is the time to think about the future of your mural – how to display, maintain, protect, and even repair your work should the occasion arise. In this final section we look at these essential finishing touches.

Many muralists regard varnishing as unnecessary, a bad habit inherited from the traditions of oil painting. Certainly, for some types of mural painting – trompe l'oeil, in particular – the glazed surface of the varnish catches the light, and interferes with the illusion. This undesirable effect is produced even with matt varnish, although to a lesser degree. However, reflection is less of a problem with other types of mural, and sometimes the practical need to protect the surface outweighs the aesthetic argument.

The presentation of your mural is crucial if its true value is to be appreciated. It is worth taking some care, therefore, when fixing a moveable mural into its final position. Having no doubt spent a great deal of time and energy with the design and painting, it is a pity to spoil the effect with poor workmanship at this stage.

Lighting, too, is important. This is often taken for granted, with no attempt to focus attention on the mural. Matt paints in particular are greatly enhanced by strong artificial light, and often their true value is never realized because of poor lighting.

Hopefully, your mural will not involve you in any upkeep. It may need to be cleaned or dusted, particularly if it graces a city wall – even an interior one. This should not present any problem, and simple instructions are given here for the different surfaces and paints covered in this book.

Should your mural be damaged in any way, it is not the end of the world. Most knocks and chips can be dealt with without much trouble. More serious injury is not common. If the injury is structural, you will probably need the help of a professional to repair the support, and once this is done, the attentions of the original artist.

VARNISHING

To varnish or not to varnish, that often is the dilemma. Some artists and clients feel happier with what they feel is a protective covering over their work. Yet, it is not usually necessary to varnish paintings; acrylics, indelible gouache, tempera or any of the household paints dry to a strong film which can be weakened by varnish. What is more, varnish, almost without exception, eventually yellows.

Having said that, there are times when varnishing is advisable. If a mural is to be subjected to a great deal of wear and tear, a couple of layers of varnish will help protect the paint film from any vigorous cleaning. A coat of varnish will also help to unify the surface of a painting that has been executed in different media. There is no doubt that the true value of some paints is greatly enhanced by the glazing effect of varnish – oil paints and sign writer's paints come into this category. But whether you varnish or not depends on the effect you want. As noted above, good lighting can greatly improve the appearance of a mural without the problem of the reflective sheen.

Applying varnish

There are a wide variety of varnishes to choose from, some of which have been developed for artists. These are sold in small quantities and are therefore expensive for large areas. Varnishes manufactured for household use, however, will not be as durable, and tend to peel off after a few years.

Be sure to choose the right varnish for the purpose. If, for example, porous water-thinned paints have been used to enable a damp wall to 'breathe', you will need to use a porous varnish. Varnish can be applied with a brush or obtained in aerosol cans and sprayed on.

Water-thinned mural paints The paints in this category (see pages 31–5) are all strong, flexible and water-resistant when dry. It is therefore not necessary to varnish your work unless it is expected to get very dirty, in which case a couple of coats of varnish will protect the paint film from vigorous cleaning. Even then, if you decide to go ahead, use acrylic varnish which can be obtained in gloss or matt varieties. Do not use a natural resin varnish as this will form a waterproof film which will seal the surface and negate the porous quality of the acrylic paint. Gloss catches the light, showing up any blemishes in the surface, so matt is generally preferable. For external murals you will need an oil-free varnish, but these are more likely to peel off than the exterior emulsion paint.

Varnishing
Use a soft paintbrush or a special varnish brush (see page 26) to varnish, and take care not to bend the bristles. *Far right* Apply the varnish to a patch at a time (see below). Finish with a light 'laying off' stroke.

When varnishing a mural, first dust it down carefully and make sure that there are no through draughts which can bring in more dust. Now, starting at the top, tackle a patch at a time, working down the mural in bands. Spread the varnish thinly and finish off with a 'laying off' stroke. Then move to the adjoining patch, working the two patches together and so on.

Artists' oils Traditionally, oil paintings were varnished because some colours dried out more than others, leaving a patchy reflection on the paint surface. The coat of varnish unified the appearance of the painting. This problem has been overcome to a great extent by the high quality of today's oil paints, but uneven porosity is still a possibility when painting directly on a wall. Some artists also like to varnish because of the protection offered and to give the pigments the added brilliance that varnish seems to impart.

Murals painted with oil paints should be left to dry out completely, which may take anything up to six months (or more if there is impasto). Damar varnish will give a glossy finish; wax varnish, semi-matt.

Application Leave your painting to dry out completely before varnishing. Then dust down the surface carefully and allow the dust to settle – if dust particles manage to combine with the varnish, you will find the surface takes on a granular effect which will then be picked up by the light. If you try to remove the ugly particles, you may end up repainting most of the mural.

A good bristle brush is worth investing in to apply the varnish. The size will depend on the area you wish to cover. Make sure that your brush has been worked in well so that it has shed all loose hair. Starting at the top left-hand corner (if you are right-handed) work down the mural in bands. If you are using a ladder, working in this way means you will not need to move it so much. Apply the varnish thinly and evenly on a patch about 6 inches (15 cm) square at one time. Work the brush sideways, and then up and down, so that the varnish is spread in a thin layer and blended into the neighbouring patch or band. Finish off by lightly brushing over the surface in one direction.

Alternatively, varnish can be applied with an aerosol spray. Make sure the room is well ventilated, though preferably without a through draught which could bring clouds of dust with it. You will have to be very systematic with your spraying, ensuring that every square inch of the painting is covered.

AFFIXING MURALS TO WALLS

If you use a moveable panel, you will need to fix it carefully in position so that it not only looks good, but also so that it cannot cause damage by literally falling off the wall. If possible, position the support before starting to paint – although, for various reasons, it is often done half-way through painting or at the end. Unless you are confident of your own ability, you will be wise to call in a professional to fix panels to walls. Heavy panels of plaster board, for example, can be dangerous if they come away.

Wooden Panels

Some panels will need cradling, which means fixing battens on the back of the panel to prevent bowing as a result of changes in moisture levels. Battens will also keep the painted panel away from a wall and allow the air to circulate behind it, which is essential if the wall is damp. Battens can be glued or screwed on the back of the panel or board, which can then be hung on the wall like a large easel painting. Alternatively, the battens can be fixed to the wall first, and then the panel pinned or screwed to them. Panels which do not need any battening can be screwed straight to the wall. If the wall is damp, consider a plastic scrim (see page 20), or even a layer of polythene between the wall and board.

If you affix panels after painting, leave those areas where the holes will be drilled loosely painted. Counter-sink the screws, which should be rust proof, then prime the indent with a multipurpose primer and fill with a flexible plaster filler. When the filler is dry, smooth down with fine sandpaper. Finally, do not forget to prime the filler before matching up the paint.

Occasionally, after you have covered a wall with panels edge to edge, gaps appear along the joins due to shrinkage. If there are not too wide, they are best filled with paint; otherwise, use a proprietary filler.

Canvas

If the wall is dry and smooth, canvas can be glued directly on the wall. Such marouflage usually needs professional help. Marouflage on a panel is described on page 25. Alternatively, stretched canvas panels can be measured to fit a space (see page 24). The fit should not be too tight otherwise it will be difficult to insert or remove the panel.

There are various methods of installing the canvas, depending on the size of the panels. A small canvas can be treated like any easel painting. Larger panels of canvas can be kept in position by screwing lengths of

Battens and supports
Most wallboards need strengthening with battens. These can be glued or pinned to the board, following the edge, with a cross-brace for extra rigidity. Each batten can be separately fixed; the framework need not be assembled beforehand or joined together. To glue battens, use a strong wood adhesive and clamp into position.

Wall panels
To line a wall with boards, saw panels to the required shape and butt them together using battens already fixed to the wall. First, screw the battens to the wall at intervals which correspond with the board size.

Place the board against the wall, lining it up with the centre of a vertical batten. Drive in fixing pins down the batten and along the cross-braces. Then, place the next board up to the fixed one so that it abuts neatly before pinning that into position. If necessary, pin beading round the perimeter.

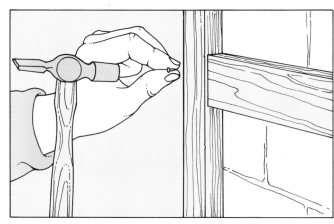

½-inch (1-cm) beading to the wall round the edge to wedge in the canvas. An additional, more decorative beading can then be pinned to this (or to the side walls if it covers a complete wall). This method will not damage the canvas – which is important – and it makes it easy to remove the canvas if necessary.

LIGHTING

The use of appropriate lighting is important for the full appreciation of murals. With trompe l'oeil particularly, the paint surface should be bathed in an even flood of light. This draws attention to the mural and improves the quality of the colour. If an outside view has been painted, good lighting can compound the illusion, making it seem as though light is flooding in from outside.

Lighting accessories

Many different types of lighting, varying considerably in price, are available. As murals vary in size and shape, professional advice is often necessary to obtain what is best for your mural.

New lights coming on the market – spots and floods – frequently come with the option of accessories to control and modify the beam spread. These include 'barn doors' that clip to the sides of a light to control the beam spread, and filters to remove ultra-violet rays that are harmful to some paints.

Probably the most efficient, and most expensive, accessory is the framing projector. Its four-sided beam can be adjusted to place the light exactly, and the edges can be sharpened or softened. Some units include integral glass filters to remove ultra-violet rays, and internal ventilation to remove the heat from the beam, thus preventing damage to the painted wall surface.

A tungsten halogen lamp is recommended for lighting paintings, but this requires a transformer which is an added expense. However, these are integral with some lights. Tungsten halogen lamps produce a high intensity beam of bright white light, giving excellent colour rendition. Despite their expense, the wattage consumption is low and lamp life is long.

Tracks Cheaper alternative lighting can be used also to produce excellent results. Choose enough lights to illuminate the whole area with an even distribution. These are best installed on a track so that a successful position can be achieved through trial and error.

When selecting a spotlight for a track, you will find a wide range of styles, but choice is usually controlled by the distribution of light required. However, some spotlight units are remarkably versatile. They can be used with a wide range of lamps in different wattages and with various beam angles. For mural lighting, the beam angle needs to be wide – 80°-100° – and as bright as possible. If installed with a dimmer switch, the lighting can be raised or dimmed according to the time of day or mood.

Framing Projector
Good lighting can greatly help a mural to succeed and, conversely, bad lighting can ruin your work. This Concord framing projector (A Targa 50 Dichroic Reflector with framing accessories) has been designed for the job. The area of light can be controlled so that it covers the dimensions of the mural.

Spotlights
Spotlights arranged on a track, if carefully positioned, can achieve an even distribution of light. Make sure the lamps do not hang down in front of the mural, blocking the view. If installed with a dimmer switch, the brightness can be controlled according to the time of day or mood.

Bad lighting
Bad lighting can be damaging both to the effect of the mural and in some cases to the paint itself. Beware of spotlights that cast bright rings of light on the mural surface. They are guaranteed to spoil the illusion. Whatever you choose, make sure that when the lighting is installed it does not interfere with the viewing of the mural. Lights that hang down in front of the mural will literally block the view. Ensure, too, that lights do not throw back a secondary glare, which can be distracting.

Strong lights placed too close to the paint surface, especially if oil-based paints have been used, will cause yellowing and could cause the paint to blister.

CARE OF MURAL PAINTINGS

Murals tend to get more noticeably dirty than easel paintings, which seem to need only the occasional dusting. Like any wall, a mural tends to attract the odd scuff or grubby fingermark, although it is rare for the damage to go any further than that (it is usually door frames and skirting boards that take the knocks). Some people hesitate to clean their murals, but this should not be a problem if it is washed gently using mild soap. Even yellowing caused by cigarette smoke or open fires will wash off to a certain extent, and, in fact, this should be done fairly regularly as the smoke deposits can damage the paint film.

Washing murals

All the waterproof or water-resistant paints reviewed in this book, if painted on a surface that cannot be damaged by water, can be cleaned with soap (washing-up liquid) and water, applied with a soft brush or wad of cotton wool. A well-used, soft decorating brush works well for this purpose.

Always wash your mural gently. Add some soap to a bucket of luke-warm water and dip in the brush. Start at the top of the mural, a small patch at a time, working the brush in a circular motion. Rinse off the soap and dirt with plenty of clean water when the job is completed or you may get streaking over the surface.

Repairing damage

If the paint film is broken, exposing the surface below, your course of action will depend on the type of support and extent of damage. There are many professional restorers who deal with all types of painting on all surfaces and you may feel happier enlisting their help and expertise.

Plaster and wood It may be necessary to replaster over a damaged area. You will then have to paint the new surface and try to match in with what is already on the wall. It is worth spending time locating a good plasterer who will contain the damage rather than spread it.

Small holes in plaster or wood supports are more easily dealt with. Hopefully, it will only be a case of brushing off any loose particles, filling with a suitable proprietary filler, rubbing down and priming before the damaged painting can be repaired. The priming is important, particularly if oil-based paints are used; otherwise there will be uneven porosity. Such repair work may also be necessary if the paint film is damaged in the course of painting – with the inopportune use of masking tape, for example.

Cleaning murals
Murals painted in water-resistant paints on surfaces that will not be damaged by water can be gently cleaned with soap and water to remove dirt and grime. Test a small patch first to make sure. Gently remove surface dust, then, using a soft decorators' brush or wad of cotton wool, work off ingrained dirt with a gentle circular motion.

Tackle a small patch at a time, rinsing of the soap and dirt with a soft cloth as you proceed, changing the water frequently. Finally, when you have finished, make sure the surface of the mural is properly rinsed with clean water otherwise streaking may occur.

Integrating the new paint surface with the old can be tricky. Matching paints, particularly those which have aged, can prove to be a problem too. If possible, recall the original artist to do the repair work. If you are restoring your own work, you may find it is more successful if the original composition is altered so that the damaged area can be covered by a single, new, element – figure, flora or fauna.

Canvas and paper Pierced canvas and paper are difficult to repair successfully without professional advice.

GUIDE TO PAINTS, PRIMERS AND SURFACES
APPENDIX TO CHART ON PAGE 40

	Paper	Aluminium	Other metals	Plastic	Tiles and glass
WATER-THINNED PAINTS Artist's Acrylics (E) and Vinyl and PVA (E)	Apply direct or prime first with acrylic medium.	Aluminium primer.	Use relevant metal primer.	Acrylic primer.	NR
Indelible gouache (Flashe)	Apply direct or prime first with universal primer.	NR	NR	Apply direct.	Apply direct.
Household emulsion (vinyl matt)	Apply direct	NR	NR	Apply direct, but will chip off.	NR
External emulsions (E)	NR	NR	NR	NR	NR
OIL-BASED PAINTS Artists' oils	Size, or size and gesso ground, or acrylic primer.	Apply direct.	Use relevant metal primer.	NR	NR
Oil-based household paint (egg-shell, silthane, silk)	Wallpaper: seal with coat of vinyl matt emulsion.	Aluminium primer.	Use relevant metal primer.	NR	NR
Gloss paint (E)	Wallpaper: seal with coat of vinyl matt emulsion.	Aluminium primer.	Use relevant metal primer.	Proprietary undercoat	NR
Signwriters' paint (E)	NR	Apply direct.	Use relevant metal primer.	Apply direct.	Apply direct.
OTHER PAINTS Modelling enamels (E)	NR	NR	NR	Apply direct.	Apply direct.
Cellulose lacquer (E)	NR	Aluminium primer.	Cellulose primer (non oil-based).	NR	NR
Tempera	NR	NR	NR	NR	NR
Silicate-based paints (E) Keim paints	NR	NR	NR	NR	NR

E – can be used externally

NR – not recommended

PRIMING CHART FOR PROBLEM WALLS

Efflorescence	Alkali-resistant primer
Alkaline residue	Alkali-resistant primer
Damp	Sealer primer, if paint needs to be sealed off from damp
Friable, chalky surface	Sealer primer
Uneven porosity	Sealer primer
Nicotine staining	Alkali-resistant primer
Bitumen surfaces	Apply anti-bleed sealer, use oil-based paints

Note: Some primers are flammable with low flash points. They are also harmful to the skin and eyes, so treat with caution and keep them away from children. Wear protective clothing and goggles and apply in a well-ventilated area.

Glossary

ABSTRACT Pictorial arrangement of form, colour and tone without a recognizable subject matter.

ACRYLIC PAINT Quick-drying, permanent paint in which pigment particles are suspended in a synthetic resin.

ACRYLIC GESSO Proprietary primer for use with acrylic paints. Not to be confused with traditional gesso.

AERIAL PERSPECTIVE Creating the illusion of space and recession by using pale tones and subdued, cool colours for objects in the distance.

ALKYDS Quick-drying paints, similar to acrylics, but soluble in turpentine and white spirit instead of water.

ARABESQUE Sinuous and flowing style of linear decoration.

BAROQUE An artistic style, which started in the sixteenth century. It emphasizes the emotional response to combined colour, movement and light.

BLENDING Merging colours gradually in order to avoid a hard, noticeable join.

CARTOON A full-scale, detailed drawing for a painting. The image is usually transferred to the canvas or panel by rubbing the reverse of the drawing or by pricking round the outlines of the image with a pin.

CORNER WEDGES Small, flat triangles of wood or plastic which are inserted in the inside corners of a stretcher. The tautness of the canvas is increased when the wedges are tapped further into position.

COTTON DUCK Fabric support often used as an inexpensive alternative to pure linen.

CRADLING Fixing battens along the edges of the reverse side of a panel or board in order to make it rigid.

DAMAR An oil painting varnish or medium made from coniferous resin. Damar does not turn yellow or become opaque with age.

DILUENT Liquid used to dilute paint. Turpentine and white spirit are oil paint diluents.

DISTEMPER Water-soluble paint often made from glue-size or casein. Traditionally used as a house paint.

EFFLORESCENCE White crystal residue that appears when dampness in building materials dries out.

EGG TEMPERA Painting medium in which the pigment is suspended in egg yolk emulsion.

EMULSION (1) A combination of oil and water with the aid of a gummy or albuminous substance – the emulsifier. (2) Type of paint, nowadays usually vinyl-based.

EYE-LEVEL The horizon line as used when constructing perspective.

FILBERT Type of artists' brush with a flattened, shaped head of bristles.

FLAT Artists' brush with a flattened head of bristles. Both edges of the bristle head can be used to produce either broad or narrow lines.

FRESCO Technique of wall painting directly on plaster. True fresco involves applying colour while the plaster is wet; dry fresco is worked on dry plaster.

FRIABLE Crumbly or powdery. The term is frequently used to describe the state of a wall or surface.

FRIEZE A decorative band

FUGITIVE A term applied to paints that do not retain their brightness of colour, either because of inherent defects or through the effect of natural forces – particularly sunlight.

HIGHLIGHT The brightest part of the subject, often a reflection or the spot that receives the most direct light.

ICONOCLASM The destruction of images, usually pictures of Christ or saints.

INSET A small picture or design inserted within the boundaries of a larger one.

LUNETTE A semi-circular or crescent-shaped space, often in a ceiling or dome, or above a window or door.

LINEAR PERSPECTIVE Space and recession created on a flat surface through the use of converging lines and vanishing points.

MASKING The use of tape, paper or other substance to protect and isolate a particular area of a painting.

MARBLING A painting technique used to simulate the look of real marble.

MAROUFLAGE A term used to describe the sticking or otherwise fixing of canvas or fabric to a board or panel.

MATT Dull, non-reflective.

MEDIUM Technically, this is either a substance mixed with pigment to make paint or, alternatively, the term can refer to any substance used with paint in order to change its consistency. More generally, a medium can mean the actual material or type of paint being used – such as acrylic, oil or crayon.

MORTAR A mixture of cement, sand and water used for rendering and for laying stones and bricks.

MOSAIC Picture or pattern made by arranging and cementing together small tiles, pieces of glass, stones or other materials.

MOTIF A decorative element used in a composition or design.

OBELISK A monolithic, tapering pillar of brick, concrete or stone, with either a square or rectangular base.

OCULUS A circular window, traditionally the large round window at the west end of a church.

OGEE A double moulding, usually with a convex curve running alongside a concave one.

OIL PAINTS Paint consisting of pigment mixed with an oil medium, such as linseed. The term usually applies to artists' paints.

PASTICHE A picture or design composed of visual fragments brought together from other sources.

PERSPECTIVE The creation of three-dimensional space on a flat surface. See Aerial and Linear perspective.

PICTURE PLANE The invisible upright plane that separates the picture subject from the viewer's surroundings – effectively, the surface of the picture.

'PIERCING' The illusion of recession on a flat surface.

PIGMENT Colouring substance from synthetic, mineral, animal or vegetable sources, used in paints and dyes.

PLANE The flat areas of the surface of an object which can be seen in terms of light and shade.

PRIMER Substance applied to the support to make it less absorbent and easier to paint on. Also known as ground.

PVA Made from polyvinyl acetates, PVA paint is durable, adhesive, quick-drying, and cheaper than acrylic.

RENDER (1) To draw, copy or paint a subject. (2) To apply a coat of plaster, cement or concrete to stone or brick.

ROCOCO Decorative art style that originated in France in the early eighteenth century, involving flowing, curved shapes and delicate ornamentation.

ROUND Artist's brush with a round head of bristles.

SABLE Hair from the kolinsky, or Siberian weasel, which is used to make the finest, soft artists' brushes.

SIZE Glue used to seal the support prior to priming. Often made from rabbit skin.

STRETCHER Wooden frame over which canvas or other support is stretched. Stretchers are usually made of separate, interlocking pieces.

STUCCO (1) Plaster for covering walls. (2) The process of ornamentation with this plaster.

SUPPORT Canvas, paper, board or other surface used for painting.

SURREAL Term describing an ultra-detailed rendering of the subject, often in an unexpected or dreamlike setting.

TEMPLATE A flat, cut-out pattern, used as a drawing aid for a difficult or complicated shape.

TONE Describes the lightness or darkness of a colour. Each colour has a tone, or tonal equivalent, from very light grey to very dark grey.

TROMPE L'OEIL Painting, or part of a painting, that is deliberately rendered so convincingly that it looks real.

UNDERDRAWING Drawing done prior to painting, usually in charcoal, pencil or very dilute paint.

UNDERPAINTING Preliminary and approximate blocking in of the main shapes and tones of a painting.

VANISHING POINT Spot on the horizon at which two parallel lines appear to converge. See Linear perspective.

VAULTED Architectural term describing the arched shapes of a constructed domed roof or ceiling.

VINYL Comparatively inexpensive plastic paints, obtainable in big containers and useful for painting large, flat areas.

Further Reading

Airbrush Techniques Workbooks 1–4 (Cincinnati, North Light, 1985)

Blanchard, Roberta R., *Traditional Tole Painting: With Authentic Antique Designs and Working Diagrams for Stenciling and Brush-Stroke Painting* (Mineola, NY, Dover, 1977)

Bowers, Michael, ed., *Painting in Oils* (Cincinnati, North Light, 1984)

Chijiiwa, Hideaki, *Color Harmony* (Rockport, dist. by North Light, Cincinnati, 1987)

Driggers, Susan Goins, Beginner's Guide to Faux Finishes (Plaid Enterprises, 1987)

Grafton, Carol B., ed., *Pictorial Archive of Decorative Frames and Labels: 550 Copyright Free Designs* (Mineola, NY, Dover, 1982)

Grafton, Carol B., *Treasury of Art Nouveau Design and Ornament* (Mineola, NY, Dover, 1980)

Hebblewhite, Ian, *The North Light Handbook of Artist's Materials* (Cincinnati, North Light, 1986)

Leland, Nita, *Exploring Color* (Cincinnati, North Light, 1985)

Little, Nina F., *American Decorative Wall Painting 1700–1850* (New York, E. P. Dutton, 1982)

Marhoefer, Barbara et al, *Early American Wall Stencils in Color* (New York, E. P. Dutton, 1972)

Monahan, Patricia, *Landscape Painting* (Cincinnati, North Light, 1985)

Monahan, Patricia, *Painting with Oils* (Cincinnati, North Light, 1986)

Muller, Mary, *Murals: Creating an Environment* (Davis, Mass., distributed by Sterling, New York, 1979)

Rodwell, Jenny, *Flower Painting* (Cincinnati, North Light, 1985)

Rodwell, Jenny, *Painting with Acrylics* (Cincinnati, North Light, 1986)

Shaw, Jackie, *Tole Technique and Decorative Arts*, 4 vol. (Deco Design Studio, 1974)

Tate, Elizabeth, *The North Light Illustrated Book of Painting Techniques* (Cincinnati, North Light, 1986)

Woolery, Lee, *Airbrush Techniques Workbooks 5–8* (Cincinnati, North Light, 1988)

List of Suppliers

ARTISTS' SUPPLIERS

M. Grumbacher
30 Englehard Dr.
Cranbury NJ 08512

Brushes, colors, art materials.

Shiva Inc.
2550 Pellissier Pl.
Whittier CA 90601

Acrylics, caseins, temperas, adhesives.

Binney & Smith Inc.
Art Products Div.
Box 431
1100 Church Ln.
Easton PA 18044-0431
Tel: 215/253-6271

Liquitex acrylic colors.

Daler/Rowney Co.
1085 Cranbury South River Rd.
Jamesburg NJ 08831

Acrylics and artists brushes.

Floquil Polly S Color Corp.
Rt. 30 North
Amsterdam NY 12010
Tel: 518/843-3610

Flo-Paque enamels.

Keim Paints
Mineral Protect Ltd
Brockton
Much Wenlock
Shropshire TF13 6RR
Tel. 074-636 419
Telex 35438

Keim mineral coatings and 'Artist Paints'.

LeFranc & Bourgeois
357 Cottage St.
Springfield MA 01104

Flashe permanent gouache.

Pelikan AG
G.H. Smith & Partners (Sales) Ltd
28 Berechurch Road
Colchester CO2 7QH
Tel. 0206-760 760

Plaka casein emulsion paints and fabric paints. Distribution throughout the UK and worldwide.

Rosco Associates Inc.
680 E. Race Track Rd.
Box 146
Alexandria KY 41001

Rosco paints.

Winsor & Newton
555 Winsor Drive
Secaucus
New Jersey 07094
USA

General artists' suppliers, including acrylics, artists' oils, vinyls, brushes, etc. Distribution throughout the UK and worldwide.

Artists Canvas Mfg. Corp.
20 Broadway
Brooklyn NY 11211
Tel: 718/384-2300

Canvas cotton, linen, mural canvas.

Tara Materials
Box 646
Lawrenceville GA 30246

Frederix canvas in all forms and grades.

Index

repointing a wall 22
resealable plastic kettles 28, 29
restaurants, murals for 102, 103
retarder for acrylic paint 32
ribbons 74-5, 136
rising damp 19
Rococo 14, 15
Rococo-style ceiling 61
Roman blind 139
Roman Doric 154
Roman mural art 9, 10-11, 14, 120
Roman-style frieze 62
Rome 10
 Sistine chapel 12
 Theatre of Marcellus 154
Romm, A.G. 15
Rosco 21, 35
roses 74
Rousseau, Henri 66
Rowney 32
Royal Academy restaurant mural 102
rumpus room, mural for a 76
rustic clay bricks 23
'rustic niche' 135

sable brushes 26, 27
'safari' mural 77
safflower oil 30
San Diego, parking lot mural 91
sand-blasting 22
sand-faced bricks 23
sanding block 19, 21
sanding down walls 19
sanding down wood 21
sandpaper 21, 28, 29
sandstone 149
Santo Domingo Custom House, Mexico
 City 16
Saqqara 54
satin finish paints 37
scaffolding 23, 29
scaffolding tower 29
scale 44, 50
scenery painting 21, 35
scissors 28, 29
'scribes of outline' 10
scrim 20, 24, 158
scumbling 133
sea-green 59
sealer primer 18, 22, 40, 161
sealer solution 37
Sesh-seshet Idut, Princess, tomb of 54
shadow 44-5, 87, 117, 134
Shchukin, S.I. 15
shed, mural painted on a 119
shot-blasting 22
shutters 17, 18, 20, 125, 155
signwriters' paints 38, 40, 157, 161
silicate-based paints 39, 40, 161
silk finish paints 37, 40

Siqueiros, David Alfaro 16
Sistine Chapel, Vatican, Rome 12
site of mural 17, 41
 to prepare 28
size 40, 161
sketchbook 41
sketches, preliminary 48
skirting boards 18, 20
sky 70-1, 82-3, 100, 112, 127
sky blue 82, 96, 112, 114
skylight (trompe l'oeil) 138
'skyscape' mural 90
slide projector 50
small-scale murals 124-41
soap-filled pads 28, 29, 50
soya oil 30
spatial illusion 44, 46, 94-109
spattering paint 39, 128, 148
spirit level 28, 29, 99
sponges 28, 29
spot-lights 36, 159
spray-diffuser 33, 115
spray guns 26, 27, 33
spray varnish 86
squared design mural 65
squaring up 48-9, 54-6, 123
squirrel hair brushes 26
St Stephen's Hospital, trompe l'oeil mural
 67
Sta Maria delle Grazie, Milan 12
stained glass 45
staining water 22
stairway 117
step ladders 17, 29
stencils 63, 138
stippling 70-1, 101, 131
stirring utensil or attachment 29
stone mask 121
stonework 83, 84-6, 109, 115, 128, 137,
 141, 143, 148-52
straight lines, to paint 38, 133
'street façade' mural, Philadelphia 106
stretching a canvas 24
string plumb line 28, 29
stripping walls 18, 19
stripping wood 20, 21
students' oils 31, 36
subject, choice of 42
sugar soap 82
'superman' photomural 93
supports see moveable panels
Surbiton, London, underground station
 mural 102
surprise element in murals 43
surreal and fantasy murals 80-93
Surrealist Movement 81
suspending cradle 23
'swimming pool' mural 94, 96-101
sword 143

'tapestry' mural 64
Targa 50 Dichroic reflector 159
teddy bear 70, 72-4
tempera 39, 40, 157, 161
templates 39, 49, 63, 123, 127, 153
terra cotta brown 54, 58
terre verte 36
textile supports 21, 40
'Thames River view' mural 102
'thatched cottage' mural 78
Theseion, Athens 154
Third Style Pompeian 60
three-dimensional illusion 44, 46, 95
three-point perspective 47
Tiepolo, Gian Battista 14
Tiffany 138
tiger 77, 121
tiles 161
titanium-based colours 36
'Toilet of the Gods' mural 82-7
tone 45
toothbrush, use for a 27
topiary shapes 115, 116
track lighting 159
trailing plants 138
transferring the design 48-50, 54-5
translucent paint 37
trees 10-11, 101
trellis 134
trompe l'oeil 42, 44, 53, 64, 67, 81, 93, 95,
 109, 119, 125, 130-3, 134, 135, 138,
 139, 140, 141, 143, 155, 156, 159
tungsten halogen lamp 159
Turner's yellow 70, 74
turpentine 30, 37
Tuscan Doric 154
two-point perspective 47

undercoats 31, 40, 161
underdrawing 50, 113
underpainting 50, 97, 114
urn 61, 107, 124, 126-9, 137
Userkaf, King 54

vanishing point 46, 47, 130
varnishes 37, 156, 157
varnishing 156, 157
varnishing brush 26
Vasari, Giorgio 12
Venetian school 14
Venetian window 155
'Venus in the Kitchen' mural 92
Verrio, Antonio 9, 12-13
Vesuvius 10
Victorian grate 139
Victorian window 155
viewpoint 96, 130
 to establish a 46
Villa Savoie 65
Vinyl Colours by Winsor & Newton 33

vinyl enamels 33, 38
vinyl matt emulsion 21, 34, 35, 40, 54, 70,
 96, 130, 146, 161
vinyl paints 20, 33, 40
visual jokes 43
Vitruvius 10

wallpaper 20, 161
 to prepare for painting over 20
walls, exterior 22-3, 30
walls, interior 17, 30
 to affix murals to 158
 to clean 18
 to fill cracks in 18, 19
 to paint a flat coat on 34-5
 to prepare problem surfaces 19-20
 to strip off paint 18, 19
walnut 25, 146
wardrobe doors, mural on 136
warm colours 45
washing down interior walls 18
washing murals 160
water-blasting 22
water-resistant paints 31, 32, 38, 160
water-thinned paints 18, 21, 28, 29, 30,
 31, 34, 69, 157
 primers for 40
 to varnish 157
water-thinned silk or satin emulsion paint
 38
watercolour paints 30, 95
wax varnish 157
WBP supports 25
'West Broadway Trolley' mural 107
'West Indian fruit' mural 124, 128-9
wet-on-wet technique 39
white 16, 54, 59, 70, 73, 74, 82, 84, 97,
 101, 112, 114, 115, 126, 127, 128, 129,
 130, 131, 133, 148
white spirit 30, 37
windmill 88
window frames 20
'window' mural 43
window styles 155
Winsor & Newton 32, 33
wire wool 21, 28, 29
wood, to strip 20, 21
wood graining 146-7
wooden palettes 29, 73
wooden supports 18, 19, 25, 37, 39, 40,
 111
 to affix to walls 158
woodwork, to prepare for painting 20-1,
 23

yellow 16, 45, 54, 70, 75, 98, 148 and see
 lemon yellow etc.
yellow ochre 82, 84, 96, 101, 126, 127,
 130, 131
yew hedges 101

Acknowledgements

The author and publishers would particularly like to thank the following individuals for their invaluable contribution to this book:

for special photography on pages 52, 54-59, 68, 70-75, 80, 82-87, 94, 96-101, 110, 112-117, 124, 126-133, 142, 144-149: Andrew Putler

for their generously given advice: Graham Rust, Alan Dodd, Graham Cooper, Leonard Rosoman and Mary Adshead

The publishers would like to thank the following for their permission to reproduce the photographs in this book:

Richard Bryant/Arcaid (artist: Simon Brady) 123 below left, (artist: Sue Ridge) 65 left; Lucinda Lambton/Arcaid (artist: Glynn Boyd-Harte) 103 right, (designer: Jocelyn Ricklands) 120 above; T. Behrens 65 right; Roderick Booth-Jones (photo: Richard Holt) 92 right; Larry Boyce & Associates, Inc. (photo: Ken Huse) 62 above, (photo: Chad Slattery) 63 left; British Railways Board and London Borough of Lambeth (artists: Anchor Design) 64 right; Jonathan Brunskill of Brunskill/Farr 104 below, 134 below, 137 above left and below; Burghley House, Leicester/Bridgeman Art Library 8; Ian Cairnie 135 right, 140 right, 151 below; Calum Colvin 93 above left; Gary Cook 123 above left; Michelle Cooper 134 above left, 141 above left; Dragons of Walton St./Frederick Warne 77 above; Elson, Pack & Roberts commission (artists: Graham Cooper, Yasuto Kato, Johan Van Den Berg) 91 above right; Nick Eustace & Ross Lewis 60 below; Evergreene Painting Studios, Inc. (design: Jeff Greene) 61 right, 107 above, 118 below, 134 above right, 138 above, (design: Richard Haas) 106 above; Colin Failes 64 left, 89 above, 105 left, 119 right, 139 above left and above right; Claire Falcon (photo: Henry Arden) 78 right, 79 above right; Roberta Gordon-Smith (photo: Michael Dunne) 79 above left; Sarah Guppy 77 below; Jean-Pierre Heim (photo: Arcadia) 90 left, (photo: Feuillatte) 103 left; (photo: F. Rambert) 88 above, 104 above; by gracious permission of Her Majesty the Queen 14; Hirmer Fotoarchiv 9; David Hoffman 96 above, (artist: Marcia Allen) 67 left, (artist: Jeanette Sutton) 62 below; Howletts & Port Lympne Zoo Parks, Hythe (artist: Rex Whistler) 109 below; Sarah Janson 60 above right, 61 left, 136 left, 141 below, 150 above, 151 above left; Keimfarben GMBH & Co. KG 150 below; Priscilla Kennedy (photo: C. Marriott) 108 right; Sally Kenny Decorations 151 above right; Carlo Marchiori 60 above left, 121 above; Lucretia Moroni, M.O.C.A. (photo: Liza Himmel) 152; Tim Plant (photo: Nick Taylor) 119 left, 121 below, 122 below, 123 right; James Prigoff (artist: Lynn Jakata) 79 below, (artist: Paul Levy) 91 above left, (artists: Sara Lindquist, Bob Fishbone) 106 below, (artists: Public Works – A Construction Company) 118 above, (artists: Jane Scheerer, Rhody Speilman) 107 below, (artist: Mario Torero) 91 below; Public Art Development Trust (artist: Faye Carey/photo: Edward Woodman) 67 right, / British Railways Board (artists: Sue Ridge, Graeme Wilson / Photo: Edward Woodman) 102 above; Royal Academy of Art (artist: Leonard Rosoman) 102 below left; Desmond Rochfort (artist: David Alfonso Siquieros) 16; Graham Rust 122 above, 137 above right; Poggio a Caiano, Villa Reale/Scala 10-11, Museo delle Terme, Rome/Scala 13; Lincoln Seligman 88 below, 92 left, 102 below right, 108 left, 109 above left, 120 below, 135 left, 139 below, 140 left, 141 above right; Richard Shirley Smith 63 right, 93 above right, 136 right; Annie Sloan (photo: Graham Challifour) 66, 76 below, 78 left; Tromploy, Inc. 90 left, 109 above right; VAAP/(c) DACS 1987 15; Tania Vartan Designs 105 right, 138 below; R.D. Warner assisted by the inmates of H.M. Prison, Reading 93 below; World of Interiors (artist: T. Behrens/photo: James Mortimer) 89 below.

Every effort has been made to trace the (c) holders, of photographs, and we apologise in advance for any unintentional omissions and would be pleased to insert the appropriate acknowledgement in any subsequent edition of this publication.

Names and Addresses

T. Behrens
Butler's Cottage
Culham Court
Henley-on-Thames
Oxon

Roderick Booth-Jones
14 Davisville Road
London W12

Larry Boyce & Associates, Inc.
Box 421507
San Francisco
Ca 94142–1507
USA

Jonathan Brunskill
Brunskill/Farr
42 Gladsmuir Road
London N19

Ian Cairnie
59 Upper Tollington Park
London N4

Calum Colvin
Dec 10 Studios
B2 Roadside
Metropolitan Wharf
Wapping Wall
London E1

Gary Cook
'The Victoria'
39 Chalk Hill
Oxhey
Herts

Michelle Cooper
18 Limerstone Street
London SW10

Graham Cooper
60 Smithwood Close
London SW19

Dragons of Walton St Ltd
23 Walton Street
London SW3

Nick Eustace and Ross Lewis
Flat 2
Barrington House
74 Peckham Road
London SE5

Evergreene Painting Studios, Inc.
365 West 36th Street
New York
NY 10018
USA

Colin Failes
6 Elfindale Road
London SE24

Claire Falcon
21 Embankment Gardens
London SW3

Roberta Gordon-Smith
103 Dawes Road
London SW6

Sarah Guppy
10 Addison Avenue
London W11

Jean-Pierre Heim
24 rue Vieille du Temple
Paris 75004
France
AND
140 West 69th Street
New York
NY 10023
USA

Sarah Janson
49 Drayton Gardens
London SW10 9RX

Yasuto Kato
701 Tojuso-Nakaoe
2-7-1 Minamishiumachi
Higashiku
Osaka
540 Japan

Keimfarben GMBH & Co. Ltd
Georg-Odemer-Strasse 4-6
D-8902 Neusäss
West Germany

Priscilla Kennedy
Tower House
Burley
Craven Arms
Shropshire

Sally Kenny
Sally Kenny Decorations
16a Talbot Square
London SW2

Carlo Marchiori
357 Frederick Street
San Francisco
Ca 94117
USA

Lucretia Moroni
M.O.C.A. Designs
241-45 West 36th Street
New York
NY 10018
USA

Tim Plant
7 Bramham Gardens
London SW5

Port Lympne Mansion,
Zoo Park and Gardens
Near Hythe
Kent

Public Art Development Trust
6-8 Rosebery Avenue
London EC1

Leonard Rosoman, O.B.E., RA
7 Pembroke Studios
Pembroke Gardens
London W8

Royal Academy of Art
Piccadilly
London W1

Graham Rust
25 Old Church Street
London SW3

Lincoln Seligman
22 Ravenscourt Park
London W6
AND
c/o Hoar
49 East 96th Street
Apartment 15E
New York
NY 10128
USA

Richard Shirley Smith
9 Douro Place
London W8

Annie Sloan
Knutsford House
Park Street
Bladon
Oxon

Tromploy, Inc.
400 Lafayette Street
5th floor
New York
NY 10003
USA

Tania Vartan
Tania Vartan Designs
970 Park Avenue
New York
NY 10028
USA

R.D. Warner
6 Barracks Lane
Spencers Wood
Reading
Berkshire